The legend of Rex—
for that is what it now is
and must of necessity be—
is one of the finest
both in the art sense
as well as the human . . .

—MARSDEN HARTLEY, 1938

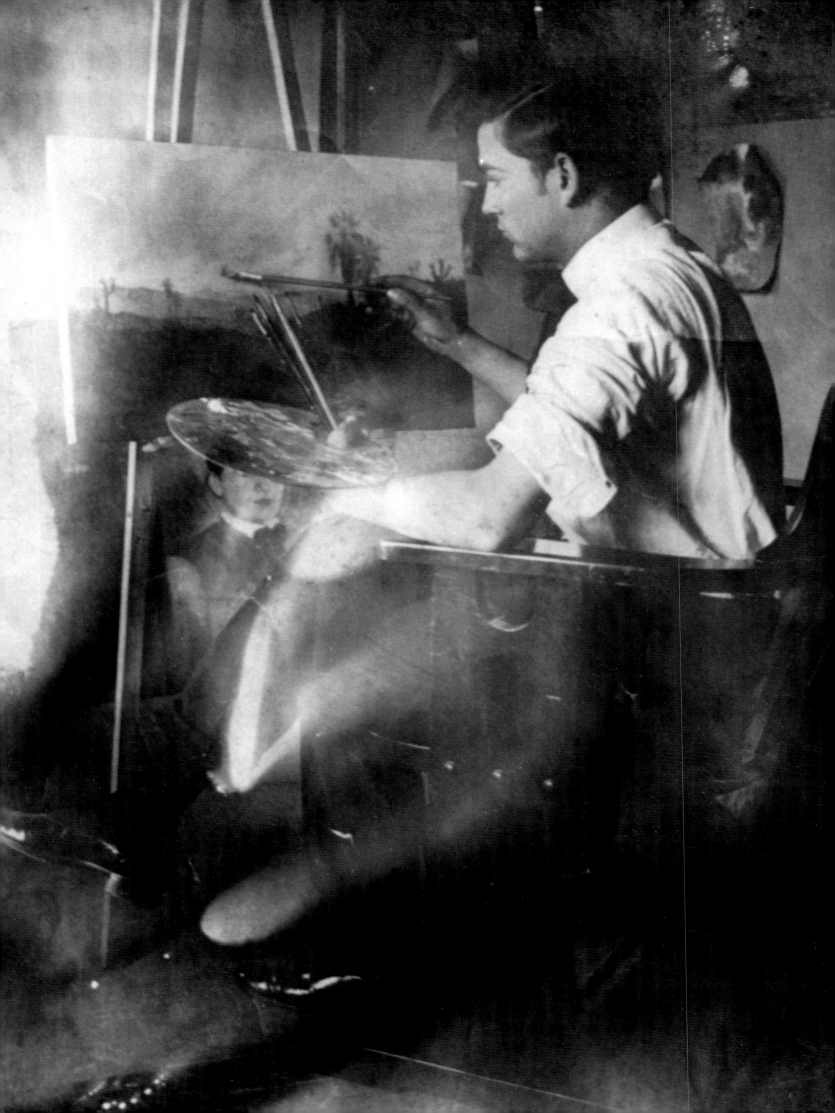

THE LEGEND OF **REX SLINKARD**

ESSAYS BY

Charles C. Eldredge
Geneva M. Gano

IRIS & B. GERALD CANTOR CENTER FOR VISUAL ARTS AT STANFORD UNIVERSITY

This catalogue is published on the occasion of the exhibition *The Legend of Rex Slinkard*, organized by the Iris & B. Gerald Cantor Center for Visual Arts at Stanford University and on view 9 November 2011–25 March 2012. The exhibition and publication of this catalogue are made possible by generous support from the Florence A. Williams Fund.

Unless otherwise indicated, all works are by Rex Slinkard and belong to the Cantor Arts Center. Height precedes width in dimensions.

Frontispiece: Unknown photographer, *Rex Slinkard Painting* (detail). Gelatin silver print, 5 × 4 in. Private collection.

LIBRARY OF CONGRESS CATALOGING-IN-PUBLICATION DATA

Eldredge, Charles C.
 The legend of Rex Slinkard / essays by Charles C. Eldredge, Geneva M. Gano.
 p. cm.
 Includes bibliographical references.
 ISBN 978-0-937031-35-3 (alk. paper)
 1. Slinkard, Rex, 1887–1918—Criticism and interpretation. 2. Slinkard, Rex, 1887–1918—Catalogues. 3. Painting—California—Palo Alto—Catalogues. 4. Iris & B. Gerald Cantor Center for Visual Arts at Stanford University—Catalogues. I. Gano, Geneva. II. Slinkard, Rex, 1887–1918. III. Title.
ND237.S569E43 2011
759.13—dc22 2010025309

Iris & B. Gerald Cantor Center for Visual Arts
Stanford University
328 Lomita Drive
Stanford, California 94305-5060
www.stanford.edu/dept/ccva

CONTENTS

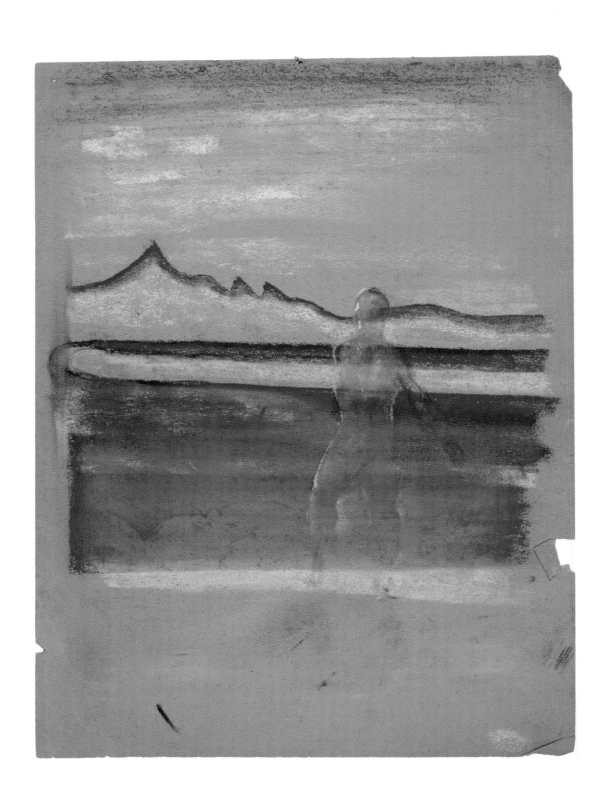

FOREWORD

The Cantor Arts Center is the primary repository of paintings and sketches by the early-twentieth-century California artist Rex Slinkard, who survived military service in World War I but succumbed to the influenza epidemic of 1918. During his too-brief life he emerged from his roots as a California rancher to become a painter who helped influence the modernist bent of the nascent California art scene. Slinkard studied with Robert Henri and shared a studio with George Bellows in New York City, returning to paint and teach in Los Angeles, where he established personal contacts with well-known people in the worlds of visual and literary arts. These contacts have recently come to light with new scholarship undertaken by Geneva M. Gano, who spent a postdoctorate year at Stanford's Bill Lane Center for the American West. Her research prompted the museum to publish and make more widely known the works of this enigmatic modernist.

The Slinkard collection came to Stanford in 1955 as a bequest from Florence A. Williams, the sister of Slinkard's fiancée, Gladys Whitney Williams. While this body of work continues to puzzle, delight, trouble, and inspire viewers, little is known about the artist. We are therefore especially indebted to Professor Charles C. Eldredge, who first touched on Slinkard in his influential exhibition *American Imagination and Symbolist Painting* (1980), and Geneva Gano for providing substantial essays that give context to Slinkard's life and illuminate his artistic legacy.

On behalf of the authors, we thank members of the Slinkard family who provided valuable information. Thanks also go to Lee Fatherree for his excellent photographs of the Slinkard collection; to Christine Taylor and the staff of Wilsted & Taylor Publishing Services for producing this handsome volume; and to the Raymond H. Fogler Library, University of Maine, and the Archives of American Art, Smithsonian Institution, sources of much original documentary material. We want to thank Spencer John Helfen and George Morgan for images and loans. At the museum, we are grateful for the efforts of Nancy Ferguson, Betsy G. Fryberger, and Patience Young, who shared curatorial responsibility for the exhibition; Judy Koong Dennis and Allison Akbay, who secured the images and rights; and Bernard Barryte, who managed production of this catalogue. We also want to acknowledge the many staff members who cared for this collection over the years. Not least, we are indebted to the Florence A. Williams Fund for supporting this publication.

THOMAS K. SELIGMAN
John and Jill Freidenrich Director

Figure in Landscape
Pastel, 12 × 8¹⁵/₁₆ in. [Cat. no. 258]

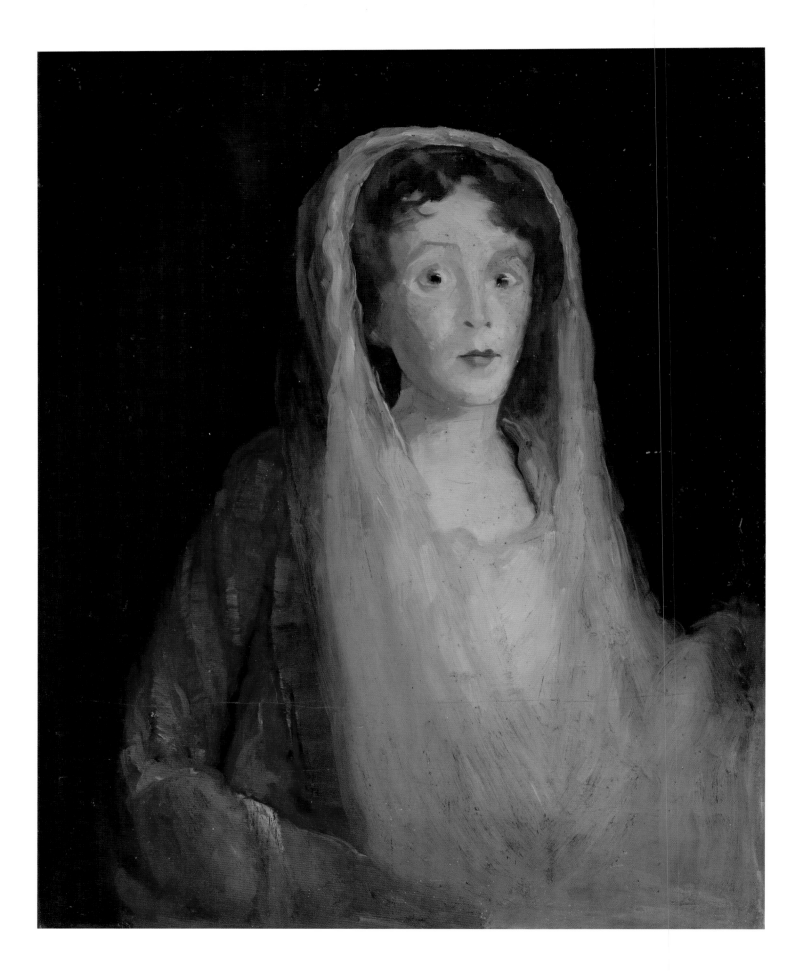

Charles C. Eldredge

REX SLINKARD 1887–1918

Following Rex Slinkard's untimely death at age thirty-one during the influenza epidemic of 1918, the California painter was mourned and remembered by many. His mother, who recognized and supported her son's aspirations in the arts—saving even his childhood copies of magazine illustrations—began a memoir of Slinkard with a simple statement suggestive of his gentle nature: "He was fond of horses and dogs."[1] Carl Sprinchorn, a classmate at Robert Henri's school in New York who became Slinkard's close and lifelong friend, recalled that "no eastern scene or life-in-the-raw, New York material . . . could ever have supplanted [the West] in his interest or love"—hence Slinkard's nickname, "the Westerner."[2] "Rex," he explained, was "always the life of the party."[3] In New York, he often accompanied his studio-mate, George Bellows, to gather material for the latter's well-known boxing subjects. In some of those pictures, Bellows included Slinkard in the ringside crowd at the lower margin of the compositions, where his likeness was recognized by friends (see FIG. 45). Robert Henri (1865–1929), who had taught both Slinkard and Bellows among scores of other students, shared the sorrow at the news of the young man's death nearly a decade after Slinkard had left his class. "We feel the loss very much ourselves," he wrote to a mutual friend, "for [Slinkard] was one of ours. One of the old school . . . related in a way so that we can not forget. . . . We loved him too."[4]

Marsden Hartley (1877–1943) knew Slinkard only through his paintings and drawings, which he encountered in Los Angeles scant months

Fig. 1 **Portrait of Gladys Williams**, c. 1914–15
Oil on canvas, 30 × 24⅛ in. [Cat. no. 15]

after the artist's death. Hartley long recalled the epiphanic moment—"I seemed to enter the personality of Rex completely"[5]—and felt a special kinship with the Californian. He hailed Slinkard, "a soldier, poet-painter by inclination, and ranchman as to specific occupation," as "one of America's most talented men."[6] Hartley's moving tribute elicited a compliment from Henri, who told him, "I don't understand how it is that you did not know Rex, you have written such a good portrait of him."[7] Art critics also praised the work, on occasion in language as laudatory as Hartley's; one San Francisco reviewer called him "an artist of exceptional originality, a great draughtsman with a limitless imagination."[8] Admirers in Los Angeles recalled Slinkard as "the first dedicated artist of stature and real genius developed here in southern California."[9] Even twenty-five years after his death, Slinkard was acclaimed by Arthur Millier, the dean of Los Angeles critics, as "California's most imaginative painter."[10]

By the late twentieth century, however, Rex Slinkard and his achievements had slipped from public memory and from the canonical accounts of American art's development, certainly from the national record and even from California's. The familiar vagaries of fashion provide only a partial explanation for the eclipse. Slinkard's career was, after all, a brief one, lasting only a few years before the artist's premature death; his memorable mature period, from circa 1914 to his enlistment in the Army in 1917, was briefer yet and resulted in the precious few dozen canvases that today are the basis of his reputation, such as it is. That any survived is remarkable, given the neglect his art suffered from his family. Within the family, Slinkard's mother was apparently alone in her appreciation of his achievement. "His father tried everything to discourage him [from the study of art]," she recalled.[11] After Rex's death, the father's attitude seemingly persisted; in 1919, visitors to the family home reported that Stephen Slinkard was using a number of his son's canvases—early, life-sized oil portraits—as fencing around a chicken yard to contain his flock.[12] (The artist's innovative "late" works were generally smaller in dimension and therefore presumably less useful for such purposes.) For more than a decade after Slinkard's death, his friend Nicholas Brigante had urged Don Slinkard, the artist's only sibling, to find a home for the paintings; but, he recalled, "in all these years his curiosity and interest hadn't been aroused enough in them to even know [their whereabouts]."[13]

Most of the paintings, and more than a hundred drawings, were fortuitously in better hands than the artist's family provided. They were placed, apparently at his mother's instigation, with his fiancée, Gladys Williams (FIG. 1); when she died but a few years later, she left most of his surviving work to her sister Florence, who proved a providential caretaker. During her lifetime Florence Williams retained custody of the estate, carefully storing, repairing, occasionally exhibiting, and generally preserving

the lot. In 1919, a memorial exhibition was organized, with presentations in Los Angeles, San Francisco, and New York; and the honor was repeated ten years later with another showing in Los Angeles, after which the works were returned to storage before eventually being bequeathed to Florence Williams's alma mater, Stanford University. Over time Slinkard's early reputation was eclipsed by newer faces, by different images, and at least until very recent years, this progressive pioneer among California's modernists would have gone unrecognized: Rex who?

A PROGRESSIVE SPIRIT

In the years around the turn of the twentieth century, progressive tendencies dominated modern American life. Progressivism is often discussed in relation to reform initiatives in business, politics, or education; but it was not limited in its impact and is manifest in the broader culture as well. It was certainly at the root of Robert Henri's innovative teaching, which deeply affected Slinkard. The latter's professional career in California extended from 1910, when he returned from his studies with Henri, to his enlistment in the Army in 1917. Those years were a period of unrest in the fledgling community of modern artists in Southern California, where a generation earlier there had been none. In the 1890s, Walter Stetson in Pasadena had complained that "I am as isolated as if in Mozambique or Iceland—yes, more so."[14] The situation had not changed markedly by 1918, when art critic Arthur Vernon lamented that in Los Angeles "the average painter of progressive trends" was "faced by the lack of local material" worthy of consideration, let alone emulation. It was "the duty of the progressives," he wrote, "to overcome the immobility of satisfied producers of out-dated art fashions and fads," who were amply represented in the annual exhibitions of the Los Angeles Art Club at the city's museum. Vernon tartly concluded that, in lieu of works by "these obvious 'buck-eyes' . . . empty space would be more educational."[15]

Slinkard was an early and enthusiastic participant in the battle against the "buck-eyes" and one of the first Californians to study modern art in New York.[16] He returned to Los Angeles as a John the Baptist for the new art spirit preached by Henri—a gospel that was greeted with mixed responses. "Californians," noted one contemporary, "are, as a rule, slow to free themselves . . . from the shackles of habit. The proverbial prophet without honor suffers more, perhaps, in places remote from the theoretical centres of culture."[17] From his charismatic teacher, Slinkard had absorbed vital lessons on art—and about the creative life. Henri believed that "an art school should be a boiling, seething place. . . . The art school should be the life-centre of a city. Ideas should radiate from it."[18] At the Los Angeles Art Students League, where Slinkard had studied before going to New York

in 1908, ideas surely radiated following his return in 1910 (FIG. 2). These new ideas and new images began appearing even before Slinkard formally assumed the director's role late in 1910.[19] He stood out in that summer's group show by League artists—"Of chief interest . . . [are] studies of figure, genre, and landscape in oil from the bold brush of Rex Slinkard"—and earned commendation for work that "possesses a gripping and intense interest for the initiated, because it represents the trend of American art and points to a new era of art training."[20] Such acclaim provided a basis for his elevation to the director's role at the League.

Slinkard's teaching reflected Henri's methods. "Rex's class was very spirited," recalled one admirer, "no idling—quick poses—fast drawing . . . reams of paper consumed—charcoal applied very freely. Rex transmitted an unbounded enthusiasm and energy, constantly animated, he kept his class at fever pitch at all times."[21] Slinkard practiced what he taught. His figure sketches from the League days are inscribed with speed and energy, the legacy of his training with Henri, whose assignments of "the

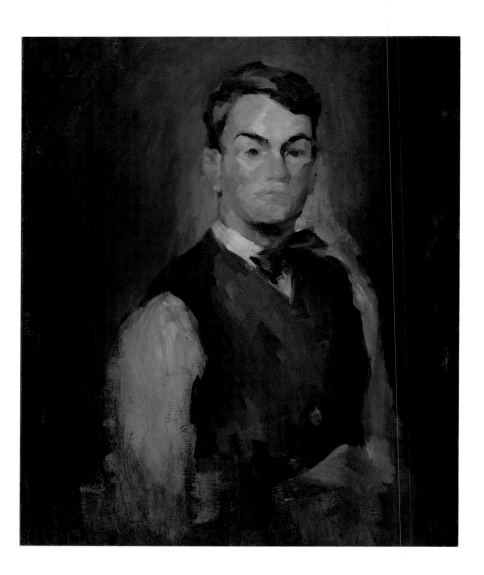

Fig. 2 **Self-Portrait**, c. 1910
Oil on canvas, 30 × 25 in. [Cat. no. 24]

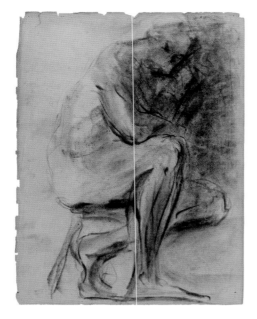

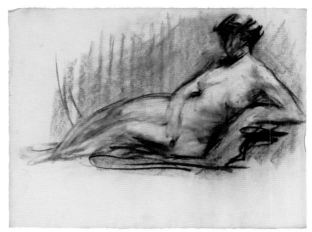

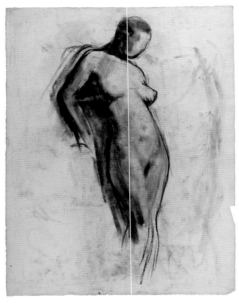

twenty-five-minute sketch" were well known among New York art students. When included in Slinkard's memorial exhibition, these works on paper earned respect from the influential New York critic Henry McBride, who reported, "The greatest vitality of all seems to be in the drawings."[22]

Many of Slinkard's sketches were of nude models, both male and female (FIGS. 3–6). Henri taught that "there is nothing in all the world more beautiful or significant of the laws of the universe than the nude human body," a lesson Slinkard clearly absorbed.[23] The painter Stuart Davis, who also studied with Henri, recalled, "We were told to draw the model not according to some formula, but in terms of how it looked to us as a fresh experience. The questions of finish or prettiness were of no importance.

Fig. 3 (top left) **Seated Male Model**
Charcoal on laid paper, 25 × 18^{11}/$_{16}$ in.
[Cat. no. 29]

Fig. 4 (top right) **Reclining Female Model**
Charcoal on laid paper, 18^{11}/$_{16}$ × 24^{7}/$_{16}$ in.
[Cat. no. 49]

Fig. 5 (bottom left) **Female Model**
Charcoal on laid paper, 24^{7}/$_{16}$ × 18^{1}/$_{2}$ in.
[Cat. no. 105]

Fig. 6 (bottom right) **Seated Male Model**
Charcoal on laid paper, 24^{7}/$_{16}$ × 18^{11}/$_{16}$ in.
[Cat. no. 41]

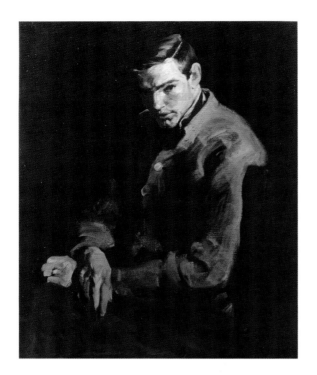

The question was whether you could communicate some direct experience with this model in terms of its form."[24] While teaching from the live model was by 1910 a commonplace in East Coast schools, and had for generations been the basis of art instruction in Europe, it was less familiar in Los Angeles, where Slinkard's practice stood out.

The bold handling in his charcoal sketches of the figure was apparent in Slinkard's oil paintings as well, where pigments were applied with broad strokes from a fully loaded brush. It was a practice prompted by Henri's dashing example and found in the paintings of numerous Henri students, including George Bellows (1882–1925). His portrait of Slinkard (FIG. 7) typifies Henri's pictorial priorities in its informal pose, gestural brushwork, and dark tones inspired by vaunted antecedents (Frans Hals, Diego Velásquez, Édouard Manet). Slinkard adopted a similar palette and technique in his figurative works; both oil portraits and paintings of studio models were brushed with rapid strokes akin to those in the charcoal drawings.

In the 1910 exhibition at the Los Angeles Art Students League, Slinkard was accorded the privilege of a wall to himself, where he hung fifteen oil paintings representing genre scenes, landscapes, and figure studies, including two nudes. The ensemble earned praise for "this young painter [who] is possessed of courage and daring which even the most conservative must applaud."[25] Nearly a century later, Slinkard's nude subjects could still capture attention for their boldness. In 2008, a large canvas of a reclining male nude, long lost, was presented in a Los Angeles gallery (FIG. 8). The painting parallels a subject and pose treated in Slinkard's drawings (FIG. 9), but the oil medium and large format result in a different visual experience. "This startlingly modern canvas," claimed the exhibition brochure, "elevates the depiction of the human form to a spiritual level."[26] When subsequently included in an exhibition devoted to the history of the Los Angeles Art Students League, Slinkard's male nude was described as "the most arresting picture from the show's earliest period—an erotic composition rendered in sensuous slathers of oil paint."[27]

The picture is at once modern, the painterly treatment of the figure's meaty bulk the antithesis of conventional academic nudes, yet also traditional, in its (nude) subject and in its pose, which echoes the Hellenistic *Barberini Faun* (FIG. 10). Spiritual or erotic? Perhaps "sensual" better describes Slinkard's reclining nude, head thrown back, legs akimbo, exposed. Slinkard was a sensualist in the way that, for instance, John Singer Sargent prized sensual experience. Sargent delighted in depicting recumbent figures—women, but more often men, clothed or nude—and numerous drawings provided the essential foundation for these paintings

Fig. 7 George Bellows
Portrait of Rex Slinkard, 1909
Oil on canvas
Private collection
Courtesy of H. V. Allison & Co.,
Larchmont, New York

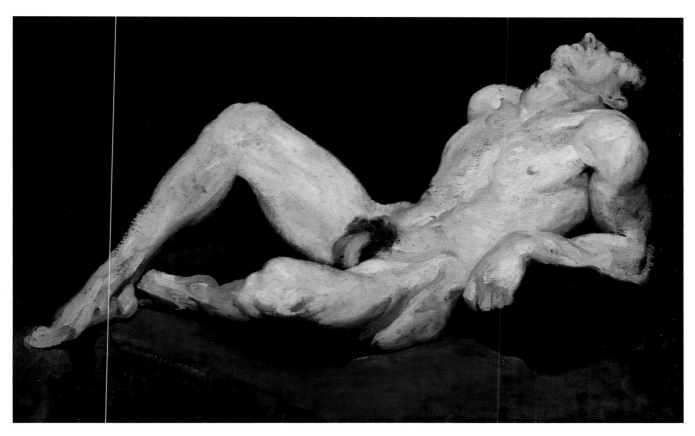

Fig. 8 **Untitled (Reclining Nude)**, c. 1910
Oil on canvas, 30 × 48 in.
Courtesy of Spencer Jon Helfen Fine Arts,
Beverly Hills, California

Fig. 9 **Male Model Lying Down**
Charcoal on laid paper, 18⁷/₈ × 24⁵/₈ in.
[Cat. no. 52]

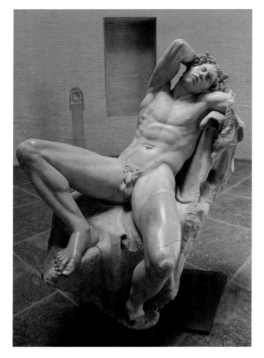

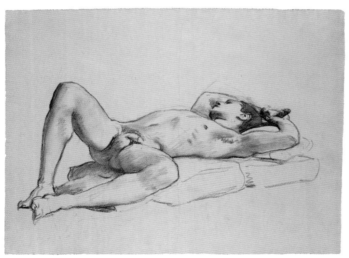

(FIG. 11).[28] Slinkard once wrote to Sprinchorn to describe an evening's activities, which included admiring his own body.[29] Slinkard's language, like his image, reflects both Henri's teaching about the timeless beauty of the human body and (despite the evident differences in their styles) a Sargent-like dedication to capturing that quality.

Everett Maxwell, art curator at the Los Angeles Museum, found "no other instructor of this kind in the West that leaves to the student in so marked a degree that freedom from academic rules which makes for individual development."[30] Slinkard's approach, however, did not suit all of his students. A few, like Conrad Buff, found the teacher overbearing and his ideas incompatible. "He was a great talker," Buff recalled, "a very important-talking fellow, and he took the whole thing over— instead of letting everybody be his own judge, he began to criticize things and he brought ideas that were not very convenient to me. . . . this fellow was so adamant that he would come to you and start to redraw and repaint your canvas according to his own ideas. Finally that made me mad, and I quit the Art Students League."[31] Much more common, however, was the reaction of young admirers like Nicholas Brigante, who counted "the few contacts that influenced the entire course of my life. The Art Students League of L.A.—Rex Slinkard—yourself [Carl Sprinchorn]—and the independent atmosphere that prevails around the 'League.'"[32] Similar was the respect paid by Hisashi Shimada, one of a number of Japanese American students who were welcomed in Slinkard's classes; according to Brigante, Shimada "visits Rex's grave and places flowers on it—a quiet demonstration of true love and affection."[33]

Most deeply felt of all was the lifelong devotion shown by Carl Sprinchorn (1887–1971), whom Slinkard had first met in Henri's classes where Sprinchorn served as monitor. His very personal unpublished account, "Rex Slinkard: A Biographical-Critical Study of His Life, Paintings and Drawings," on which Sprinchorn labored for many years, perforce provides the essential foundation for any subsequent account of the artist's life and appreciation of his work. The friendship was important to each artist, as suggested by the correspondence between "Dear Slink" and "Dear Sprink" that extended from 1910, when they both left Henri's school, until Slinkard's death eight years later.

Over that period they were rarely together, except during 1913, when Sprinchorn arrived from New York to replace Slinkard as instructor at the League, after the latter suddenly quit the post. The reasons for his leave-taking remain unclear. The artist's own words suggest that he was frustrated

and ultimately exhausted by the responsibilities: "I threw my energy into that school," Slinkard wrote in 1913. "I thought out so many things. But about the time I got a fellow living and being himself he became a follower of myself, or someone else. I don't know how many times I rolled that stone up the hill, only to see it come down again. . . . I am glad I did it and I got ever so much out of it. But I'm glad I'm out."[34] His friends Sprinchorn and Brigante attributed the abrupt resignation to a different cause, having to do with Slinkard's marriage to Jessie Augsbury, an aspiring actress in the fledgling movie business and the artist's "model and companion in Bohemia."[35] The match did not win favor with the Slinkard family. Referring to his son as "a dreamer-artist" who "gave no thought to making money," Stephen Slinkard told reporters, "It was a bad blunder for him to get married."[36] The union was short-lived, and the subsequent divorce suit required Slinkard's temporary relocation to Nevada. The circumstances surrounding the wedding (15 February 1912), the birth of a son, Robert (né Maurice, 19 March 1912), and the divorce (initiated by Jessie, July 1913), all in a relatively short time, fueled a scandal in the conservative city and apparently contributed to the artist's leave-taking from both the League and Los Angeles.

TO THE RANCH

Slinkard's departure, whatever the motivation, marked a crucial juncture in his life and in his art. He relocated (compelled by his father, according to the artist's friends) to the family's ranch near Saugus, which was then about a three-hour drive north of Slinkard's Los Angeles home. What another might have regarded as exile, to Slinkard seemed salvation. Not long after leaving Los Angeles he wrote to Sprinchorn, "I'm up here [at the ranch] where nothing bothers me. The air is great, and also the earth. Three years spent in the city, trying my best to help. But the country out here is new and out here they don't know how much it means to live."[37] In another letter he exclaimed, "This is the most beautiful place in the world. I love it. Would like to tell you what I like about it. But can't. It [is] too close to my heart. Maybe some day I'll have it in a canvas. . . . this place, Sprink, has become part of me."[38]

More than a decade after the artist's death, Arthur Millier wrote perceptively about the significance of Slinkard's move: "Not for nothing did young Slinkard go finally to the soil of his father's ranch at Saugus, for he touched it afresh, an instinctive poet, his labors and contacts with it becoming joyous moments in an unfevered ritual. The art that expressed this essentially religious experience has a radiant rightness that we associate with mythical golden ages, when every act and movement was deemed worshipful."[39] Like some artistic Antaeus, Slinkard touched native ground and was revivified.

How fully a part of him the ranch and country life became is apparent in Slinkard's writings and in his art. Typical was an ecstatic account to his confidant Sprinchorn, describing a ride into the hills:

> The Great Ones [trees] are covered with snow. Wish you could see them. I like the open air, the clear air, the free air. The air between me and the snow mountains. The snow air. I like the breeze air between me and the pine trees on the ridge top. I think the big open mountains wonderful. The freedom of the open. . . . O it was great. A new state of mind. It's great. . . . Wonderful.[40]

On another winter evening he wrote to Gladys Williams:

> Almost dark now. It's not snowing. There's a new moon in an exquisite clear sky that is around with copper clouds. . . . I stand and look into the heavens—in the cool fresh air I almost rise. I paint again for you. I am thinking of the universe.[41]

In the isolation of the ranch, Slinkard's thoughts turned often to universal themes (FIG. 12). In the evenings, he reported thinking "of the inhabitants of the Earth, and of the World."[42]

Fig. 12 **My Friends of the Soil**, c. 1914–16
Oil on canvas, 26 1/8 × 30 in.
[Cat. no. 3]

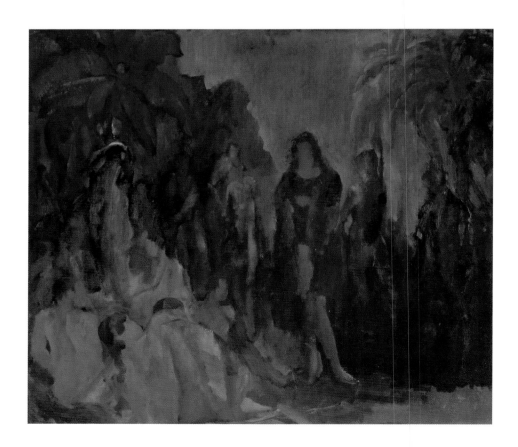

The ranch work was physically demanding. On occasion it was dangerous, too. (Slinkard once suffered a hernia while lifting a heavy load, an injury he thought would make him ineligible for service in the Army. It did not.) Nevertheless, the environmental influences were strong and affected Slinkard's art as well as his spirits. It was perhaps no surprise that Marsden Hartley should have reacted so strongly to an artist whom he knew only posthumously. Years later Sprinchorn suggested that the environs of Provence, where Hartley found such stimulation in the 1920s, "produced the identical impact on Hartley, even to the words that express it, that had crowded the mind of Rex Slinkard . . . on the ranch which, as far as nature goes, was a very similar milieu. It is a document to the power of the sun, on the 'children of the sun' which I think one was and the other became—for the time being."[43]

Child of the sun, child of the land, Rex Slinkard responded powerfully to the natural environs of the California ranch. At the time of his memorial exhibition, one reviewer observed that "the entire trend of his art constitutes an ancient pantheism. . . . he portrays man as very close to Mother Earth and in absolute harmony with Nature."[44] The turn to Nature was not a phenomenon unique to Slinkard, nor even to Southern California, where plein air landscape painting thrived. But Slinkard's vision had little in common with the popular masters of the "eucalyptus school," whose delicate treatments of their subjects won many devotees in the early years of the twentieth century. The genteel Impressionist views were particularly prominent at the Panama-Pacific International Exposition in 1915. When the influential critic Christian Brinton visited that San Francisco show, he noted that Impressionism initially had been "fresh and invigorating, [but] the personal equation was nevertheless lacking. . . . You cannot open the window to nature and close it upon the human soul. . . . Analysis was bound to give place to synthesis, and hence Impressionism, which ignored the individual, was supplemented by Expressionism, which exalts the individual."[45]

By contrast to that of the California Impressionists, Slinkard's vision of landscape was more spiritual, as suggested by the artist's own rhapsodic reports; by critics' estimations, it was more personal and expressive. In depictions of the rugged landscape of the Tehachapi region early in his stay at the ranch, Slinkard turned away from metropolitan motifs and the complexities of urban life. Reviewers of the memorial exhibition remarked on "this 'back to nature' movement in art," which was viewed as part of the ongoing and "eternal renaissance."[46] This proclivity grew more pronounced in Slinkard's later works, but it was forecast in his first ranch landscapes, such as *Tehachapi* (FIG. 13). The palette of ochres and sooty blue-grays, as well as the gestural brushwork, were similar to those employed during his years with Henri; but instead of urban motifs Slinkard now turned attention to the decidedly non-urban, raw landscape of the ranch country. To an

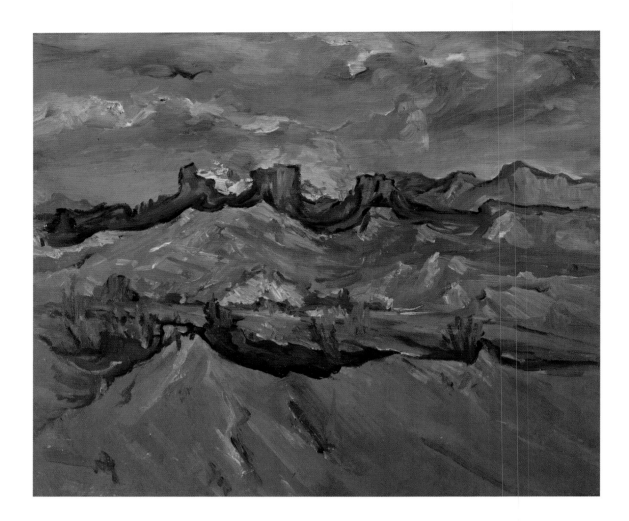

Fig. 13 **Tehachapi**, c. 1914
Oil on canvas, 28¼ × 32¾ in.
[Cat. no. 18]

outsider the subject might appear unpromising. Recalling his initial visit to the ranch, Sprinchorn admitted that "to my unaccustomed eye the country presented a barren and inhospitable, even desolate appearance strange enough to have been a landscape on the moon."[47] To Slinkard, however, the ranch and the Tehachapi country offered inspiration. He wrote ecstatically of "the horse lot[,] my home[, which] has beauty wherever I look."[48]

The horses, for which Mrs. Slinkard recalled her son's fondness, provided subjects for drawings and canvases from early in his ranch period. In a drawing inscribed "ferry Horses" (FIG. 14), a pair of animals is flanked by two standing figures; the forms of horses and men are defined by black ink wash surrounding the figures' negative space. In other drawings, spirited steeds rear and prance; in some cases (FIG. 15), they are described with an active line reminiscent of Henri's drawings of Isadora Duncan dancing. In yet another drawing (FIG. 16), apparently a study for a painting, men and animals appear in a landscape. The sheet is heavily inscribed with penciled color notations—"soil darkest & rich"; "Bank rich / brown"; "Blue men"; "Black & brown horses"; "Green blue trees / depth deep / trunk of tree / rich gold red"—that suggest a fascination with color, whose importance

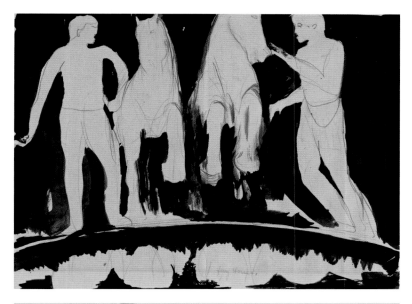

Fig. 14 **Ferry Horses**
Pencil and black wash on paper,
6¹/₈ × 8¹/₄ in.
[Cat. no. 240]

Fig. 15 **Figures with Horses**
Pen and brown wash on paper,
8¹/₁₆ × 10¹/₂ in.
[Cat. no. 215]

Fig. 16 **Landscape with Figures**
Pen and wash in blue ink on paper,
7⁷/₈ × 10¹/₄ in.
[Cat. no. 226]

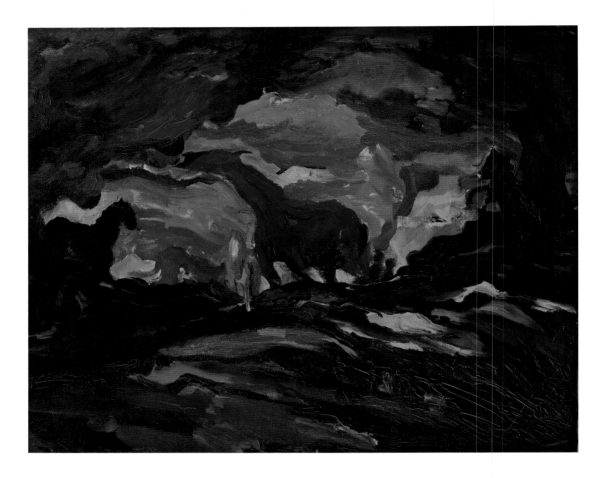

had been stressed in Henri's classes. His teacher emphasized that "one has not only to see color but he must see it beautifully, meaningly [*sic*], constructively!" Color should be "borrowed from nature, not copied, and used to build, used only for its building power, lest it will not be beautiful."[49] Slinkard's notes suggest he had been an attentive student.

COLOR AND DECORATION

Color certainly played a role in Slinkard's pair of paintings, *Wild Horses (Red)* (FIG. 17) and *Wild Horses (Green)* (FIG. 18). The first is a boldly brushed, intensely colored composition; the "dramatic, startling canvas," in his friend Sprinchorn's estimation, "makes the Franz Marc Horses seem bad modernistic decoration—as they are. Rex Slinkard knew horses; Franz Marc didn't."[50] Though more intensely colored than anything he had produced in Henri's classes, Slinkard's *Wild Horses (Red)* seems rooted in his teacher's exploration of color theory, especially that of artist-and-paint salesman Hardesty Maratta (1864–1924). Henri and Maratta first met in March 1909—while Slinkard was Henri's student—when Maratta gave a demonstration of his paints that were developed in accordance with the "color law" of the spectrum, arraying colors on a scale of tonal gradations. Slinkard's teacher quickly became an advocate for Maratta's pigments and

Fig. 17 **Wild Horses (Red)**, c. 1914–15
Oil on canvas, 24 × 27⁷/₈ in.
[Cat. no. 19]

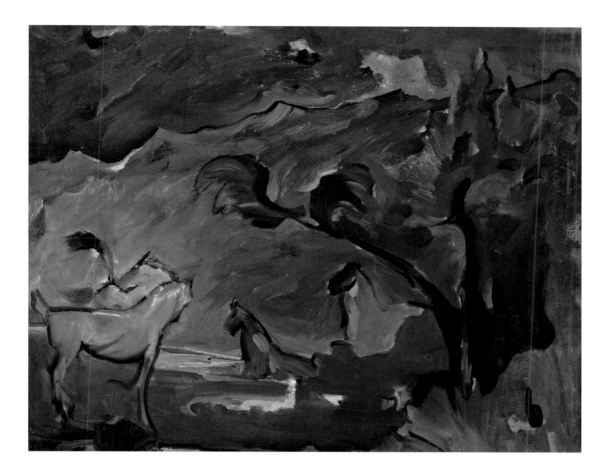

principles and shared both with his pupils. Henri also introduced them to artists of his circle, including John Sloan, who began his own color experiments in 1909. By late 1910 Maratta was making demonstrations in person for Henri's students, and his visits soon became nearly daily occurrences.[51]

Although Slinkard returned to Los Angeles in the summer of 1910, he had ample time in New York to become acquainted with Maratta's theories, which made an impression on the young painter, even though he never became a slavish follower. One friend recalled Slinkard's palette: "Technically, the colors were made of a few Maratta colors with complete disregard of the Maratta system. [Slinkard] took three or four colors or half tones he liked and made his picture. What he called Red was something you could make out of raw umber and Light Red. . . . he never owned a complete set of colors such as painters ordinarily use."[52]

Even if he lacked a complete Maratta set, Slinkard shared the period's interest in color. This attention is suggested by a letter of 1916, in which he describes works in progress in his basement studio at his parents' Los Angeles home:

A still life with a Chinese vase of *Blue, Red, Red-Violet, White* and *Yellow*, and all a beautiful design. This sets against a green-blue Pearl-diver picture of mine. And in all a beautiful

Fig. 18 **Wild Horses (Green)**, 1915–16
Oil on canvas, 24¹⁄₈ × 30¹⁄₈ in.
[Cat. no. 1]

thing in color which I am painting. I have three canvases going now. The still life, one of some men and women against water and a tree beyond—this is all outside light, figures, trees, all warm colors of *Orange, Red Blue-green, Purple, Purple-blue, Yellow-green and Yellow* and a rich blue sky all in design with a reflected light of *Blue-violet, Green-blue* and *Violet-blue-green.* . . . On my easel I have a canvas 48×40. . . . its general colour is *Gray-green.* This green is made up of *Blue, Purple, Green, Yellow, Orange, Red and Violet.*[53]

A change in Slinkard's palette was already apparent in *Wild Horses (Green).* Like its predecessor, the paints are laid down with gestural brushwork, but now cooler notes replace the hot, expressive reds. The sense of imminent apocalypse in *Wild Horses (Red)* yields to a more Edenic vision. Carl Sprinchorn was struck by the new "archaic, pastoral spirit prevailing throughout" the second canvas.[54] "In the green *Horses,*" he wrote, Slinkard shows "the first intimation of that stage of 'color,' which he now begins to talk and write about incessantly as being his ultimate goal. . . . it is a direct foil to the earlier, more intuitively painted red *Horses* which is as dark, hot and wild as this one is morning cool, calm and controlled."[55]

The new direction would take Slinkard beyond the drear urban palette of the Ash Can school, or the secondary and tertiary hues promoted by Maratta, and into new imaginative realms depicted with a novel palette and decorative touch. Sprinchorn recalled that by late in 1915, Slinkard was painting with " 'imaginative color' as he used to say, highly imaginative . . . colors like the colors of ores, copperized, corrosive, oxidized."[56] "For a long time," Slinkard wrote in 1916, "I've realized that I am working on a flat surface. This painting is a decoration."[57]

The artist's recognition of the decorative qualities of pigments on a plane echoed one of the essential tenets of modernism, as expressed by Postimpressionist Maurice Denis in his 1890 manifesto, "Définition du néo-traditionnisme." In that codification of his modern aesthetic, the French artist stressed the hermetic and formal world of the picture itself, divorced from naturalist concerns for the external world. Denis famously asserted, "Before it is a battle horse, a nude woman, or an anecdote, a painting is a flat surface, covered with colors arranged in a certain order."[58]

Although Slinkard was not a student of French aesthetic theory, he was acquainted with developments in contemporary art and also well versed in the history of art. Slinkard's own exploration of the decorative potential of pigments on a plane parallels in key respects the ideas espoused in paint and text by his French counterparts. The imagery of his mature phase—sometimes obscure in meaning, sometimes nearly illegible

in form—suggests that in the isolation of the California ranch, a highly subjective spirit blossomed and thrived, the Symbolist of Saugus.[59]

PORTRAITS

Los Angeles artists showed a growing interest in portraiture during the 1910s. Art historian Susan Anderson credits Henri's example, which Slinkard knew firsthand. Other Californians gained exposure to the artist and his work when Henri sojourned in Southern California in 1914 while serving as advisor to the art committee for the upcoming Panama-California Exposition in San Diego. Anderson characterized the portraits by the "California Progressives"—citing Bert and Meta Cressey, Henrietta Shore, and Slinkard—as "simple and direct . . . [and] usually not destined for the sitter, nor were they commissioned. They were the choice of the artist, and for the most part, their interest lay in the humanity of the subject or the opportunity to explore the potential of paint."[60]

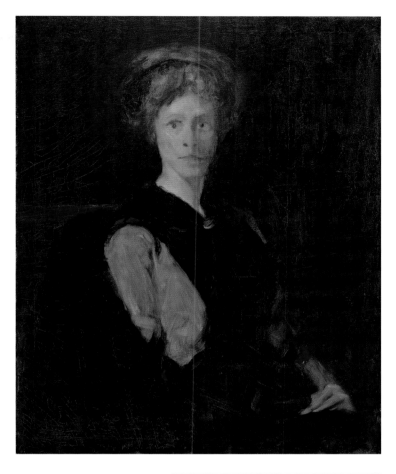

Henri's students certainly knew how to explore the potential of paint, lessons learned from "the fastest brush in the East."[61] The best of them excelled at capturing the distinctive personality of individual sitters. George Bellows, for example, earned his reputation in part based on such strengths, which are evident in the portrait of his friend Slinkard (see FIG. 7) and of street urchins such as *Paddy Flannigan* (1908; Erving and Joyce Wolfe Collection). Slinkard, while he might not rival Bellows's mastery, did earn kudos for his portrait of the same memorable gamin; when he showed his portrait of Flannigan in Los Angeles in 1910, it was praised for having "caught the vital thing, the character"—just as Henri taught.[62] Friends recalled that later in the decade, when he had discovered his individual style, "Rex intended to destroy all his near-Henri things"[63]—at least those that the chickens did not ruin. This perhaps accounts for the relatively few early examples that survive, among them a pair of sketchy self-portraits (see FIGS. 2 and 49) and several likenesses of Gladys Williams (FIG. 19, and see FIG. 1), one in a Goya-like manner (FIG. 20).

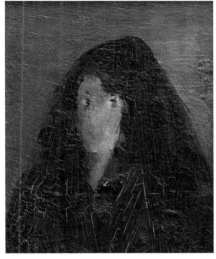

Fig. 19 **Portrait of Gladys Williams**, c. 1912
Oil on canvas, 29½ × 24 in.
[Cat. no. 25]

Fig. 20 **Portrait of Gladys Williams**, c. 1912
Oil on board, 5 × 4½ in.
[Cat. no. 27]

By 1916 a pronounced change was apparent in his figurative work. That autumn and winter marked a productive spell with the completion of three or four canvases, one of which was *Young Priest* (FIG. 21), a haunting

Fig. 21 (right)
Young Priest, c. 1916–17
Oil on canvas, 35 × 40¹⁄₈ in.
[Cat. no. 11]

Fig. 22 (below, top)
Acolyte—Self-Portrait, c. 1914–16
Oil on canvas, 28⁷⁄₈ × 25¹⁄₈ in.
[Cat. no. 4]

Fig. 23 (below, bottom)
Rex, c. 1914–15
Oil on canvas, 30¹⁄₈ × 26¹⁄₄ in.
[Cat. no. 7]

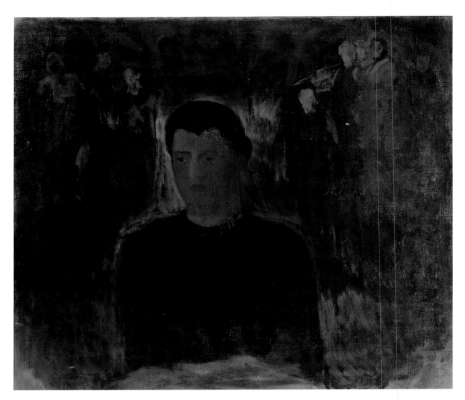

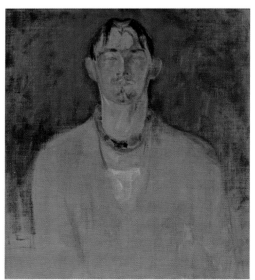

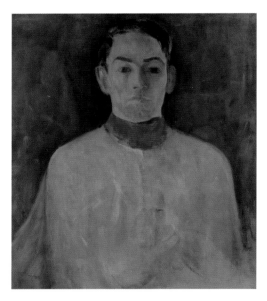

image of saturated hue. "I'm trying for rich color," he reported, "and trying to keep the painter out of it. That is, the brushwork that attracts so many." Slinkard wanted to "get at facts in a simple way. To make one see this young man as . . . a sad young man. And a good one. Not too good. But good enough." He concluded his account with a dismissal of his former teacher: "Am not painting along the lines of our old school. That is, the brush of the old school. Dear Mr. Henri. I like him as well as I use[d] to but his pictures are not the thing for me. . . . I'll paint different."[64]

Brigante thought that Slinkard's *Young Priest*, as well as *Acolyte* (FIG. 22)—another title with religious connotation—referred cryptically to Slinkard's guilt and remorse over Jessie Augsbury's pregnancy, their marriage and divorce, and the child he had abandoned.[65] The latter painting's full title, *Acolyte—Self-Portrait*, does suggest a focus on himself—and perhaps on his conscience. A red stripe at the neck, similar to that in his self-portrait (see FIG. 49), may suggest a bandana of the sort "the Westerner" sometimes wore.[66] Is it a red cassock beneath a white surplice? Or is it a noose? A slit throat? The pink form (blossom?) on the figure's chest might similarly have personal significance (blessing? sacrifice?). But the meaning of such details is now lost. Whatever his intentions in these unusual figures, they surely mark a departure from the realism of the Henri manner.

Marsden Hartley recognized that "when [Slinkard] painted a head which is called a self-portrait it was in no sense an image of his physical self—but was an image of idealistic desire."[67] The late self-portraits—*Rex*

with its flower on the forehead (FIG. 23); the atoning *Acolyte*; a rare example in pastel, the intense blue *Head of a Medieval Youth* (FIG. 24);[68] and the oddly arresting *Colossus* (FIG. 25)—mark a clear break with the realism of Robert Henri and announce Slinkard's new and personal manner. The meaning of his late self-images may be open to interpretation. Whatever their meaning, they are certainly novel.[69]

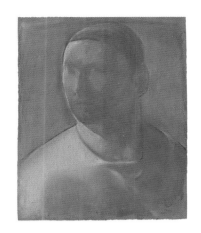

OLD MASTERS, AND SOME NOT SO

The sources for Slinkard's mature style were many and diverse. One friend recalled, "Despite his educational handicaps and his complete ignorance on many things that most people take for granted he was a keen student who had the rare gift of knowing *how* to study. He knew practically everything that had been painted if it had been reproduced. . . . On the score of painters he was never ignorant."[70] Sprinchorn recalled how postcard reproductions from the fabled Armory Show, sent in 1913 by friends in New York, "became a source of great interest to [Slinkard]. Every 'wrinkle' and phase of style was thoroughly exhausted in discussion, scrutinized from every angle of performance."[71] But his attention was scarcely limited to the moderns.

Marsden Hartley noted Slinkard's "true comprehension of esthetics as imbibed from the great men of the Renaissance and from the Chinese . . . [with] of course the Greek notion to be added."[72] That the last was

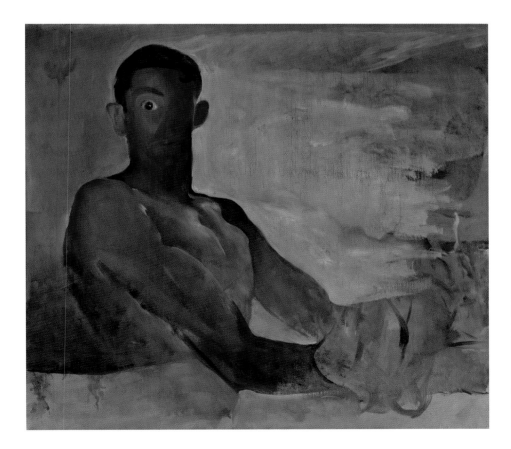

Fig. 24 (above)
Head of a Medieval Youth
Pastel on paper, 9³/₁₆ × 7⁷/₈ in.
[Cat. no. 200]

Fig. 25 (left)
Colossus (The Pearl Fisher), c. 1915–16
Oil on canvas, 35 × 40¹/₄ in.
[Cat. no. 12]

Fig. 26 Greek, Niobid Painter
Kastor, detail from the **Niobid krater**,
c. 460–450 BCE
Musée du Louvre, Paris. Photo credit:
Hervé Lewandowski. Courtesy of Réunion
des Musées Nationaux/Art Resource, New York

Fig. 27 Marsden Hartley
Sustained Comedy, 1939
Oil on academy board, 28¹⁄₈ × 22 in.
Carnegie Museum of Art, Pittsburgh,
Gift of Marvin Jules in memory of Hudson
Walker. Photograph © 2010 Carnegie
Museum of Art, Pittsburgh

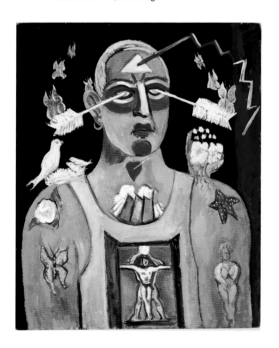

added is suggested by statements from friends such as Antony Anderson, a fellow Los Angeles modernist, who recalled that "Rex Slinkard was as strangely and unaccountably Greek as John Keats."[73] Anderson's comment was perhaps an allusion more to sentiment than to form, although in some Slinkard works echoes of the ancients might be evident. In *Ferry Horses* (see FIG. 14), for instance, the effect of white figures defined by surrounding black ink is like that of Attic red-figure vase painting (FIG. 26). In a different vein, his idyllic landscapes populated with somnambulant nudes evoke an Arcadia remote from the rugged ranch country of the Tehachapi Valley.

Chinese notions were also present, although perhaps less obvious. As a student, Slinkard had been exposed to Asian sources. "Look at the stroke of a Chinese master," Henri advised, specifically the masters of the Sung period.[74] But, as Carl Sprinchorn observed, it was not until Slinkard returned to Los Angeles that he for the first time "came under a strong 'Pacific Basin' influence."[75] In this he was not alone; some California artists succumbed to an extent that drew the attention of visitors from afar. At the Panama-Pacific International Exposition, for example, Philadelphia's Christian Brinton discovered that "the modernists have reverted to an earlier type of art, and in doing so it was inevitably to the East that they were forced to turn . . . [representing a] subtle ascendancy of Orient over Occident."[76] Hartley noted Slinkard's "predilections for the superiority of Chinese notions of beauty over the more sentimental rhythms of the Greeks," as if "the Buddhistic feeling of reality . . . gave him more than the platonic." He concluded that Slinkard "was searching for a majesty beyond sensuousness, by which sensuous experience is transformed into greater and more enduring shades of beauty. He wanted the very life of beauty to take the place of sensuous suggestions."[77]

The beauty of Asian ceramics was greatly admired by connoisseurs from the late nineteenth century onward; thus, Slinkard's description of the colorful still life with a Chinese vase may be no more than a reflection of period tastes in collecting. In other paintings, however, and in more subtle ways the arts of Asia may have shaped his work. Sprinchorn detected similarities between depictions of hands in Slinkard's work and those in Hindu and Chinese art.[78] Brigante credited the older artist with inspiring his "appreciation of Chinese paintings with emphasis on the Sung painters," a source that was to be consequential in Brigante's depictions of the California landscape.[79] More unusual than Sung landscapes, Chinese vases, or even "Hindu" hands is Slinkard's curious self-portrait, *Rex* (see FIG. 23). On the subject's forehead he depicted a curious yellow form, like a floral caste mark. Whether from South Asian sources or simply from the artist's rich imagination, the combination is arresting and perhaps accounts for the "Buddhistic feeling" noted by some viewers.[80] The attribute and its unexpected placement may also have been recalled years later by Marsden

Hartley when he painted *Sustained Comedy* (FIG. 27), which depicts a similarly posed male figure accompanied by a blossom and even odder attributes.

The Old Masters particularly fired Slinkard's imagination and fueled his creativity. Friends recalled that he always carried with him art books, "a Giotto, a Gozzoli, Botticelli, etc.," the small, pocket-sized reproductions providing inspiration from revered art ancestors.[81] Individual masters caught his fancy at various times. "Botticelli I love," he wrote to Sprinchorn, "and another Teppo Tiffi. That's not right, but maybe you will know who I mean."[82] On another occasion he exclaimed, "The old Florentine *Giotto* seems to interest me most. In him I find a reason, a moving reason back of all, a before and an afterward, a belief in something."[83] And on yet another day, "I have El Greco's St. Maurice in front of me. It's a great and beautiful thing."[84]

"Greek paintings, Chavannes and Botticelli have me," he once confessed. In this simple statement Slinkard at once made clear both his extension of eclectic interests to the modern era, by including the French painter Puvis de Chavannes (1824–1898), and his chief criterion for celebration: "I find more Beauty in them [than] all of the others put together."[85] American collectors prized Puvis's elegant paintings—peaceful, decorative landscapes populated by graceful figures in pale robes or nude. Henri had hailed Puvis among the "academy of the rejected," modern masters who had been "despised and laughed at at first, but later recognized as dreamers of fresh dreams, makers of new songs, creators of new art."[86] Puvis's palette, his distinctive "blues and greys and pinks, were modern to [Slinkard] and to most of us then," recalled Sprinchorn, "and carried a far greater appeal" than the tones popularized during the "Brown Decades."[87] Slinkard recalled the impression of Puvis's palette even long after his first encounter. "The country [in North Carolina, where he was stationed with the Army] is a wonder," he reported. "The color is that wonderful mixture of the Puvis de Chavannes we saw at San Francisco [in the Panama-Pacific International Exposition]."[88] Puvis was represented in the French section of that omnium-gatherum by *A Vision of Antiquity* (FIG. 28). The painting earned praise from the chief chronicler of the fair, who thought it gave "a very fine idea of the idealistic outlook of this greatest of all modern decorators."[89] The seeming paradox—a vision of antiquity exemplifying modern decoration—went unremarked; but Puvis's example was inescapable, both in San Francisco and in the cultural landscape at large.

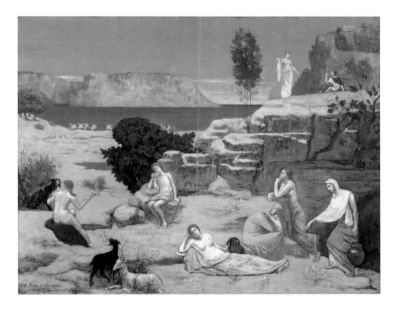

Fig. 28 Pierre-Cécile Puvis de Chavannes
A Vision of Antiquity—Symbol of Form,
c. 1887–89
Oil on canvas, 41¹/₄ × 52 in.
Carnegie Museum of Art, Pittsburgh,
Purchase. Photograph © 2010 Carnegie
Museum of Art, Pittsburgh

In a letter to Carl Sprinchorn, Slinkard once wrote, "Puvis de Chavannes and Arthur Davies I love."[90] The joining of the two names—the decorative French painter and the senior American in the fabled exhibition of "The Eight"—suggests the extent to which the "idealistic outlook," the visionary strain, permeated turn-of-the-century painting internationally, and Slinkard's mature aesthetic.

DREAM-SCAPES

"Imagination—that's the one thing I can paint with. I am lost without it."[91] Rex Slinkard's exclamation suggests a move away from representations of the external world (realism) toward an inner vision, a personal reality, dependent on his own rich imagination. In this he seemingly illustrated the expectation of noted connoisseur and author Arthur Jerome Eddy, who in 1914 described modern art's movement toward *"expression of self*; that is, the expression of one's *inner self* as distinguished from the representation of the outer world."[92] And he paralleled the interests of the so-called Introspectives, a New York group who were featured in a 1917 exhibition of "Imaginative Paintings" at Knoedler Galleries, the same venue that would host Slinkard's memorial exhibition three years later.[93]

One reviewer of that memorial exhibition perceptively noted that Slinkard "had the 'prehistoric' outlook. His imagination worked somewhat like the minds of the ancients must have, when at eventide they looked upon the darkening woods, and peopled these with the creatures of phantasy. In fact, the entire trend of his art constitutes an ancient pantheism." The writer summarized the artist's aim to "portray man as very close to Mother Earth and in absolute harmony with Nature."[94]

Like some latter-day Transcendentalist with a brush, Slinkard pursued this objective during his fruitful years at the Saugus ranch. Robert Henri had preached that "everything depends on the attitude of the artist toward his subject. It is the one great essential."[95] Slinkard was fortunate to have his essential inspiration, Nature, close at hand and in glorious abundance in a place where, as the poet Vachel Lindsay reminds us, "There are ten gold suns in California / When all other lands have one."[96] Slinkard's reaction to the rural setting was ecstatic. Passages from his correspondence are similar to the excited reports that, in the same years, Georgia O'Keeffe was dispatching as she discovered the dramatic country around Canyon, Texas, or the responses to natural phenomena that Charles Burchfield was confiding to his journals. For Slinkard the measure of Nature's greatness was found in the trees, the "Great Ones," as he often referred to those in the ranch country. "Great trees!" wrote Sprinchorn, quoting his friend; "these were an obsession and a test of might to him." The phrase recurred often in Slinkard's speech and writing, just as the image did in his art. "Great trees *were* the measure of man, of his men and women, one the perfect setting,

the other the adornment of it and thus scaled symbolically to complement one another. It is," Sprinchorn recalled, "a juxtaposition which he always insists on."[97]

The pairing of the human and the natural is evident in Slinkard's late paintings. As critic Arthur Millier recognized, during Slinkard's time at the Saugus ranch, "The overstressed drama of his earlier works, in which one finds an echo of his admiration for Bellows, and a passing enthusiasm for Maratta's spectrum pigments, disappeared."[98] In their place appeared fantastic dream-scapes in which figures emerge from grounds saturated with the hues of Nature. Many of Slinkard's colorful fantasies recall visionary scenes that the esteemed Arthur Davies created during and after his California visit in 1905: lithe nudes, unicorns, or other imaginative beings parading among the redwoods or before distant mountains. Not surprisingly, viewers often responded to Slinkard's work with analogies to the older artist. Parallels to Davies's contemporary, Maurice Prendergast, were also proposed, as were those to younger painters whose work had been recently featured in exhibitions in the region, such as the Russian Boris Anisfeld. One critic advised visitors to the 1919 memorial show to approach Slinkard's art with "the open mind that was a prerequisite" to appreciation of Davies, Prendergast, Anisfeld, Rockwell Kent, and Odilon Redon, "the famous Frenchman. . . . [Y]oung Slinkard is of their company, and of the choice companionship of Ornstein and Debussy and Maeterlinck and Walt Whitman and the rest of the moderns who dare to adopt new forms to express their emotions."[99] To this distinguished roster another writer added more luminaries from the imaginative camp, calling Slinkard "a true mystic of the order of Blake, Maeterlinck, and [the German romantic] Novalis."[100] New York reviewers similarly noted the affinities when Slinkard's memorial exhibition appeared there; as one wrote, "there was a white fire and a strange mysticism in his love [of nature] that somehow made his art akin to that of William Blake."[101]

The note of fantasy or reverie grew more pronounced during Slinkard's period at the ranch. The Los Angeles painter Mabel Alvarez once aptly described his work as "all emotion—a dream world of the spirit."[102] Dreamlike certainly describes Slinkard's drawing of *The Great Air Spirits* (FIG. 29), in which the airborne pair hovers weightlessly, like the levitating figures from Blake's Preludium to *The Book of Urizen*.[103] It is also an apt description for *Young Rivers* (FIG. 30), one of the artist's most important late works. The changes hinted at in *Wild Horses (Green)* become more apparent in this subsequent work, where horses again figure prominently. Now, however, the animals are not of the loosely brushed, expressionist breed seen earlier. Instead, these pale creatures stand on spindly legs, as delicate as Elie Nadelman's plasters of the same period, legs that seem barely capable of holding up their voluminous bodies, let alone the

Fig. 29 **The Great Air Spirits**
Pen and wash in blue ink on paper, 5 1/8 × 7 7/8 in.
[Cat. no. 242]

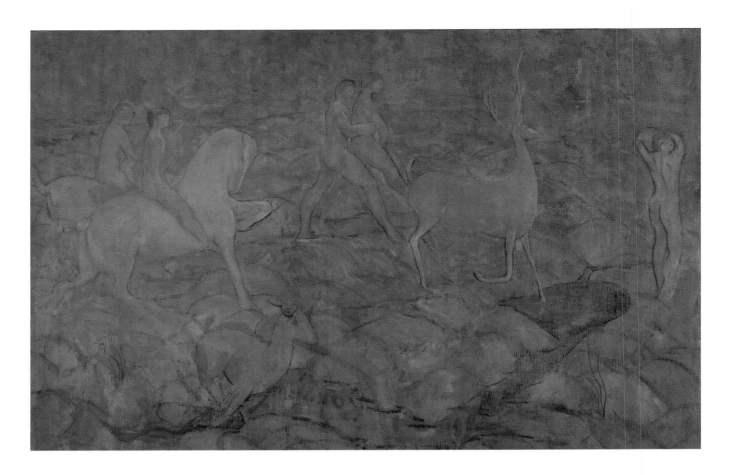

Fig. 30 **Young Rivers**, 1916
Oil on canvas, 34¹/₈ × 45¹/₄ in.
[Cat. no. 13]

young riders. While working on *Young Rivers* in September 1916, Slinkard was excited by a revelation discovered in the creative process. "This canvas is far from my surroundings," he wrote to Sprinchorn, meaning that it was not a topographic view of the ranch country, nor even an expressionist transformation of that terrain.[104] The curious image of nudes and animals traversing a delicately tinted ground patterned with rills might have been inspired by the laborious irrigating of alfalfa fields at the ranch, as some have suggested; but ultimately the vista is from the realm of imagination, and the artist's aim transcended conventional landscape.

Slinkard seemed to appreciate the work's significance when, in September 1916, he wrote that he had "never been so interested in painting a thing before. I have been working on this [*Young Rivers*] for weeks, every day but one, from 9:30 to 4."[105] By late January 1917, he reported with satisfaction that "the deer picture . . . is finished," one of three or four canvases completed in the several months preceding.[106] The painting was well received by Slinkard's artist friends; Sprinchorn admired it as "an indulgence in natural beauty," and Brigante claimed it was "Rex's most important painting."[107] Critics agreed. Arthur Millier, for instance, called *Young Rivers* "his masterpiece and one of the fine pictures of his generation. . . . It is California as sheer poetry."[108] The *San Francisco Examiner* described the picture as "a vision of the Dawn of the World" and praised it for "breathing

the very spirit of the Garden of Eden." The reviewer saw the painting as representative of a salutary art, one that "constitutes reaction against present day materialism . . . reaction against the factory, against the office chair and ledger, and against everything else that is not natural."[109]

In this reaction Slinkard was scarcely alone. He represented an impulse stirring among many, from the 1890s to Slinkard's day and from coast to coast. One Boston aesthete, for example, responding to the suffocating materialism of the waning nineteenth century, catalogued the means for escaping the oppressive mood:

> We have tried . . . to reform the world, to induce mankind to turn now and then from the mad chase after Almighty Dollar, and smoke cigarettes and read Oscar Wilde. We have taken sides against electric cars, bicycles, and Mr. [William Dean] Howells. We have played at theosophy . . . [and] sung the praises of cigarettes and coffee . . . because they stand for a mood opposed to the prevailing tone of our times which turns life into an express train and makes old men at forty.[110]

For these sensitive souls, escaping the quotidian realities of the modern age became a prerequisite for a worthwhile life, a bearable existence.

The means of escape were many, among them drugs, alcohol, cigarettes, spiritual pursuits of various sorts, and dreams. Without a release from the here and now—from the factory, office chair, and ledger—life "is a drab transaction, a concatenation of unimportant events; man is impotent and aimless: beauty, and indeed all the fine things which you desiderate in literature [or art]—and in your personal existence . . . —are nowhere attainable save in imagination. To the problem of living romance propounds the only possible answer, which is, not understanding, but escape." And that escape could only be made, said novelist James Branch Cabell, through "the creation of a pleasing dream, which will somehow engender a reality as lovely."[111]

This recoil from mechanized modernity and the embrace of the spiritual and the natural, which both artists and critics recognized in Slinkard's work, exemplify the response that cultural historian Jackson Lears later characterized as antimodernism. The attitude was, Lears wrote, "not simply escapism . . . [but] part of a much broader quest for intense experience." He argued that "antimodernism was a complex blend of accommodation and protest" that has profoundly shaped modern American culture.[112] Slinkard's aversion to factories, office chairs, and ledgers, and his turn from the complexities of urban life to the verities of Nature—the Great Ones—illustrate this impulse, a potent legacy of the turn of the twentieth century.

The fantasies painted by Arthur Davies typify an imaginative strain that runs persistently if not always strongly through American art. Upon entering "Davies-Land" (as historian Virgil Barker called it), the viewer is advised to seek "not an optical recognition of familiar details, but an emotional comprehension of mood."[113] In that evocative realm, as critic Royal Cortissoz wrote, "landscape is chiefly a setting for his ideas."[114] The idea for Davies's *The Flood* (FIG. 31) is, like many of his pictorial concepts, not easily discerned, for his is not a narrative art of clear exposition. And neither was Slinkard's. Indeed, "the essential Davies . . . puts before you not so much the thing seen as the thing divined."[115] The same could be said for the late work by the younger painter. What is "divined" in Davies's *The Flood* is the force of nature, represented by wind and water, and man's (or, in this case, two women's) smallness before it, a primal theme in many cultures' mythologies. On another level, as Elizabeth Tebow argues, Davies's figures against the flood may allude metaphorically to the confrontation with "the realities, both sociological and psychological, of the new [twentieth] century"—in other words, factories, office chairs, etcetera.[116]

Davies's visionary flood was echoed in works by Slinkard, who shared the older artist's visionary temperament and greatly admired his work. Slinkard's *The Flood* (FIG. 32) shares both title and subject with Davies's canvas. His bathers' movements through the running stream suggest the force of Nature before which the figures are powerless. Like those in Davies's painting, Slinkard's two figures are immersed in Nature and open to her powers. So too was the artist. "I've just finished my bath," Slinkard once reported to Sprinchorn. "My bath of the air. The bath of the setting sun. The bath of the running stream."[117]

In the arid ranch country, running streams were few. While northern California was blessed with abundant waters, the land south of the

Fig. 31 Arthur B. Davies
The Flood, c. 1903
Oil on canvas, 18¹⁄₈ × 30 in.
The Phillips Collection, Washington, D.C.

Tehachapis received scant rainfall; hence, for the area to develop agriculturally, as it did beginning in the late 1800s, irrigation played a crucial role. "Simple irrigation was old in California," explained historian George Mowry. But, he noted, "It was not until the new century . . . that water diversion on a Herculean scale was tried and proved feasible."[118] The water culture that eventually developed in the region is the product of engineering feats—and great imagination. Slinkard's imaginative feat was to turn "the parched's dream of water" (as Sprinchorn called it) into the blue-green flood, "from a desire for water for reservoir"[119]—or, as Hartley noted, to observe closely the rilled landscape of his father's irrigated alfalfa fields and transform it into the fantasy realm of *Young Rivers*. In Hartley's estimation, the "irrigation ditches were 'young rivers' for [Slinkard], rivers of being," across which pale youths and horses and fawns "were gliding to the measure of their delights." He likened Slinkard's "quest of the modern rapture for permanent things" to those by Mallarmé and Debussy, searches for what Hartley called "those rarer, whiter proportions of experience."[120]

NIGHT MUSIC

Other experience was darker, in the sense of nocturnal. Midnight inspired some of Slinkard's most memorable expressions. An early example, simply titled *Nocturne*, showed the Jersey shore viewed from New York City's Riverside Drive. When exhibited in Los Angeles in 1910, this "wonderful canvas" won praise for its "repose equal to that of Whistler's themes on the same subject. . . . Mr. Slinkard has caught the morbidezza of night with

Fig. 32 **The Flood**, c. 1914–16
Oil on canvas, 24 × 30 in.
[Cat. no. 5]

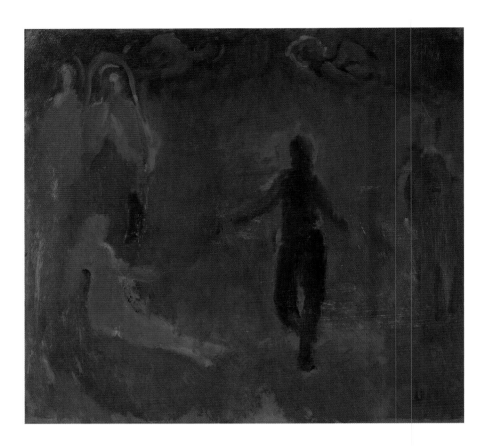

a skill that does not fall short of the masterly. The brooding mystery, the poetic uplift of night, are here."[121] The painting (now lost) conformed to the urban subjects advocated by Robert Henri and presumably did in its palette as well. Henri taught that "night can be painted so that it will be beautiful and true with a palette that does not drop into black but has instead a surprising richness of tone."[122] Richness was certainly Slinkard's goal in his California nocturnes, such as the one he described to Sprinchorn, a "moonlight picture, painted out in the white moonlight. . . . It's very high in key, pink, lavender, and gold-blue."[123] In *Night Life* (FIG. 33), the contrast of fiery reds and sooty blacks suggests a dramatic midnight moment rendered in an emotional high pitch. In contrast, Slinkard's *Night Air* (FIG. 34) suggests a more pacific mood as a lone figure stands in the blue-blackness; the figure's isolated position against the darkened ground is similar to the composition of *Oasis* (FIG. 35), both pictures suggesting affinities with the mysterious midnight mood that pervades many of Davies's designs.

On this subject, Slinkard waxed ecstatic. In language and cadence worthy of Whitman, he celebrated

> night, that I love like nothing else. I own air, night air that creeps down my breast and send[s] cool quivers over my skin. . . . The night of air, that makes me feel like the breeze itself. . . . The world so large, mine, and all mine for tonight.

Fig. 33 **Night Life**, c. 1915–16
Oil on canvas, 22¹/₈ × 24 in.
[Cat. no. 8]

Fig. 34 (opposite, top) **Night Air**, c. 1915–16
Oil on canvas, 26¹/₈ × 33⁷/₈ in.
[Cat. no. 16]

Fig. 35 (opposite, bottom) **Oasis**, c. 1915–16
Oil on canvas, 36 × 40¹/₄ in.
[Cat. no. 17]

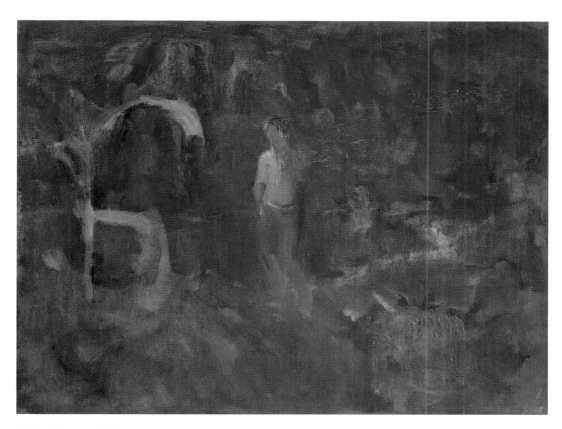

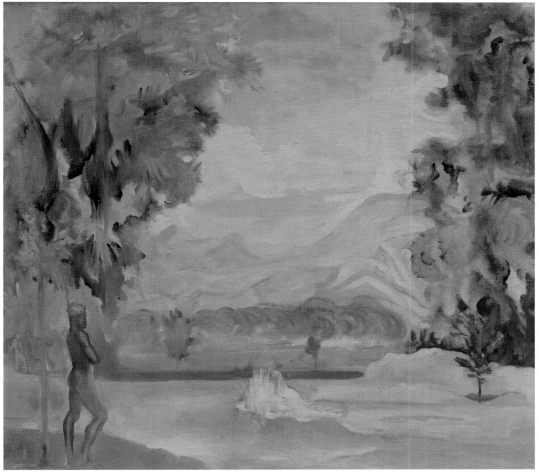

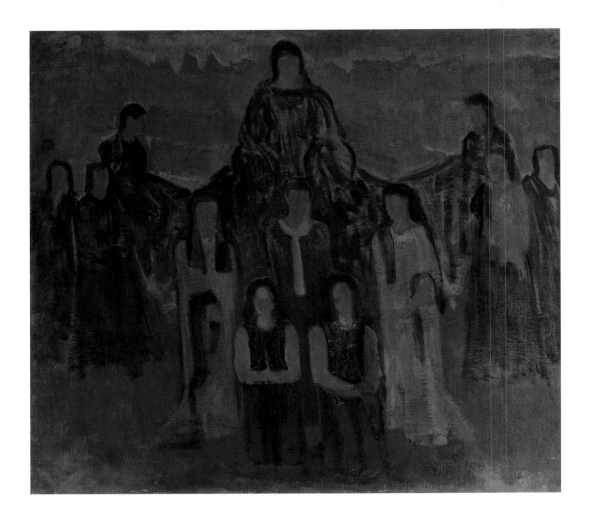

Fig. 36 **My Song**, c. 1915–16
Oil on canvas, 36 × 40⅛ in.
[Cat. no. 14]

What wonderful thoughts night has. They belong to the air—
so methink—breezes. How clean I feel. So unlike myself of
the day. How sensitive I am. How everything is banished, but
Beauty. The music of the night. I sing. I want to tell everybody
everything. How wonderful I am—how wonderful the day
makes me—but most wonderful the night.[124]

Slinkard's fascination with "the music of the night" reflects an interest
common to many turn-of-the-century artists. In the visual arts, expressions
of this interest ranged from Whistlerian nocturnes to modernist experi-
ments with synesthesia.

Robert Henri shared this generational preoccupation and used musi-
cal analogy to explain the artistic process. "There are moments in our lives,
there are moments in a day," he wrote, "when we seem to see beyond the
usual—become clairvoyant. We reach then into reality. Such are the mo-
ments of our greatest happiness. Such are the moments of our greatest wis-
dom." While such moments might be common to many, "it is only a rare
few who are able to continue in the experience, and find expression for it."
The artist's gift, his task, is then to visualize the "song going on within us,

a song to which we listen. It fills us with surprise. We marvel at it," even as the fleeting musical moment vanishes. "We would continue to hear it, but few are capable of holding themselves in the state of listening to their own song. Intellectuality steps in, and as the song within is of the utmost sensitiveness, it retires in the presence of the cold and material intellect." Yet the memory of those clairvoyant moments—of the individual's "song"—lingers, and it is the artist's unique role to "express these intimate sensations, this song from within, which motivates the masters of all art."[125]

Slinkard's *My Song* (FIG. 36), on which he was working late in 1916, captures the essence of Henri's principle in both title and image. Working alone in the West, far from metropolitan centers of invention, he was creating (in Brigante's words) "in a language, a music of a world of his own imagination peopled with his own people, creatures deep with a lasting song."[126] The "hieratic" composition earned acclaim from critic Arthur Millier, who noted the development beyond Slinkard's early manner and welcomed the "musical bordering of robed female figures in a cool night harmony of blue-green and violet, as still as night as subtly moving."[127] Twelve standing figures, each heavily draped, coalesce into a chorus. While Slinkard sometimes drew individual robed figures of similarly elongated, columnar type (FIGS. 37 and 38), the multiplication and generalization of the forms in *My Song* suggest a goal beyond mere transcription of carefully studied details.

Elsewhere I have described *My Song* as a "tableau of revery," its mood paralleling that of compositions by other imaginative painters in this country and Europe.[128] The broad handling of the figures reminded another writer of contemporaneous works by *Die Brücke* artists, but without the Germans' "overtone of disturbance"; instead, the musical title "hints at the strong sense of revery, at the mysticism that was part of Slinkard's temperament."[129] Yet another commentator noted that the picture prizes mood over action, the mood being established by figures, "generic and idealized, bound to each other as one melted organic mass."[130]

Carl Sprinchorn found in several of Slinkard's late works echoes of Gladys Williams's presence, conveyed through forms reminiscent of her physical self but "transposed into those symbolisms which he saw as a visionary artist in the natural forms of mountains or clouds." As an example he cited "the heavily draped figures that comprise the mountain-forming arrangement in the picture called *My Song*."[131] In discovering these forms of Slinkard's fiancée in the compositions, Sprinchorn did so "not in conjunction with likeness—they are all like her—but rather as a motive power, force of sex on a higher spiritual plane."[132] Slinkard's "song" then becomes a celebration of life, of the generative principle expressed through

Fig. 37 **Woman in Exotic Dress**, 1917–18
Pen and blue ink over pencil on paper,
4$^{15}/_{16}$ × 7$^{7}/_{8}$ in.
[Cat. no. 210]

Fig. 38 **Standing Clothed Female Model**
Charcoal on laid paper, 24$^{7}/_{16}$ × 18$^{1}/_{2}$ in.
[Cat. no. 194]

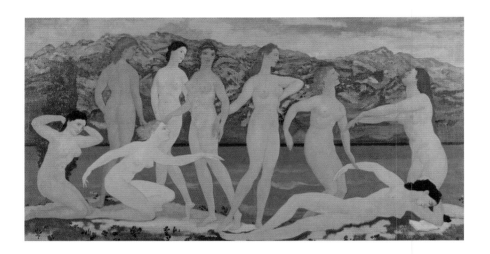

generalized human form massed into a natural, geological arrangement. Whereas Davies's dancers formed a frieze before the mountains (FIG. 39), Slinkard's singers become the mountains.

Anthropomorphic landscapes such as Slinkard's have a long history; they are not confined to modern art or to California. Yet the tendency did seemingly appeal to Slinkard's generation, particularly to some of the more subjective, even mystical artists, such as George Alfred Williams and Augustus Tack. In California, Adele Watson in Pasadena and San Francisco's Chee Chin S. Cheung Lee made distinctive contributions to the tradition. Looking back at Slinkard's generation of early modernists in California, historian Bram Dijkstra found "a predilection for topographical anthropomorphism quite common," a fascination he attributed to the state's natural beauty.[133] Like certain of their works, Slinkard's *My Song*—as well as *My Friends of the Soil* (see FIG. 12), in which he takes titular possession of the land—suggests a purposeful merger of the human and the natural and a concomitant avoidance of the mechanical and modern artifice.

THE LAST YEAR

Even after the Army had called Slinkard from his Southern California home, he continued to explore his states of mind, giving expression through drawings that Sprinchorn described as "blueprints to paintings that unfortunately never came to see daylight."[134] More specifically Brigante recalled "Rex telling me of his desire to paint murals. Those drawings were preliminary works for larger murals," plans for projects that suggest the persistence of Puvis's example.[135] A number of these late examples were drawn on military stationery while Slinkard was stationed at the newly established Camp (now Fort) Lewis in Washington State, or Camp Greene in Charlotte, North Carolina (where the landscape reminded him of Puvis's palette). Unlike the large figure studies of his early years, these sketches are drawn on small sheets, sometimes not much more

Fig. 39 Arthur B. Davies
Rhythms, c. 1910
Oil on canvas, 35 × 66 in.
Milwaukee Art Museum, Gift of Mr. and
Mrs. Donald B. Abert in memory of
Harry J. Grant. Photo credit: Dedra Walls

than scraps of note paper, and made with simple media (ink and pencil). *Youth on the Way* (FIG. 40) is typical. Before a forested landscape, marked by tall firs and soldiers' tents, a figure (Slinkard?) strides boldly toward an uncertain future. At the right margin, stumps commemorate the fallen Great ones cleared for the western cantonment; simultaneously they evoke tombstones, commemorating the fallen heroes of the Western Front. Other drawings are even more poignant, such as that inscribed "Hospital 1918" (FIG. 41), depicting two seated figures, one slumped onto the other. This image was probably the product of Slinkard's hospitalization with scarlet fever; it seems less likely to date from his final illness in October 1918, when he was felled by the influenza epidemic in New York City. Wherever it was created, the hospital drawing is a reminder of war and illness that weighed on Americans during that awful year.

For Slinkard, 1918 began inauspiciously. In January, from Camp Greene in North Carolina, he reported, "I'm feeling fine. My mind is right. My body is not near as good."[136] Over the preceding several years his usually robust health had periodically faltered—in about 1915, a precipitous weight loss occasioned by strenuous ranch work had weakened him for a year—but Slinkard seemed always to recover. And even illness could provide inspiration. "Strength is a great thing," he once wrote, then optimistically added, "So is weakness."[137] But by 1918, weakness and illness were taking their toll. That spring he was back in the base hospital for scarlet fever and was marked for limited service.[138] As the year progressed, the need for American doughboys continued; by autumn, Slinkard's unit was preparing for dispatch "over there." After transfer to Fort Niagara, his unit was sent midsummer to New York City, the embarkation point for American troops heading to Europe. His arrival coincided approximately with that of the influenza that had first appeared at an Army base in Kansas months earlier.

On 15 September, New York City recorded its first death from the pandemic, which ultimately claimed its greatest number of victims among the population twenty-five to twenty-nine years old, and second-greatest among those aged thirty to thirty-four—victims lamented as "doubly dead in that they died so young."[139] Among the young were numerous American soldiers; housed in close proximity in large barracks, many contracted the highly contagious disease, and one out of every sixty-seven eventually succumbed to it.

In New York the crisis peaked in mid-October. On 12 October, Rex Slinkard wired his mother in Los Angeles: "Am in St. Vincent's Hospital, New York. Pneumonia." His father promptly offered to pay for "the best doctor in New York," but money could not buy a remedy. On 15 October, Slinkard's faithful friend Carl Sprinchorn arrived at the hospital to be with the ailing artist. Two days later Sprinchorn sent another telegram to the parents, informing them, "Your son in desperate condition tonight.

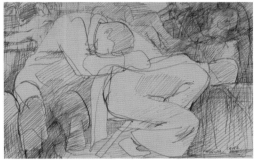

Fig. 40 **Youth on the Way**
Pen and blue ink on paper, 8 11/16 × 7 5/16 in.
[Cat. no. 254]

Fig. 41 **Hospital**, 1918
Pen and blue ink on paper, 5 1/8 × 7 7/8 in.
[Cat. no. 244]

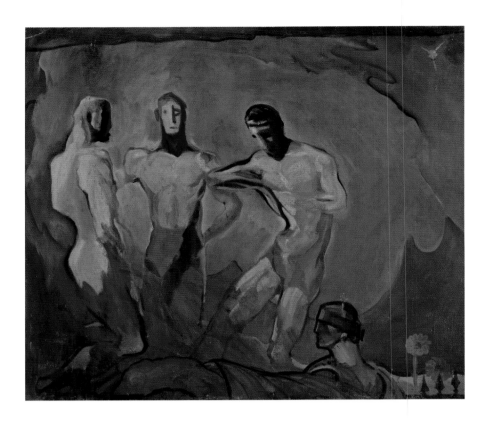

Sends you his love and to Gladys. Have been with him night and day since Tuesday. Everything has and is being done. The dear boy fighting bravely still."[140] The next day, Slinkard's brave fight ended; his death added to the city's highest weekly toll of the entire epidemic.

Sprinchorn accompanied his friend's body on its sad trip home to California and remained there for an extended stay. He was still in California in February 1919 when his friend Marsden Hartley arrived for a visit, providing the latter's introduction to Slinkard's pictorial estate. Among the works he admired was Slinkard's *Ring Idols* (FIG. 42), a curious picture that one curator described as "either a reference to Richard Wagner's opera, *Der Ring des Nibelungen*, or a highly poetic and mystical evocation of boxing."[141] Slinkard's tastes in opera are not known, but his love of the prize fight was familiar to his friends, who might have noted figures of pugilists among his drawings (FIG. 43). Sprinchorn could have explained to Hartley even more specifically the genesis of *Ring Idols*. Unlike that of his friend Bellows, Slinkard's interest in the subject was more personal than pictorial; Sprinchorn proposed that *Ring Idols* was inspired by an incident during a fight both artists attended in Los Angeles at Thanksgiving 1913. The late-afternoon bout in an outdoor arena featured Slinkard's friend Joe Rivers, the Mexican lightweight champion. Sprinchorn remembered:

Seated with our backs toward the sunset sky, we had the full power of its reflected color and light focused directly on the

fighting bodies. Within a few minutes and without a no- ticeable change in the effect for some time, the hidden flood lights were turned on the ring. In the quickly descending twilight and with the fighters still appearing to remain in the light of the sunset glow, the ring appeared to be lifted up into a sort of hallowed region of intensely blue night skies that gave to the whole scene an atmosphere of Holy Night, or Transfiguration; an atmosphere of unreality and divorcement from the usual noisy ringside associations. Judging from the similar unreality and orange glow over the boxers (strangely three in number) this occasion may well have been the one that gave rise to the idea which de- termined this single fight scene painting.[142]

In the early 1950s, a decade after Hartley's death, a young scholar corresponded with Carl Sprinchorn about Hartley, Slinkard, and the legacy of which Sprinchorn was by then the chief steward. "You really have to realize for [Slinkard] the des- tiny that he did not live long enough to do himself," he wrote, " . . . and is not this even harder than realizing one's own destiny. Few persons are capable of it . . . [for] it involves a most incredible entanglement of psyches, rich beyond expression."[143] A decade later, Sprinchorn lamented to Brig- ante that "you are now the only one . . . except myself, who can still carry on the Rex + Gladys + Florence Williams 'idea' . . . which, to me, represents my youth—all over."[144] Later yet, in the spring of 1971—fifty-three years after their friend's demise and scant months before Sprinchorn's own—he and Bri-gante were still communicating, trying to bring attention to Rex Slinkard's neglected life and art.[145]

Now they are all gone. Only the artworks survive to convey the record of the brief but creative life of Rex Slinkard, ranchman, poet, and painter.

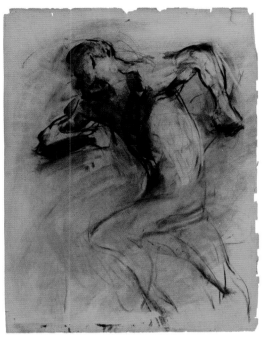

Fig. 43 **Male Striding Forward**
Charcoal on laid paper, 25 × 18 11/16 in.
[Cat. no. 28]

NOTES

1 [Laura Simonson Slinkard], "Memoir of Rex Slinkard by his mother," typescript, 1; Carl Sprinchorn Papers, Archives of Amer- ican Art, Smithsonian Institution, reel 3014/frame 67 (hereafter AAA, reel no./frame no.). Years later, Nicholas Brigante recalled that Slinkard's mother had encouraged Rex's pursuits, "aiding and encouraging him—fighting his battle with the father—she said Rex inherited the urge to paint from her." Brigante to Mars- den Hartley, 29 April 1942; AAA, 3004/184.

2 Carl Sprinchorn, "Notes"; AAA, 3014/221. Carl Sprinchorn (1887–1971) emigrated from his native Sweden to New York City in 1903. Three days after his arrival, he enrolled in classes with Robert Henri at the New York School of Art (founded by Wil- liam Merritt Chase); he followed his teacher when he broke with Chase to establish the Henri School of Art, with Sprinchorn as

manager. He first met Slinkard in 1908, beginning a close friend- ship that lasted until the latter's death ten years later. In 1919 Sprinchorn first visited the Maine woods, a subject with which he later became prominently identified. In Maine he continued his friendship with Marsden Hartley; Sprinchorn ceded coastal subjects to Hartley, preferring to depict the interior woodlands where he spent the majority of his time from 1937 to 1952, paint- ing its forests, lakes, and lumberjacks. For more on Sprinchorn, see Gail R. Scott, *Carl Sprinchorn* (Farmington, ME: Tom Veilleux Gallery, 1994); and Scott, *Carl Sprinchorn: King of the Woods* (Lew- iston, ME: Bates College Museum of Art, 2002).

3 Carl Sprinchorn, "Rex Slinkard: A Biographical-Critical Study of His Life, Paintings and Drawings," 2; AAA, 3014/336.

4 Henri to Sprinchorn, 4 November 1918; AAA, 3014/133.

5 Marsden Hartley, "Letters Never Sent: Rex Slinkard," c. 1940. Marsden Hartley Papers, Yale Collection of American Literature, Beinecke Rare Book and Manuscript Library, Yale University; copy at AAA, 3014/1059.

6 Marsden Hartley, "Rex Slinkard," *Adventures in the Arts: Informal Chapters on Painters, Vaudeville, and Poets* (New York: Boni and Liveright, 1921), 87; Hartley to Florence Williams, postmarked 9 June 1939, AAA, 3014/134. Hartley's tribute to the artist was first published as "Rex Slinkard: Ranchman and Poet-Painter," in *Memorial Exhibition: Rex Slinkard, 1887–1918* (Los Angeles: Los Angeles Museum of History, Science, and Art, 1919) and reprinted in *Rex Slinkard, 1887–1918: Memorial Exhibition* (New York: M. Knoedler & Co., 1920).

7 Hartley, "Letters Never Sent: Rex Slinkard." The incident is also recounted in Marsden Hartley's autobiography, *Somehow a Past*, ed. Susan Elizabeth Ryan (Cambridge, MA: MIT Press, 1997), 101.

8 E. Van Lier Ribbink, "Open Minds Give Slinkard True Value," *San Francisco Examiner*, 12 October 1919.

9 Nicholas Brigante to Anita Mozley, 28 August 1974; letter in curatorial file, Cantor Center for the Visual Arts, Stanford University (hereafter CCVA).

10 Arthur Millier, "Rex Slinkard Paid Tribute by Exhibit," *Los Angeles Times*, 8 August 1943.

11 "Memoir of Rex Slinkard by his mother," 9; AAA, 3014/67.

12 Sprinchorn, "Rex Slinkard: Biographical-Critical Study," 36–37; AAA, 3014/447–48.

13 Brigante to Sprinchorn, 21 October 1930; AAA, 3004/88. Discouraged in his efforts, Brigante concluded that Slinkard's brother "no doubt is a modern business man and that is where his interest lies."

14 Stetson to Dr. E. B. Knight, 1 March 1896; Walter Stetson Papers, Bancroft Library, University of California, Berkeley.

15 Arthur G. Vernon, "Modern Art in California," *The Graphic*, 20 April 1918, 18.

16 According to one contemporary account, Slinkard received "the first scholarship given by the [William Merritt] Chase school to an Art League pupil [i.e., Los Angeles Art Students League]." Everett C. Maxwell, "Art: Exhibitions Next Week," *The Graphic*, 20 August 1910, 8.

17 Porter Garnett, "Art: Painting in California," *The Nation* 108, no. 2809 (3 May 1919): 702. Garnett concluded, "In far countries, like California, he is the victim of those misgivings on the part of possible patrons which arise from the fear of appearing provincial—doubts which are of the very essence of provincialism."

18 Robert Henri, *The Art Spirit: notes, articles, fragments of letters and talks to students, bearing on the concept and technique of picture making, the study of art generally, and on appreciation*, comp. Margery Ryerson (Philadelphia: J. B. Lippincott, 1923), 105.

19 John Alan Walker proposed that Slinkard was "elected" director by his fellow students following a favorable notice of his work in press coverage of the school's annual exhibition. Slinkard replaced the conservative—and therefore presumably less popular—sculptor C. C. Christadore, who had assumed interim leadership following the untimely death of director Warren Hedges in June 1910. John Alan Walker to Anita Mozley, 7 September 1975; letter in curatorial file, CCVA. Like Slinkard, Hedges had studied with Henri and was an advocate of his innovative methods.

20 Maxwell, "Art: Exhibitions Next Week," 8.

21 Brigante to Hartley, 29 April 1942; AAA, 3004/181.

22 Henry McBride, "Rex Slinkard as War Superman and Poet," *New York Herald*, 25 January 1920.

23 Henri, *Art Spirit*, 47.

24 William Innes Homer, *Robert Henri and His Circle* (Ithaca, NY, and London: Cornell University Press, 1969), 162.

25 Maxwell, "Art: Exhibitions Next Week," 8. The review included the titles of Slinkard's works, the products of his New York study: *The Garden*; *The Wire Dancer*; *Café Sterling*; *The Hobble Sisters* (an Everett Shinn–like vaudevillian subject); *Patty Flanigan* [sic] (presumably the same subject famously portrayed by George Bellows in 1908); *End of Seventy-second Street, New York*; *The Spot Light*; *Hudson and Fulton Exhibition by Night*; *The Hippodrome Ballet*; *Nocturne*; *Open Air Café*; *Portrait Sketch of a Man*; *Fifth Avenue*; plus the two nude studies.

26 *Figurative Art in California during the Modern Period*, exh. brochure (Los Angeles: Spencer Jon Helfen Fine Arts, 2008), n.p.

27 Christopher Knight, "Surprise Sprouts from a 'Seed'; Modern Art's L.A. 'Seed'" (review of *A Seed of Modernism* exhibition, Pasadena Museum of California Art), *Los Angeles Times*, 26 January 2008. Knight concluded, "Impressionist it's not."

28 Trevor Fairbrother, "Sargent's Genre Paintings and the Issues of Suppression and Privacy," in *American Art around 1900: Lectures in Memory of Daniel Fraad*, eds. Doreen Bolger and Nicolai Cikovsky, Jr. (Washington, D.C.: National Gallery of Art, 1990), 29–48. Elsewhere Fairbrother described the dual appeal to the senses in Sargent's art: "First, it depicts and celebrates sources of pleasure—enchanting places, intriguing objects, and striking individuals of diverse types and classes. Second, Sargent's way of painting is itself sensual. The conspicuously worked, physically appealing surfaces of his pictures are the visible remains of the pleasure he derived from wielding his brushes." Trevor Fairbrother, *John Singer Sargent: The Sensualist* (Seattle Art Museum and Yale University Press, 2000), 43–44.

29 Slinkard to Sprinchorn, n.d. ["Sunday evening"]; AAA, 3014/87; reprinted in "Rex Slinkard's Letters," *Contact* 3 (Spring 1921): 2. The letter is quoted below, p. 56.

30 Everett C. Maxwell, "Art," *The Graphic*, 16 December 1911, 9.

31 Conrad Buff Oral History, University of California at Los Angeles; quoted in Will South, "A Singular Vision: The Life and Art of Conrad Buff," *The Art and Life of Conrad Buff* (West Hollywood, CA: George Stern Fine Arts, 2000), 39.

32 Brigante to Sprinchorn, [1937]; AAA, 3004/84.

33 Brigante to Sprinchorn, 25 December 1932; AAA, 3004/136. At least one of Slinkard's drawings (see cat. no. 198) depicts a seated man (his student?) with vaguely Japanese facial features.

34 Slinkard to Sprinchorn, 1913; reprinted in *Contact* 3: 6.

35 "Sues Parents-in-Law for Fifteen Thousand," *Los Angeles Times*, 28 February 1913.

36 "'Nymph' Asks Divorce from Absent Artist," *Los Angeles Times*, 4 July 1913.

37 Slinkard to Sprinchorn, 1913; reprinted in *Contact* 3: 6.

38 Slinkard to Sprinchorn, [1914]; AAA, 3014/92; reprinted in *Contact* 3: 6.

39 Arthur Millier, "Slinkard Memorial Exhibit," *Los Angeles Times*, 10 March 1929.

40 Slinkard to Sprinchorn, n.d.; reprinted in "Letters of Rex Slinkard," *Contact* 1 (December 1920): 2.

41 Slinkard to Gladys Williams, n.d.; reprinted in "Rex Slinkard: Extracts from Letters," *Contact* 2 (January 1921): n.p.

42 Slinkard to Sprinchorn, 1913; quoted in Sprinchorn, "Rex Slinkard: Biographical-Critical Study," 61; AAA, 3014/395.

43 Carl Sprinchorn, "Notations on reading Robert Burlingame's M.S. 'Marsden Hartley,'" c. 1955; AAA, 3004/433. Could Hartley's later responses to Provençal (and other) landscape environs have been conditioned by Slinkard's language?

California's environment was often and loudly celebrated by the state's boosters. "One of the chiefest resources of California," boasted Benjamin Wheeler, president of the University of California, "is its climate . . . [which] gives the opportunity of full days and full years of effective living. Old age will be prolonged five years or more by coming here." Wheeler claimed that California's salubrious climate caused its people to "turn with their chief life interests toward humanism. Their instinctive fondness for music, the drama, color, and all beauty, as well as their preference for literature, philosophy, art, and history among the higher pursuits, testifies to the bent which the land has given them." Benjamin Ide Wheeler, "A Forecast for California and the Pacific Coast," *The Outlook* 99 (23 September 1911): 174. A similar "fusion of self and nature" was described by Susan Anderson in her study of the artists whom she called California Progressives: "Like Slinkard . . . [they] spent much time in solitude in the Western landscape, creating idiosyncratic paintings of the vast spaces and enormous distances of its arid deserts, majestic mountains, deep canyons, and rocky coastline." Susan M. Anderson, *California Progressives, 1910–1930* (Newport Beach, CA: Orange County Museum of Art, 1996), 7.

44 Ribbink, "Open Minds Give Slinkard True Value."

45 Christian Brinton, *Impressions of the Art at the Panama-Pacific Exposition* (New York: John Lane, 1916), 17.

46 Ribbink, "Open Minds Give Slinkard True Value."

47 Sprinchorn, "Rex Slinkard: Biographical-Critical Study," 31; AAA, 3014/365.

48 Rex Slinkard, "Things that help me paint . . . "; Sprinchorn Papers, AAA, 3014/84–85. Reprinted (with slight variations) as "Rex Slinkard's Letters," *Contact* 3 (Spring 1921): 6.

49 Henri, *Art Spirit*, 168–69.

50 Sprinchorn, "Notes on Oil Paintings," August 1945; AAA, 3014/430. In Sprinchorn's records, the two paintings are variously titled *Wild Horses* or *Horses on the Range*.

51 For more on Maratta and Henri, see Valerie Ann Leeds, *My People: The Portraits of Robert Henri* (Orlando, FL: Orlando Museum of Art, 1994), 48ff. John Sloan was a particularly enthusiastic convert, whose growing interest is recorded in his journal: "H[enri] is full of a scheme of color, a new set of pigments made by a man named Maratta. A regularly gradated sequence; red, orange, yellow, green, blue, and purple with the same 'intervals' and a low keyed set of 'hues' of the same colors. Henri thinks there are great possibilities" (9 June 1909). "No reason why a man shouldn't get the habit of thinking in these [Maratta] colors. . . . The lower 'hues' are particularly interesting" (15 June 1909). "God Bless the Maratta Colors. I can think in these!" (8 March 1911). "Maratta is all immersed in his theories of art and form and color. He is a great innovator in these ways. The pigments I'll swear by, and their possibilities are boundless, unguessable" (5 November 1911). *John Sloan's New York Scene*, ed. Bruce St. John (New York: Harper & Row, 1965), 318, 319, 514, 575.

52 Jack Gage Stark to Hartley, 4 May 1942; quoted in Sprinchorn, "Rex Slinkard: Biographical-Critical Study," 43; AAA, 3014/371.

53 Slinkard to Sprinchorn, September [1916]; reprinted, with emphasis, in *Contact* 3: 1.

54 Sprinchorn, "Notes on Oil Paintings," August 1945; AAA, 3014/430.

55 Sprinchorn, "Rex Slinkard: Biographical-Critical Study," 40, 42; AAA, 3014/368, 370.

56 Sprinchorn, "Notes on Oil Paintings," August 1945; ellipses in original. Sprinchorn was here describing Slinkard's painting *Infinite*, c. 1915–16 (FIG. 48).

57 Slinkard to Sprinchorn, September 1916; AAA, 3014/110; reprinted in *Contact* 3: 1. Slinkard was referring to *Young Rivers* (FIG. 30), on which he was working at the time.

58 Pierre-Louis (pseudonym for Maurice Denis), *Art et Critique*, 23–30 August 1890, 1. The concepts initially expressed in 1890 were incorporated into Denis' *Théories, 1890–1910: Du Symbolisme et du Gauguin vers un nouvel ordre classique* (Paris: Bibliothèque de l'Occident, 1912).

59 Nancy Moure has noted the appearance of such subjective concerns and imagery in the art of Slinkard's time and place, suggesting that his interest was not unique. "In the realm of Symbolist painting, comparatively sparsely populated Southern California holds its own with the north. Southern California Symbolist painting, however, was of a completely different character. . . . Unlike the American Renaissance style that came to its end with the Panama-Pacific Exposition [in 1915], Symbolism, in new forms, continues as a minor and peripheral thread through the early 1900s, especially in Los Angeles." Nancy Dustin Wall Moure, *California Art: 450 Years of Painting and Other Media* (Los Angeles: Dustin Publications, 1998), 106–7.

60 Susan M. Anderson, *California Progressives: 1910–1930*, exh. cat. (Newport Beach, CA: Orange County Museum of Art, 1996), 10.

61 Amy Goldin, "The Eight's Laissez Faire Revolution," *Art in America* 61, no. 4 (July–August 1973): 49.

62 Antony E. Anderson, "Art and Artists," *Los Angeles Times*, 28 August 1910.

63 Jack Gage Stark to Hartley, 4 May 1942; quoted in Sprinchorn, "Rex Slinkard: Biographical-Critical Study," 38; AAA, 3014/372.

64 Slinkard to Sprinchorn, 29 January 1917; AAA, 3014/120; reprinted in *Contact* 3: 5.

65 A. V. Mozley, Notes transcribed from meeting with Nicholas Brigante, 2 September 1976; curatorial file, CCVA.

66 Writing from Paris shortly after leaving California, Sprinchorn recalled a Sunday outing in the hills above the ranch, "when you [Slinkard] wore a red bandana around your neck and a background like Mona Lisa's." Sprinchorn to Slinkard, 25 February 1914. I am grateful to Stephen Slinkard for sharing this correspondence with me.

67 Marsden Hartley, "Rex Slinkard's Spirit and Purpose," typescript, 3; Marsden Hartley Papers, AAA, 3014/1068.

68 Slinkard's pastels are relatively few in number and may reflect the influence of Jack Gage Stark, with whom he shared studio space in Los Angeles for several years. Stark's colorful Postimpressionist palette and his tales of Tahiti may have influenced Slinkard's

brightly colored pastels, some of which have themes of the South Pacific, a region he visited only in his imagination.

69 Brigante, for one, declined to read significance into the blossoming forehead, claiming that the flower was simply one that Slinkard liked and put into the work; similarly he claimed that *Colossus* was the result of a happy accident, not a reflection of influence from, say, Odilon Redon. "The Self-Portrait with one eye, Nick [Brigante] also recalls, as a work that was causing Rex a lot of problems, and at one point he quickly painted out part of the face & liked what was left! So he left the oil that way." John Alan Walker to Anita V. Mozley, 25 July 197[?]; curatorial file, CCVA.

70 Jack Gage Stark to Hartley, 1942; quoted in Sprinchorn, "Rex Slinkard: Biographical-Critical Study," 71; AAA, 3014/399.

71 Sprinchorn, "Rex Slinkard: Biographical-Critical Study," 77; AAA, 3014/405.

72 Hartley, "Rex Slinkard's Spirit and Purpose," typescript, 2; Marsden Hartley Papers, AAA, 3014/1066.

73 Antony Anderson, quoted in Arthur Millier, "Slinkard Memorial Exhibit," *Los Angeles Times*, 10 March 1929.

74 Henri, *Art Spirit*, 72.

75 Carl Sprinchorn, "Rex Slinkard," manuscript, 19; AAA, 3014/277.

76 Brinton, *Impressions of the Art at the Panama-Pacific Exposition*, 18. This statement was certainly true of Stanton Macdonald-Wright, Slinkard's onetime classmate at the Art Students League of Los Angeles and his successor as head of the school. According to Nicholas Brigante, Macdonald-Wright "steeped himself in the Chinese so much that he has emerged without anything of himself." Brigante's own deep interest in Chinese art "began with Rex's influence upon me in my early years. It has helped me wonderfully in the painting of this our western desert and mountain landscape." Brigante to Sprinchorn, 8 November 1936; AAA, 3004/110.

77 Hartley, *Adventures*, 87–95.

78 Sprinchorn, "Notes on Rex Slinkard," 2 September 1945; AAA, 3014/passim. Sprinchorn also noted similarities between Slinkard's painted hands and those in Etruscan art.

79 Brigante, Handwritten statement about Rex Slinkard, n.d.; copy in curatorial file, CCVA. Brigante entered the Los Angeles Art Students League in 1913, shortly after Slinkard's departure. Although no longer teaching at the League, Slinkard did periodically visit the studio, where he befriended some of the young art students, most notably Brigante, who years later recalled with pleasure the time spent with Slinkard at the Los Angeles Public Library, poring over art books and studying reproductions of Chinese art.

80 Hartley, *Adventures*, 89. A local critic, probably referring to this painting, similarly noted that "one of the self portraits gives a hint of Oriental study." Unidentified clipping from a Los Angeles newspaper, 1919; AAA, 3014/465.

81 Jack Gage Stark, quoted in Sprinchorn, "Rex Slinkard: Biographical-Critical Study," 20; AAA, 3014/355. Nicholas Brigante identified Slinkard's small volumes as part of "the Gowan series." He also noted other reproductions that Slinkard favored, the Painters Series published by the Frederic A. Stokes Co., New York. Annotation on copy of Sprinchorn typescript in curatorial file, CCVA.

82 Slinkard, Fragment of a letter to Sprinchorn, n.d.; AAA, 3014/82; reprinted in *Contact* 3: 5. "I'll send you a print of his," Slinkard promised his correspondent, in the event Sprinchorn did not recognize "Tiffi." Slinkard is likely referring to Lippo Lippi, i.e., Fra Filippo Lippi (c. 1406–1469).

83 Slinkard to Sprinchorn, 29 January 1917; AAA, 3014/114–15.

84 *Contact* 3: 4.

85 Slinkard to Sprinchorn, n.d. ["Sunday evening"]; AAA, 3014/88; reprinted in *Contact* 3: 3.

86 "The Lounger," *Putnam's Monthly & The Reader* 5 (December 1908): 378. The other members of the "academy of the rejected" named by Henri were Degas, Manet, and Whistler.

87 Sprinchorn, "Rex Slinkard: Biographical-Critical Study," 64–65; AAA, 3014/391–92. Lewis Mumford titled his classic study of the arts in America, 1865–95, *The Brown Decades* (New York: Harcourt, Brace, 1931).

88 *Contact* 3: 6.

89 Eugen Neuhaus, *The Galleries of the Exposition: A Critical Review of the Paintings, Statuary and the Graphic Arts in The Palace of Fine Arts at the Panama-Pacific International Exposition* (San Francisco: Paul Elder & Co., 1915), 14.

90 Slinkard, Fragment of a letter to Sprinchorn, n.d.; AAA, 3014/82; reprinted in *Contact* 3: 5.

91 *Contact* 3: 4.

92 Arthur Jerome Eddy, *Cubists and Post-Impressionism* (Chicago: A. C. McClurg & Co., 1914), 112; emphasis in original.

93 See my essay, "Claude Buck and the Introspectives," in *The Shape of the Past: Studies in Honor of Franklin D. Murphy*, eds. Giorgio Buccellati and Charles Speroni (Los Angeles: University of California Press, 1982), 306–22. Like Slinkard, Claude Buck, leader of the Introspectives, drew upon diverse artistic traditions, old and new, and prized the power of imagination. "The poetry of a picture means more . . . than the imitation or even the representation of nature," he said in 1920. "What the world needs most . . . is poet painters!" (310).

94 Ribbink, "Open Minds Give Slinkard True Value."

95 Henri, *Art Spirit*, 235.

96 Vachel Lindsay, "The Golden Whales of California," in *The Golden Whales of California and Other Rhymes in the American Language* (New York: Macmillan, 1920).

97 Sprinchorn, "Reminiscence of Rex Slinkard"; AAA, 3014/222; emphasis in original. Sprinchorn judged, "How much finer, that [arboreal standard], than to use man for a measure always."

98 Arthur Millier, "A Calm Declaimer of Everlasting Beauty," *The Argus*, April 1929, 2.

99 Laura Bride Powers, "Rex Slingard [*sic*] Canvases at Fine Arts Palace," *Oakland Tribune*; undated clipping in AAA, 3014/481.

100 "An Interesting Art Collection," *The Wasp* [San Francisco], 20 September 1919.

101 Review of Slinkard memorial exhibition at Knoedler & Co., *New York American*, 25 January 1920.

102 Alvarez diary entry for 8 June 1919; quoted in Richard Candida Smith, "The Elusive Quest of the Moderns," in *On the Edge of America: California Modernist Art, 1900–1950*, ed. Paul Karlstrom (Berkeley: University of California Press, 1996), 26.

103 Slinkard's *Great Air Spirits* also resembles Carl Sprinchorn's *Gods at Play* (now lost), which was shown at the 1915 Panama-California Exposition in San Diego and illustrated in publications about that exhibition.

104 Slinkard to Sprinchorn, n.d. [c. September 1916]; reprinted in *Contact* 3: 1.

105 Slinkard to Sprinchorn, n.d. [c. September 1916]; reprinted in *Contact* 3: 2.

106 Slinkard to Sprinchorn, 29 January 1917; reprinted in *Contact* 1: 3.

107 Sprinchorn, "Notes on Rex Slinkard's Paintings," August 1945, AAA, 3014/460. Brigante to Anita Mozley, 28 August 1974; curatorial file, CCVA.

108 Millier, "Rex Slinkard Paid Tribute by Exhibit," *Los Angeles Times*, 8 August 1943.

109 Ribbink, "Open Minds Give Slinkard True Value."

110 *The Mahogany Tree* [Boston], 28 May 1892; 411.

111 James Branch Cabell, *Beyond Life* (New York: Robert M. McBride & Co., 1919), 327.

112 T. J. Jackson Lears, *No Place of Grace: Antimodernism and the Transformation of American Culture, 1880–1920* (New York: Pantheon Books, 1981), xiii.

113 Virgil Barker, *An Exhibition of Paintings, Drawings and Water Colors by Arthur B. Davies*, exh. brochure (Pittsburgh: Carnegie Institute, 1924), n.p.

114 Royal Cortissoz, *American Artists* (1923; reprint, Freeport, NY: Books for Libraries Press, 1970), 103.

115 Royal Cortissoz, "The Character and Art of Arthur B. Davies," *Art News* 27 (27 April 1929): 66.

116 Elizabeth Tebow, "Arthur B. Davies, *The Flood*," in *The Eye of Duncan Phillips: A Collection in the Making*, ed. Erika D. Passantino (New Haven: Yale University Press, 1999), cat. no. 179.

117 Slinkard to Sprinchorn; n.d.; reprinted in *Contact* 2: n.p.

118 George Mowry, *The California Progressives* (Berkeley: University of California Press, 1951), 3. See also Kevin Starr, *Material Dreams: Southern California Through the 1920s* (New York: Oxford University Press, 1990), chapter 1 ("Prophesying Through Water: Hydraulic Visions and Historical Metaphors").

119 Sprinchorn, "Notes on Oil Paintings," 1945, typescript, 3; AAA, 3014/461.

120 Hartley, *Adventures*, 90.

121 Anderson, "Art and Artists."

122 Henri, *Art Spirit*, 47–48.

123 Slinkard to Sprinchorn, n.d.; reprinted in *Contact* 3: 3.

124 Slinkard to Sprinchorn, n.d.; reprinted in *Contact* 1: 2.

125 Catherine Rogers, "Mary Rogers—Sister and Artist," *International Studio* 73, no. 290 (May 1921): 81.

126 Brigante to Hartley, 9 September 1938; AAA, 3004/120.

127 Millier, "Slinkard Memorial Exhibit."

128 Charles C. Eldredge, *American Imagination and Symbolist Painting* (New York: Grey Art Gallery and Study Center, 1979), 98–100.

129 Abraham A. Davidson, *Early American Modernist Painting, 1910–1935* (New York: Da Capo Press, 1994), 277–79.

130 Moure, *California Art: 450 Years*, 107.

131 Sprinchorn, "Rex Slinkard: Biographical-Critical Study," 54; AAA, 3014/380.

132 Sprinchorn, "Notes on Slinkard Paintings," 1945, typescript, 4; AAA, 3014/463.

133 Bram Dijkstra, "Early Modernism in Southern California: Provincialism or Eccentricity?" in Karlstrom, *On the Edge of America*, 163.

134 Sprinchorn, "Rex Slinkard: Biographical-Critical Study," 63; AAA, 3014/391.

135 Brigante to Sprinchorn, 5 April 1933; AAA, 3004/105.

136 Slinkard to Sprinchorn(?), 27 January 1918; reprinted in *Contact* 3: 5.

137 Slinkard to Sprinchorn [c. 1916]; reprinted in *Contact* 3: 7.

138 Slinkard to Sprinchorn, 3 May 1918; reprinted in *Contact* 3: 7. Slinkard was hoping to get into a unit building camouflage, an area that used the talents of enlisted artists.

139 Dr. Harvey Cushing, quoted in John M. Barry, *The Great Influenza* (New York: Penguin Books, 2005), 239. Barry's study is the fullest account of the pandemic and the source of data cited here.

140 Telegrams and message are in the possession of the artist's grandnephew, Stephen Slinkard, to whom I am grateful for sharing this information.

141 Anderson, *California Progressives*, 7.

142 Sprinchorn, "Rex Slinkard: Biographical-Critical Study," 73; AAA, 3014/401. Fisticuffs as Transfiguration suggests the possibility of other interpretations. Might the unusual composition be read as a Prefiguration, specifically of the artist's posthumous career? A trio of admirers—Sprinchorn, Hartley, and Brigante—form a ring around a vacant center, the vanished (and idolized) Rex Slinkard. They are overseen by a robed female figure in the foreground—Gladys/Florence Williams, the keeper of the precious legacy and supervisor of the campaign. The gathering suggests their long, mutual and ultimately futile effort to bring attention to the artist's life and work. The interpretation is my fantasy, to be sure, one inconceivable to the painter and possible only with hindsight. But one arguably appropriate for a fantast like Slinkard.

143 Robert Burlingame to Sprinchorn, 21 March 1952; AAA, 3004/48. Elizabeth McCausland, Hartley's biographer, seemed to suggest how complicated this mixture of psyches was when she admitted, "This [interest in Slinkard's work] is one of the few examples I found in Hartley's career of his trying to do something for another person. Mostly he was pretty egocentric." "Marsden Hartley: Hudson Walker Interviewed by Elizabeth McCausland and Mary Bartlett Cowdrey," *Archives of American Art Journal* 8, no. 1 (January 1968): 18.

144 Sprinchorn to Brigante, 10 January 1963, following the death of Brigante's wife, Francesca; AAA, 3004/67.

145 Brigante to Sprinchorn, 8 April 1971; AAA, 3004/350.

Geneva M. Gano

THE LEGEND OF **REX SLINKARD**

Virtually unknown outside the provincial village of Los Angeles in his own lifetime, the California painter Rex Slinkard set the New York art world "all abuzz" after his death in late 1918.[1] Marsden Hartley wrote a passionate and appreciative catalogue essay about the man and his work for the memorial exhibitions that were held in Los Angeles, San Francisco, and New York City; Slinkard's sketches were reproduced in the important little magazine *The Dial*; and his personal letters (as well as reproductions of his work and a photograph of the artist) were reprinted in William Carlos Williams and Robert McAlmon's little magazine, *Contact*.[2] "The legend of Rex Slinkard," as Hartley referred to the reputation of the artist, far exceeded an aesthetic interest in the very small collection of finished work that Slinkard left behind when he died at age thirty-one.[3] Indeed, as the influential modernist poet Marianne Moore recognized, Slinkard's drawings, like much of his work, were "so good and so hampered."[4] Even Slinkard's most enraptured admirers were forced into speculation: Arthur Millier, influential art critic for the *Los Angeles Times*, proposed that Slinkard's untimely death robbed America of what *might have been* the nation's "most sensitive imaginative painter," and Hartley himself thought that the nation had "lost a true, pure artist—as well as a *possible* great one" (my italics).[5] Why, then, such a surge of interest in Slinkard after his death? And why do both the man and his work continue to interest us today?

Such questions might be asked about numerous artists, of course, but Slinkard's fascinating life, magnetic personality, flashes of artistic

Fig. 44 Louis Fleckenstein
Rex Slinkard Standing, c. 1916
Toned bromide print, 6⅝ × 5 in.
Stanford Museum Collections, 2002.2

brilliance, and—not least of these—early death made him an especially compelling character to his contemporaries. As a man and artist, Slinkard embodied a Whitmanic ideal cherished by many who had come of age just before World War I. In being cut down in his prime—with so much promise that would never be fulfilled—he symbolized all of the beautiful young men who had been sacrificed in the name of an extremely unpopular war, one that was opposed by most of the socialist, anarchist, and avant-garde artists with whom he was associated. Examining the curation and creation of the legend of Rex Slinkard enables us to flesh out the way his life and wartime death simultaneously shaped and responded to the aesthetic, political, and sexual dimensions of American culture during the early decades of the twentieth century.

Slinkard himself was very likely the source of the "legend of Slinkard" as it developed both during and after his life. Carl Sprinchorn, the painter who was Slinkard's *camerado* (Whitman's word for a lover, friend, and supporter) throughout his life and after his death, remembered him as "gay, popular, with many clinging Western traits in speech, dress, and gait—Rex was a fanatic addict of the prize-ring, a tap-dancer, teller of stories and singer of songs."[6] Stories about Slinkard ran to the exotic, the gritty, and the romantic—some of which were corroborated by family and friends, while some may never be verifiable—including those about helping to run his family's ostrich farm in Texas, bartending (at age fourteen or fifteen) at a waterfront saloon in San Pedro, California, and witnessing the "Fight of the Century" on 4 July 1910 between Jack Johnson and Jim Jeffries in Reno, Nevada.[7] In addition to tales of art and sport,

> the West, the Far West, was the favorite theme. At the drop of a hat he would take off with whoever would listen for the west of the Rockies or of Texas or any other section of the country containing great spaces where one could ride and look far. Also extolled were the pictorial beauties of Southern cotton fields, negroes and mules. It would have been impossible to find one more contagiously infective on these grounds, were one in the least inclined—as who isn't in time of youth—to yearn for the unconfined, the large and the wild.[8]

He was, as they say, devilishly handsome, sporting "a shock of coarse, black hair" and "prize-fighter's heavy white turtle-neck sweater—a boy on the grid"[9] (FIG. 44). He embodied this persona, as illustrated by an anecdote that Sprinchorn related from their time together as students of Robert Henri at William Merritt Chase's New York School of Art:

> [Henri's conversation with Slinkard about his charcoal work in studio]: "You like to go out a lot, don't you?" Yes. "And stay

up late nights?" Yes. "And smoke?" Yes. "And drink?" Yes. "Go out with women?" Yes. This having been settled conclusively if not altogether happily, Henri unfolds himself to rise in majestic dignity, slowly, towering (same black hair as Rex; orientally placed eyes wide apart, searching). But the shaft is still to be brought home. This comes in the act of passing on to the next in line, offhand, but peremptory and in a tone at once stringent and resignedly kind: "Well,— *keep your energy for your work*."[10]

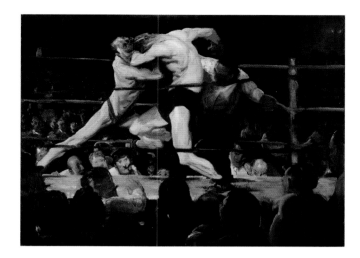

The dynamic boxing paintings produced by George Bellows, Slinkard's sometime flatmate, indicate that, admonishments or no, Slinkard's bohemian lifestyle continued as ever: in Bellows's masterpiece, *Stag at Sharkey's* (FIG. 45), we see what appears to be Rex's jolly face looking back at the artist from ringside, a cigar protruding from his mouth, hand being raised in a "hail fellow well met" gesture. Bellows, Slinkard, and Sprinchorn were all part of Henri's class of 1910, which also included Stuart Davis, Peggy Baird, and others (FIG. 46). Such a "live group" could take credit for initiating the young playwright Eugene O'Neill into the "creative anarchist circles" in which he would find inspiration and dissipation (O'Neill, too, shared Bellows's flat at times), and it was in this milieu that Slinkard's relationship with Sprinchorn flourished.[11] Though Slinkard's yarns suggested that he was a rolling stone, he was financially dependent on his father, Stephen Wall Slinkard, a middle-class Los Angeles businessman who, by all accounts, only very begrudgingly bankrolled his younger son's education, clothes, and pocket money.[12] In 1910, when Slinkard's

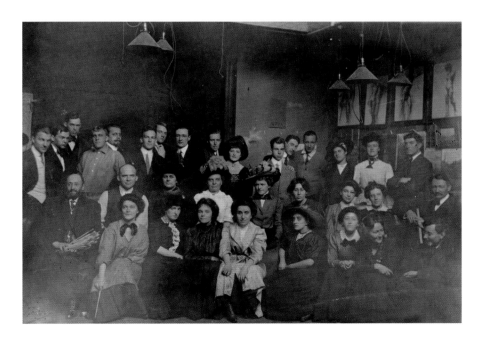

Fig. 45 (above) George Bellows
Stag at Sharkey's, 1909
Oil on canvas, 36¼ × 48¼ in.
The Cleveland Museum of Art,
Hinman B. Hurlbut Collection

Fig. 46 (left) Unidentified photographer
Henri School—Morning Life Class, 1910 (?)
Carl Sprinchorn Papers. Courtesy of Special
Collections Department, Raymond H. Fogler
Library, University of Maine. Rex Slinkard is
standing, second from left.

father threatened to cut off his son's support unless he returned to Los Angeles, the young bohemian capitulated and returned home.

If his father had intended to rein him in, he did not succeed especially well. Slinkard persisted with his art, returning to the Art Students League of Los Angeles (ASL-LA), where he had studied years before under Warren Hedges and alongside Stanton Macdonald-Wright. Hedges drank himself to death that January (at the young age of twenty-six) and had left no clear heir to operate the school. Slinkard eventually stepped in and took over as director, making incredibly devoted, even worshipful, friends as well as bitter enemies, particularly among what he derided as the "Barn-Yard School" of Los Angeles painters.[13] The ASL-LA, where Slinkard taught between 1910 and 1913, shared Main Street with shops "devoted to saddlery and souvenirs; cheap wines and chili con carne; movies and Mexican vaudeville houses . . . the street teemed with an endless procession day and night of types from the desert, the orchard, the ranch; come by railroad, by car or by foot, or for the matter of that, by ship; all looking as if they had just arrived and mostly from long distances."[14] The artist's life, as Slinkard lived it, was not one of "high culture."

Slinkard's turbulent personal life fed into the legend of Slinkard as it later took shape. In 1911, while he was at the ASL-LA, Slinkard's muse and model, the "nymph" Jessie Augsbury, became pregnant. He married her in 1912, against his parents' wishes, but later fled the state—very likely at his father's insistence—leaving her and the baby behind. The scandalous news of the "runaway husband" was in the newspapers, which reported that Augsbury sued for divorce. Family lore has it that Slinkard's family paid her off, or at least attempted to do so.[15] Slinkard publicly denied paternity of the child, a claim his family maintained, though his protests seem spurious: according to Carl Sprinchorn, young Maurice Rudy Slinkard bore a striking resemblance to Rex Rudy Slinkard.[16] Moreover, Rex and Jessie lived together for almost two years, traveled together, and continued to keep in contact through letters and through personal visits after Rex was exiled to the ranch.

This event tarnished Slinkard's public stature, prompting his resignation as director of the ASL-LA in late 1912. He was supposed to be out of the state, but actually he was hiding out at a ranch near San Bernardino.[17] Once the scandal died down, he retired to his family's alfalfa ranch in Soledad Canyon near Saugus, California. There, he tended horses and did ranch work, painting in the evenings and on Sundays. He persuaded Carl Sprinchorn to come to Los Angeles to direct the League in his stead, while he maintained his presence at the school by way of clandestine visits. Students and friends also made regular pilgrimages to the ranch to visit him.[18] Throughout this period, he was courting Gladys Williams, a well-to-do girl from Los Angeles, whom he had known since they were students

under Hedges at the ASL-LA. The courtship—and later engagement—was a secret one, as Gladys was from a society family, and his notorious reputation made him an unacceptable match for her.[19] Though Florence, Gladys's sister, aided and abetted the lovers, and Gladys's mother also came around to their side, no concrete plans for a wedding were made.

Slinkard's romantic life was not bound to a strictly heterosexual sphere: throughout his career in the arts, he was involved in deeply passionate relationships with men. Carl Sprinchorn, whom Slinkard had met while a student of Henri, was his most important male lover.[20] Marsden Hartley, a close, lifelong friend of Sprinchorn's, described the relationship between Slinkard and Sprinchorn as "one of those classical matters," surely an allusion to the "Greek" (shorthand in that period for homosexual) aspects of their romantic friendship.[21] Across physical distance and throughout the most artistically significant years of Slinkard's life (even when Slinkard was involved with women), the two men engaged in an exchange of erotic letters, photographs, and mementos. When Sprinchorn followed Slinkard to California to run the ASL-LA after the scandal with Jesse prompted Slinkard's resignation, the two men were able (despite Slinkard's public status as an exile) to see each other frequently.

In 1916, Slinkard had a series of compelling, intimate portrait photographs taken by the internationally known photographer Louis Fleckenstein (1866–1943), who, along with Edward Weston and Margarethe Mather, had formed the Camera Pictorialists Group of Los Angeles.[22] Slinkard must have liked the photos—which gave him the rough-but-sensitive workingman's look later perfected by the young Marlon Brando and James Dean—because he distributed them liberally to his friends and lovers (see cover and FIG. 44). Meanwhile, the nation was gearing up for war, and young men between the ages of twenty-one and thirty were told that they would, for the first time in the nation's history, need to register for selective service. Slinkard did not want to go to war and was confident that the hernia that constantly bothered him would render him unfit for service in the Army.[23] For this reason, when his student and friend Nick Brigante attempted to persuade him to volunteer with him for a calvary brigade, he declined to do so, preferring instead to take his chances.[24] He registered for the draft on his thirtieth birthday, 5 June 1917. That summer, Gladys, Carl, and Rex formed an intimate threesome, spending days on end together and cherishing one another's company.

Slinkard was called to service in September 1917. He spent the final year of his life in the Army, first at Camp Lewis in Washington State, then at Camp Greene in North Carolina, and finally in New York City, where he was stationed through the summer of 1918 while waiting to be sent across the pond. During most of this time, Slinkard was physically unable to be assigned anything more than barracks duty; he was in and out of the hospital

with complaints of chronic appendicitis, scarlet fever, and pneumonia. He had heard that he would be discharged from service, but that never came to pass.[25] He wrote to his friends often, frequently declaring his love for both Carl and Gladys, and encouraged them to write to one another. The two of them commenced a correspondence, cementing their unique relationship; it was one that would culminate, in the coming years (surprisingly, perhaps, since Sprinchorn seems to have been otherwise exclusively involved—romantically—with men), with mutual declarations of love and an engagement to be married.[26] While Slinkard was stationed in New York City, he saw Sprinchorn often.[27] It was there that he contracted influenza, and he died, with Carl Sprinchorn at his side, on 18 October 1918.

Some version of this exceptional life story reached the ears of Slinkard's posthumous admirers before they ever saw the mysterious and beautiful paintings that comprised his most compelling work.[28] Among the first to hear of Slinkard's tragic death was the already well-known painter and poet Marsden Hartley, who had been friends with Carl Sprinchorn since 1915; the friendship would last throughout their lives. When Sprinchorn accompanied Rex's body back to Los Angeles, he invited Hartley to meet him there to assist in reviewing Slinkard's art and personal effects. Hartley had never personally known Slinkard, though he knew of the close relationship between Slink and Sprink (as they signed themselves); Carl had shared with him photographs of Rex, sketches of his work, and a series of beautiful letters.[29] Over the course of two months, the men assembled a selection of Rex's work for a memorial exhibition to be held in Los Angeles that June, carefully deciding which pieces to include and which to exclude, and Hartley wrote a moving foreword to the catalogue.[30] Hartley was very proud of the essay, which he reprinted in his 1921 collection, *Adventures in the Arts*, and which has been excerpted widely in exhibition reviews since its initial publication.[31] This authoritative and influential assessment of the paintings, the letters, and the man himself had a particularly Whitmanic resonance, one that continues to influence our understanding and appreciation of them today.

Hartley's experience of reading Slinkard's letters and viewing his drawings was one of immediate attraction and, undoubtedly, identification. Slinkard was a beautiful youth, one Hartley imagined that he could have, might have, been. In Slinkard's writings and art, Hartley saw him as "a young boy of light walking upon real earth over which there was no shadow for him. He walked straight-forwardly toward the Elysium of his own very personal organized fancies."[32] The memorial exhibition catalogue essay describes an artist who was Hartley's kindred spirit: Slinkard was "the calm declaimer of the life of everlasting beauty" who "saw with a glad eye the 'something' that is everywhere at all times, and in all places." Hartley wrote admiringly, "He had found his Egypt, his Assyria, his Greece, and his own specific Nirvana at his feet everywhere."[33]

Sprinchorn and Hartley selected around two dozen pieces for the memorial exhibitions, constituting a group of an incomplete body of work in both senses of the phrase. Most of these are ecstatic Western landscapes, peopled and inhabited by creatures of symbolic meaning: naked, alabaster youths, young stags, wild horses, and imagery suggestive of Catholic ritual.[34] Many of the paintings are dark-toned, yet even these emit a phosphorescent, almost otherworldly glow, an effect emphasized by the blurred, deliberately obscured features of the ubiquitous young men's faces and the hazy outlines of their bodies.[35] *Los Angeles Times* art critic Arthur Millier described them as "fragmentary works" that "show [Slinkard] feeling his way toward a cosmogony of ideal beings, beautiful young men and women, half-veiled creatures of the spirit, expressive creations of a nature that felt in the common stuff of life the whirring of angelic wings."[36] In these pieces, skin and body dissolve into landscape, negating human individuality; figures are provisional, dream-creatures set in a mythical, yet distinctly Western, landscape. There is an almost inescapable sense that Slinkard's paintings are palimpsests: sketches of unfinished figures hover close to the surface, unrealized, or perhaps realized but then taken away again (FIG. 47).

Hartley's description of Slinkard's art communicates both his admiration for and bewilderment aroused by the paintings: "He was searching for a majesty beyond sensuousness, by which sensuous experience is transformed into greater and more enduring shades of beauty. He wanted the very life

Fig. 47 **Ultimate Reunion**, c. 1915–16
Oil on canvas, 34¼ × 48¾ in.
[Cat. no. 10]

of beauty to take the place of sensuous suggestion. Realities in place of semblances, then, he was eager for, but the true visionary realities as far finer than the materialistic reality." Hartley's fairly indecipherable prose is a fair companion to the artworks themselves: symbolic, luminous, and suggestive of something not quite representable in the real, material world, full of the "meaning of magic and the meaning of everlasting silences" available, as if articulated in a secret language, "only to a few of us who understand."[37] Sensuous, visionary, beautiful, simple: these qualities reminded Hartley of Whitman, who provides his essay's epigraph: "I doubt not that the passionately wept deaths of young men are provided for."

In imagining Slinkard's kinship with Whitman, Hartley could convey with somewhat more specificity the "electricity" and "sensuousness" they shared; the references to Whitman—both explicit and oblique—function within an established homosexual tradition in which "allusions can serve as code references" that signal both Hartley's and Slinkard's queerness.[38] Indeed, Hartley's infatuation with Slinkard derived at least in part from his appreciation of the language of male-male love, one that was both spiritual and quite decidedly physical, evident in Slinkard's letters to Carl Sprinchorn:

> *Well! You dear old fellow*. A print of a string of young naked
> Greeks. One of the Greek Gods. A print of a German. By John.
> And a little wooden man of mine. Some heather from across
> the sea. And myself. All thinking of you. Night. I linger on the
> same. It sounds fine. . . . Another night. Weeks after. I've been
> lying here with nothing on. Looking at myself. Seeing nothing but my legs. How sincere the working. How beautiful the
> muscles, the bones and the running together of it all.[39]

The secret language, the personal idiom, through which Slinkard's paintings seem to express themselves is clear in this letter. Rapturously, lyrically, Slinkard sings the body electric, a body he describes explicitly and erotically for Sprinchorn. The passionate exchange was mutual: Sprinchorn responded in kind, sending Slinkard erotic art and photographs, including one of himself, nude, on a beach in France.

Male-male love and physical desire are openly avowed in these letters and suggested in the paintings that feature lonely male figures lingering at night or coupled in sylvan paradises (FIG. 48; see also FIGS. 34 and 35). *Young Rivers* (see FIG. 30) communicates the idealized beauty of homosexual love. Slinkard described it quite plainly:

> This painting is a decoration. Its background-top is of green
> bushes, waterfalls and pools, and rock. Then coming on down,
> more rocks, water running between the water-smoothed rocks

which are oval-shaped everywhere—with pools of cold, clear water, some above some below one another. And all coming down and moving to the right. In the center of the canvass, moving up and down, and to the right are two white boys on two white boy-horses, then two boys moving across, and a little up. And then a white deer with long listening horns, and he is listening, hesitating, and moving down, one foot in a pool of purple water, which is hesitating, but running. And then a little up, and down, a girlish boy—a back view, arms folded above and in back of head. Head is turned sideways and looking directly out of canvass to the right. The legs and back are stretched up and forward. Then moving on down, there are rocks and water that are of the same quality as all above. Then comes a large pool of clear blue water and at the left a goat running and jumping the pool. And the pool has the same movement as the figures and water above. And then at the extreme left is a 3-stemmed, stripped bush which takes the gesture of the girlish boy above, at the extreme right. And, you have the picture.[40]

The twinned boys, like the bush that mirrors the girlish boy, evoke the Narcissus myth as well as the twins Castor and Pollux, recognizable icons

Fig. 48 **Infinite**, c. 1915–16
Oil on canvas, 26 × 30¼ in.
[Cat. no. 6]

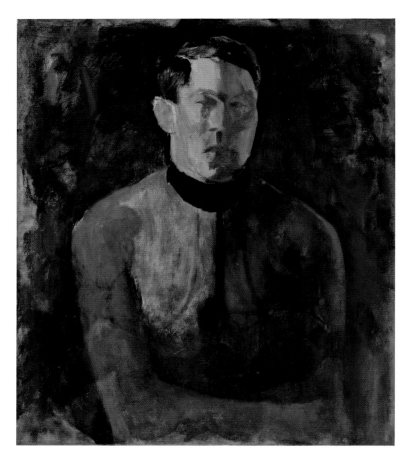

of homosexuality in Western art. The stag and the goat, representing Diana and Pan, also are familiar symbols of sexual difference (Diana as chaste and Pan as randy); these echo figures from Greek sculptures described in Adolf Furtwängler's *Masterpieces of Greek Sculpture*, which Carl and Rex pored over together.[41] Without seeing the painting himself, Sprinchorn could divine from Slinkard's description that *Young Rivers* was to be read as a queer idyll. More suggestively, though, the streaming and moving water—really, the kinetic energy of the painting as a whole, mirrored by Slinkard's description of it—indicates that movement itself is homoerotic.[42]

Slinkard's claim that his "intention in this canvas is far from [his] surroundings" indicates the suggestive, symbolic, and psychological character of his paintings.[43] He achieved the effect of fantasy, in part, by painting over previous works so that the most visible subject competed with—or complemented—another, less apparent one. While many artists painted over previous works, conserving their canvases for monetary reasons, Slinkard's methods of overpainting were unusual. He did not attempt to entirely cover his previous paintings but seems to have deliberately left traces visible beneath the subsequent paintings. For example, in the *Self-Portrait* that Carl Sprinchorn owned (FIG. 49), the ostensible subject, Rex's face and clothing, is sketchily painted; it seems only minimally covered by the bust. A close examination reveals a sylvan scene with a standing male nude peeking through the surface, perhaps suggesting an inner psychic landscape of the artist's mind peopled by homosexual, erotic fantasies. This painting is not very different from *The Young Priest*, which could easily be its companion piece (see FIG. 21). In this work, the figures behind the priest are slightly more visible, yet still seem to be intentionally obscured. The priest's pensive look suggests that these figures are not real people standing in a real background, but rather figures from memory or dreams that loom large in the man's consciousness.[44]

Hartley and Sprinchorn reinforced the provisional, ephemeral quality of many of Slinkard's paintings by including in the memorial exhibitions an array of true sketches, a number of which were made on the back of Army camp or YMCA stationery, with the identifying letterhead visible[45] (FIGS. 50–52). These sketches, certainly already fading and

Fig. 49 **Self-Portrait**
Oil on canvas, 30 × 26 in.
[Cat. no. 26]

crumbling in 1919 due to the poor-quality paper and ink, seemingly were meant not for posterity or exhibition but for private consumption only.[46] Their typical subject matter—languid young men at ease with one another—suggests a private, quiet intimacy between men forged in all-male environments: a secret, otherworldly space. Slinkard's notes to himself along the margins, such as "remember in the Great Pines" and "what many don't know," affirm the presence in the sketches of something even the artist could not capture, something that Slinkard wanted to evoke. These sketches complement the paintings, adding to the mysterious mood and sense of secrecy that might be linked with the Symbolist mode and its connection to the love that dare not speak its name.[47]

Sprinchorn and Hartley's curation of the Slinkard oeuvre was highly selective in terms of both subject and style, and their selections have shaped our understanding of Slinkard's work. Curation, of course, virtually defines the way an artist's reputation is formed and transmitted.[48] What may be surprising about Hartley and Sprinchorn's creation of a particular sort of Rex Slinkard—the "soldier, poet-painter by inclination, and ranchman as to specific occupation"—is that they seem to have deliberately chosen those works that, "for a few of us who understand" (to again use Hartley's words), represent a distinctively queer spiritual passion.[49] Works that did not fit into this schema were excluded from the memorial exhibitions. Among those excluded were the heavily worked, dark, realist paintings in the Henri mode that were exhibited in Slinkard's lifetime, such as

Patty Flanigan [sic] and The Hobble Sisters (both whereabouts unknown).[50] While Sprinchorn in particular made much of the development and maturation of Rex's style, rejecting everything considered to be "early Slinkard," style and date alone did not guide the curatorial process. Excluded as well were all depictions of women, including the fairly overwrought portraits of Jessie and Gladys, some of which could be identified as produced in the "early Slinkard" years and others as "late Slinkard."[51] The paintings that they chose, rather, suggest the isolation of the queer self in the world, that of the marginalized or ostracized denizen of the night. For Hartley and Sprinchorn—and, perhaps, for their ideal audience—these works indicated more than a "retreat into the life of the imagination"; they were an

Fig. 50 **Rain on the Roof Tops**
Pen and wash in blue ink on paper, 8⁷/₁₆ × 11 in.
[Cat. no. 246]

Fig. 51 **What Many Don't Know**
Pen and blue ink on paper, 3⁹/₁₆ × 7⁵/₁₆ in.
[Cat. no. 213]

Fig. 52 **Study for *Self-Portrait in the Pines***
Pen and wash in blue ink on paper,
5¹/₈ × 8¹/₄ in.
[Cat. no. 231]

attempt to realize in art a beautiful, accepting place for a community of men loving one another that is only sometimes glimpsed in the actual world.[52] In their own, somewhat obscure idiom, these paintings "speak for vice,"[53] to use the phrase of the painter Charles Demuth, Slinkard's contemporary.

Strikingly, Hartley spends very little of the essay discussing Slinkard's art, stating flatly that "there will be no argument to offer or to maintain regarding the work of Rex Slinkard. It is what it is, the perfect evidence that one of the finest lyric talents to be found among the young creators of America has been deprived of its chance to bloom."[54] Rather, Hartley focuses on what he thought of as Slinkard's "spirit and purpose": his exuberance, simplicity, and transcendent love of humanity and earth.[55] For Hartley, Slinkard's "clear vision of life" emerged most concretely in his correspondence and marginalia, and it is his lyric gift—particularly in writing—that demonstrates his "genius."[56] He quotes a fragment of a letter from Slinkard to Sprinchorn, written from the ranch at Saugus: "The day's work done and the supper past. I walk through the horse-lot and to my shack. Inside I light the lantern, and then the fire, and sitting, I think of the inhabitants of the Earth, and of the World, my home."[57] Hartley describes such sentiments as "the simple speech of a ranchman of California, a real boy-man who loved everything with a poet's love because everything that lived, lived for him."[58] His writing served as evidence of the "radiance and simplicity immingled in [Slinkard's] sense of things,"[59] an essentially Whitmanic way of being. Hartley's assessment of Slinkard's painting, writing, and life seems to salute the young artist, echoing the sentiments of Ralph Waldo Emerson's well-known response to Whitman's *Leaves of Grass*, "I give you joy of your free and brave thought. I have great joy in it. I find incomparable things said incomparably well, as they must be. I find the courage of treatment which so delights us, and which large perception only can inspire."[60]

Hartley's invocation of Whitman tapped into a passion shared by many Americans at the time: Whitman was, perhaps, at the height of his popularity in the early twentieth century. By his own admission, Hartley was "all Whitmanic" during the prewar years: he had painted Whitman's house, owned a large collection of Whitman memorabilia, and knew his writings by heart.[61] Yet Hartley's enthusiasm for Whitman only surpassed that of many of his contemporaries—of all sexual persuasions—by a matter of degrees.[62] The disciples of Whitman made for strange bedfellows indeed, as they represented a range of "moderns," including those belonging to socialist and anarchist circles, bohemians and artists, homosexuals (to the degree that this identity existed as such at the time), and—particularly during and just after wartime—fervent American patriots.[63] The "Whitmanic ideal" celebrated simple, clear expression; the working man; "native" American forms and ideas; resistance to a stuffy, "Puritan" morality

(especially regarding sexual matters); and fearless experimentation as an artist. The Whitmanesque thus included an array of aesthetic choices, from the gritty, urban aesthetic prescribed by the realist Ash Can school to the mystical symbolism of Hartley's *New Mexican Recollections #12* (Austin, Blanton Museum of Art), from the "straight" photography of Stieglitz's *Camera Work* to the effusive lyricism of Edna St. Vincent Millay. The diverse set of compelling qualities that Whitman seemed to represent made it easy for many to admire him, and, by extension, Slinkard. As one early reviewer noted, echoing Whitman's well-known lines, "[Slinkard] did not loaf at Saugus, but he invited his soul after days of hard labor on the ranch, and in the cellar of the ranch house, where he withdrew to paint, were stored the wonderful records of what his soul had to say to him."[64]

Those who admired Slinkard were also, invariably, lovers of Whitman. These fans included Slinkard's mentor and teacher, Robert Henri, who was known to read Whitman's poetry aloud to his classes in New York City (and thus may have introduced Slinkard to Whitman's work), and William Carlos Williams and Robert McAlmon, who published excerpts from Slinkard's letters in every issue of *Contact*.[65] Slinkard thus became the most published "author" in the magazine, garnering more space than such modernist luminaries as E. E. Cummings, H.D., Mina Loy, Marianne Moore, Wallace Stevens, and even Williams himself.[66] Williams explained his fervor for Slinkard in an essay published in the Spring 1921 issue of *Contact*, titled "Yours, O Youth" (the words were borrowed from one of Slinkard's letters). To his question "What is it I see in Rex Slinkard's letters?" he answers, "the unironic, the unbent vision of youth." He continues, "In this case it is a full release without sacrifice of intelligence. There is an abundance of fresh color but presented without the savage backbite of a Degas using pinks and blues. It is all very young, this man's writing about his painting; it is what I recognize as in some measure definitely and singularly American."[67] Like Hartley, Williams saw in Slinkard what he hoped others would see in himself: clarity, innocence, passion, sincerity, simplicity, and raw beauty. He envisioned Slinkard as he envisioned himself, the quintessential American artist: striving nobly toward art in a wilderness, unacknowledged by his countrymen, yet undaunted and persevering nonetheless.

Ironically, it was Slinkard's untimely death that catapulted him into the modernist limelight, giving the legend of Slinkard a momentum he could not have dreamed of in his lifetime. He was roundly viewed as a young artist just coming into his own. Only a glimpse of what he might have achieved was visible in the small body of work that he left behind. Yet the testimony of Hartley, Williams, and other fellow artists (including Robert Henri, George Bellows, Stanton Macdonald-Wright, Mabel Alvarez, Carl Sprinchorn, and Nick Brigante) asserts that these few pieces were

indications of a powerful, unique talent.[68] Like the American artists Van Wyck Brooks described in his definitive essay, "On Creating a Usable Past," Slinkard suffered a too-typical fate, ignored by an insensitive and unappreciative wider American culture and ultimately dying a virtual unknown.[69] It was a theme many artists and cultural critics of this period would return to.[70] According to these men, America simply did not value its artists highly enough, giving priority instead to scientists and businessmen, and thus American art floundered.

Hartley's memorial to Slinkard and his lifelong obsession with him—a man he never met—may be partly attributed to his feelings for another recent war casualty: the love of his life, a young German officer named Karl von Freyburg, had died in World War I.[71] While Hartley is sometimes thought of as having been enamored of the military (especially in light of his "Amerika" paintings), he abhorred war. As he wrote to Nick Brigante on the eve of World War II, "we are slipping off the cliff into another war any minute perhaps, tho' last night's radio news seemed a little more hopeful—it seems dreadful to me that in this civilized age, war would be such an obsession. But 'they say' who think they know that war is a natural function & always will be & all I can think of is the shipping off of all the strong healthy beautiful lads to slaughter 'em down—pin a medal on 'em & kill 'em. God!"[72]

As one of many "strong healthy beautiful lads" who had died during the Great War, Slinkard served as a representative of a generation lost.[73] The tragedy of such a loss was keenly felt in the years immediately following Slinkard's death, particularly by the intelligentsia. While most Americans rallied around the flag once the United States became involved, the war was never popular. Even during wartime, critics such as Randolph Bourne argued volubly that "war is the health of the state."[74] After the war, the sense of betrayal became magnified, among both the general populace and the avant-garde, who imagined their disillusionment with America mirrored that of the soldiers. In the words of expatriate poet Ezra Pound, the boys had

> walked eye-deep in hell
> believing in old men's lies, then unbelieving
> came home, home to a lie,
> home to many deceits,
> home to old lies and new infamy.[75]

"The promise-breaker war," as Slinkard's (and Pound's) fellow Westerner Robinson Jeffers called it, was proof positive that the nation was "tired and corrupt": "Culture's outlived, art's root-cut . . . / Only remains to invent the language to tell it."[76] The legend of Slinkard coincided with Americans'

disenchantment with the national government that had sent its citizenry unwillingly to war, ostensibly to salvage Western culture (which Pound infamously characterized as an "old bitch gone in the teeth"[77]) and promote democracy and peace. That Slinkard was an unwilling warrior, a draftee who never actually saw the front (he died before shipping out), was overlooked by his memorializers. In their eyes, he, too, was a war casualty whose death amounted to "another charge against the crime of war."[78] His memorialization was a part of the avant-garde's criticism of both the recent war and the U.S. government more broadly—though this criticism was not limited to the avant-garde. The opening lines of the *New York American*'s review of the Slinkard memorial exhibition expressed a typical sentiment among the admirers of the show: "Many in the great war laid their lives on their country's altar; Rex Slinkard, rare painter and dreamer of dreams, laid his genius there. And that this country may know the full measure of the sacrifice—and of her loss—[a selection of his works] are now on view at the Knoedler Galleries."[79]

Like the Symbolist art he was producing at the end of his life, "Slinkard" represented something intensely personal and deeply felt that was much larger and grander than the artworks themselves could ever have been. As Robert Henri used to tell his classes, "Walt Whitman was such as I have proposed the real art student to be. His work was an autobiography—not of haps and mishaps, but of his deepest thought, his life indeed."[80] Rex Slinkard's life, his work, and his deepest thought became fodder for the legend, which in turn came to have a life and meaning of its own. As *Los Angeles Times* art critic Antony Anderson, in his review of the first memorial exhibition of Slinkard's work, proclaimed, "When death claims an artist . . . his dream becomes ours."[81]

NOTES

The author would like to thank many people who, in ways both small and large, encouraged me in my research for this project and contributed their wisdom and expertise to this essay, including Bernard Barryte; Terry Castle; Wanda Corn; Cindy Criner; Michael Devine; Charles C. Eldredge; Nancy H. Ferguson; Estelle Freedman; Jennifer Marshall; Joshua Paddison; Gail R. Scott; Stephen Slinkard; Brenda Steeves from the Fogler Library, University of Maine, Orono; and Patience Young.

1 Bram Dijkstra, "Early Modernism in Southern California: Provincialism or Eccentricity?" in *On the Edge of America: California Modernist Art, 1900–1950*, ed. Paul J. Karlstrom (Berkeley: University of California Press, 1996), 161.

2 Slinkard's letters appeared as "Letters of Rex Slinkard," *Contact* 1 (December 1920): 2–4; "Extracts from Letters," *Contact* 2 (January 1921): 3; and "Rex Slinkard's Letters," *Contact* 3 (Spring 1921): 1–8. His drawings were reproduced in vol. 70 (June 1921) of *The Dial*.

3 Marsden Hartley to Nick Brigante, 17 September 1938, typescript,

3; Carl Sprinchorn Papers, Special Collections, Raymond H. Fogler Library, University of Maine/Archives of American Art, Smithsonian Institution (hereafter AAA), microfilm reels 3004–14.

4 Moore's assessment of Slinkard's sketches is notably ambivalent. These sketches were published (alongside work by W. B. Yeats, Mina Loy, T. S. Eliot, John Dos Passos, and other notable modernists) in June 1921 when Moore was a regular contributor to *The Dial*. Marianne Moore to Carl Sprinchorn, 5 January 1947, 2; Carl Sprinchorn Papers, Special Collections, Raymond H. Fogler Library, University of Maine/AAA, microfilm reels 3004–14.

5 Arthur Millier, "Slinkard Memorial Exhibit," *Los Angeles Times*, 10 March 1929, ll 16; Marsden Hartley to Nick Brigante, 17 September 1938, typescript, 5, Carl Sprinchorn Papers, Special Collections, Raymond H. Fogler Library, University of Maine/AAA, microfilm reels 3004–14.

6 Carl Sprinchorn, "Rex Slinkard: A Biographical-Critical Study of His Life, Paintings and Drawings," unpublished biography; Rex

Slinkard Papers, Cantor Center for the Visual Arts, Stanford University (hereafter CCVA), 2.

7 Though Carl Sprinchorn was skeptical that Rex really bartended at a (disreputable) waterfront saloon when a young man, the *Los Angeles Times* reported that Stephen Wall Slinkard did, in fact, own and operate a saloon in the "terminal" district of San Pedro, California, during 1903, and possibly later as well. See the *Los Angeles Times*, 12 May 1903; also see an advertisement in the *Los Angeles Times*, 7 August 1904.

8 Carl Sprinchorn, "Rex Slinkard," 7.

9 Ibid., 6.

10 Ibid.

11 Doris Alexander, *Eugene O'Neill's Last Plays: Separating Art from Autobiography* (Atlanta: University of Georgia Press, 2005), 29.

12 "Sues Parents-In-Law for Fifteen Thousand," *Los Angeles Times*, 28 February 1913. The article illustrated the tense relationship between Rex and his father: Stephen Slinkard is quoted as saying, "When my son's wife complained to me that he had left her without support I informed her that he was not capable of taking care of himself. . . . I buy all his clothes and furnish him with money. He's a dreamer and not a money-maker. I advised her to get a divorce and I furnished her with money for a while on the condition that she do so."

13 Nicholas Brigante to Marsden Hartley, 29 April 1942, typescript, 3, Carl Sprinchorn Papers, Special Collections, Raymond H. Fogler Library, University of Maine/AAA, microfilm reels 3004–14; quote from John Alan Walker, "Rex Slinkard (1887–1918): Pioneer Los Angeles Modernist Painter," *The Los Angeles Institute of Contemporary Art Journal*, no. 3 (December 1984): 23.

14 Carl Sprinchorn, "Rex Slinkard," 20.

15 " 'Nymph' Asks Divorce From Absent Artist," *Los Angeles Times*, 4 July 1913; "Sues Parents-In-Law for Fifteen Thousand." Augsbury's family, to this day, reports that Jessie never saw any money from the Slinkards. Phone interview with Cindy Criner, 2 July 2009.

16 According to Marsden Hartley, Carl Sprinchorn saw Maurice Rudy at age two "and he was the image of Rex." Marsden Hartley to Nick Brigante, n.d. [c. October 1938], typescript, 6; Carl Sprinchorn Papers, Special Collections, Raymond H. Fogler Library, University of Maine/AAA, microfilm reels 3004–14. Slinkard told friends and family that he was not the child's father, asserting that it was merely a "one-sided marriage of convenience": he "simply wanted the child to have a father." Sprinchorn, "Rex Slinkard," 22. This claim seems unlikely, as Slinkard signed both the marriage certificate and the birth certificate (also signed by Jessie), and no record of a divorce seems to exist.

17 Carl Sprinchorn note appended to letter fragment from Rex Slinkard, [c. January or February 1913 (Sprinchorn's dates)]; Carl Sprinchorn Papers, Special Collections, Raymond H. Fogler Library, University of Maine/AAA, microfilm reels 3004–14.

18 Sprinchorn, "Rex Slinkard," 21–24.

19 According to Carl Sprinchorn, Slinkard was not permitted in the Williams house from about 1913 to 1916. Carl Sprinchorn note appended to letter fragment from Rex Slinkard, [c. January or February 1913 (Sprinchorn's dates)]; Carl Sprinchorn Papers, Special Collections, Raymond H. Fogler Library, University of Maine/AAA, microfilm reels 3004–14.

20 Nancy Dustin Wall Moure romantically links Slinkard with the California Postimpressionist artist Jack Gage Stark, who shared a studio with Slinkard in Los Angeles. Moure, *California Art: 450 Years of Painting and Other Media* (Los Angeles: Dustin Publications, 1998), 107.

21 Marsden Hartley to Nicholas Brigante, 17 September 1938, typescript, 3; Carl Sprinchorn Papers, Special Collections, Raymond H. Fogler Library, University of Maine/AAA, microfilm reels 3004–14.

22 Fleckenstein was one of the best-known portraitists working in Los Angeles at the time, having been involved in a number of salons before arriving in the city. Michael Dawson, "Photography: South of Point Lobos," in *LA's Early Moderns: Art, Architecture, Photography*, eds. Deverell, Dailey, Dawson, and Shivers (Glendale, CA: Balcony Press, 2003), 210; Michael G. Wilson and Dennis Reed, *Pictorialism in California* (Malibu, CA: J. Paul Getty Museum; San Marino, CA: Henry E. Huntington Library and Art Gallery, 1994); and Stacey McCarroll, *California Dreamin': Camera Clubs and the Pictorial Photography Tradition* (Boston: Boston University Art Gallery, 2004).

23 Nicholas Brigante to Marsden Hartley, 29 April 1942, typescript, 9; Carl Sprinchorn Papers, Special Collections, Raymond H. Fogler Library, University of Maine/AAA, microfilm reels 3004–14.

24 Ibid.

25 Gladys Williams to Carl Sprinchorn, 3 January 1918; Carl Sprinchorn Papers, Special Collections, Raymond H. Fogler Library, University of Maine/AAA, microfilm reels 3004–14.

26 One might speculate that the classical element of the relationship between Sprinchorn and Slinkard had an almost mythical dimension, forcefully recalling Castor and Pollux, the twin brothers who were so devoted to one another: first the professional "death" and later the physical death of Slinkard prompted the assumption of his roles (as director of ASL-LA and as fiancé to Williams) by Sprinchorn. The repeated images in Slinkard's art of sailors and horsemen (Castor and Pollux were patron gods of both) likewise encourage such a reading.

27 Carl Sprinchorn, "Date Decl. of Int. Dec. 24/1935," typescript; Carl Sprinchorn Papers, Special Collections, Raymond H. Fogler Library, University of Maine/AAA, microfilm reels 3004–14.

28 Only four of Slinkard's paintings were shown since his 1910 exhibition in the studios at the ASL-LA: *Christmas, Easter, Young Rivers,* and *Tehachapi,* and only the latter two are known to be extant. These were exhibited at the MacDowell Club in New York City with paintings by Robert Henri, George Bellows, Leon Kroll, John Sloan, and others, 18 February–2 March 1919. *Exhibition of Paintings and Sculpture,* exh. cat. (New York: MacDowell Club, 1920); Carl Sprinchorn Papers, Special Collections, Raymond H. Fogler Library, University of Maine, box 1896, file 80.

29 One might wonder, though, if Slinkard knew Hartley's work. Hartley's first exhibition, under the auspices of Alfred Stieglitz, was held in 1909, when the young bohemian was living the life of the artist in New York City.

30 The most mysterious and symbolic works were selected for exhibition, while the life-sized portraits of women (possibly including those of Jessie Augsbury), painted in the palettes of Goya and Whistler, were discarded as either retrograde or too large; some ended up as fencing for Stephen Slinkard's chicken coop.

Sprinchorn, "Rex Slinkard," 26; also Carl Sprinchorn to Nick Brigante, 9 December 1929, 4, Carl Sprinchorn Papers, Special Collections, Raymond H. Fogler Library, University of Maine/ AAA, microfilm reels 3004–14). A few of these seem to have been preserved, worse for the wear, and are now in the possession of Stephen Slinkard, Davis, CA. A very large, erotically charged male nude—recalling those by Slinkard's contemporary, John Singer Sargent—survived in good condition and is currently with Spencer Jon Helfen Fine Arts, Beverly Hills (FIG. 8).

31 Marsden Hartley, "Rex Slinkard," *Adventures in the Arts: Informal Chapters on Painters, Vaudeville, and Poets* (New York: Boni and Liveright, 1921), 87–95.

32 Ibid., 90.

33 Ibid., 93.

34 These subjects are familiar ones within the Symbolist canon, which formally and topically overlapped with both the iconography of homosexuality and its common formal features. See Marcia Brennan, *Painting Gender, Constructing Theory: The Alfred Stieglitz Circle and American Formalist Aesthetics* (Cambridge, MA: MIT Press, 2001), 156–201; Charles J. Summers, ed., *The Queer Encyclopedia of the Visual Arts* (San Francisco: Cleis Press, 2004); and Jonathan Weinberg, *Speaking for Vice: Homosexuality in the Art of Charles Demuth, Marsden Hartley, and the First American Avant-Garde* (New Haven and London: Yale University Press, 1993).

35 Such sculptural works were nods to some of the painters Slinkard greatly admired and mentioned frequently in his letters, including Botticelli, Puvis de Chavannes, Fra Filippo Lippi, and others.

36 Arthur Millier, "Daumier Lithographs Seen," *Los Angeles Times*, 10 November 1929.

37 Hartley, "Rex Slinkard," 87.

38 Robert K. Martin, *The Homosexual Tradition in American Poetry* (Iowa City: University of Iowa Press, 1998), 134. Martin also claims that Whitman was the central gay figure for poets of the twentieth century.

39 Rex Slinkard to Carl Sprinchorn; reprinted in "Letters of Rex Slinkard," *Contact* 3 (Spring 1921): 2; also reprinted in Hartley, "Rex Slinkard," 87.

40 *Contact* 3 (Spring 1921): 1.

41 Slinkard and Sprinchorn's shared interest in the classics—particularly the Greeks—was literal (as the references to Adolf Furtwängler's *Masterpieces of Greek Sculpture* [1895] show), but this interest was also a coded reference to homosexuality, as Marsden Hartley's euphemistic comment to Nick Brigante was surely intended: "The friendship of Carl and Rex was one of those classical matters." Marsden Hartley to Nick Brigante, 27 August 1939, typescript, 3; Carl Sprinchorn Papers, Special Collections, Raymond H. Fogler Library, University of Maine/AAA, microfilm reels 3004–14; Carl Sprinchorn to Rex Slinkard, 25 February 1914; private collection of Stephen Slinkard, Davis, CA.

42 A much more involved consideration of water and male homosexual desire in American art can be found in Jonathan Weinberg, *Male Desire: The Homoerotic in American Art* (New York: Abrams, 2004), 13–33.

43 Rex Slinkard to Carl Sprinchorn, n.d. [c. September 1916]; reprinted in *Contact* 3 (Spring 1921): 1.

44 Charles C. Eldredge's pioneering account of American Symbolism shows that memory and dreams were central topics of explo-ration; Slinkard fits squarely into this schema. Eldredge, *American Imagination and Symbolist Painting* (New York: Grey Art Gallery and Study Center, 1979).

45 The YMCA, as the Village People told the world in 1977, was a notorious site for male-male hookups: Chauncey affirms that "by World War I, the YMCAs in New York and elsewhere had developed a reputation among gay men as centers of sex and social life." Soldiers and sailors were part of the popular gay iconography, as the works of Slinkard's contemporaries, Charles Demuth and Paul Cadmus, illustrate well; Slinkard's status as a soldier and his real-world connection to the homosocial space of the military camp undoubtedly signaled a homoeroticism to those viewers who would or could see it. In electing to include this stationery, Hartley and Sprinchorn were affirming the homosocial and homoerotic quality of Slinkard's work. Jason Goldman, "Subjects of the Visual Arts: Sailors and Soldiers," in *The Queer Encyclopedia of the Visual Arts*, 319–20; and George Chauncey, *Gay New York: Gender, Urban Culture, and the Making of the Gay Male World, 1890–1940* (New York: Basic Books, 1995), 155.

46 As Jonathan Weinberg explains, "Paintings about homosexuality made use of certain disguises that were meant to be uncovered only by a particular audience." Weinberg, *Speaking for Vice*, 19.

47 Emmanuel Cooper identifies the Symbolist movement as a gay movement in art as well as literature. Cooper, *The Sexual Perspective: Homosexuality and Art in the Last 100 Years in the West* (New York: Routledge, 1994), 126–27. See also Kieron Devlin, "Symbolists," in *The Queer Encyclopedia of the Visual Arts*, 325–27.

48 In her landmark book, *The Great American Thing*, Wanda Corn examines how the way an artist's gender and sexuality was understood greatly affected the critical reception of his or her work. Her text is a model for the argument I am developing here. Other treatments of the "curation" of an artist's reputation include Corn's discussion of the curation of Stieglitz, Tyrus Miller's consideration of Hartley, and Sarah Greenough's and Marcia Brennan's reflections on O'Keeffe. Corn, *The Great American Thing: Modern Art and National Identity, 1915–1935* (Berkeley: University of California Press, 1999); Miller, "Ridiculously Modern Marsden: Tragicomic Form and Queer Modernity," in *Modernist Cultures* 2 (Winter 2006): 87–101; Greenough, *Modern Art in America: Alfred Stieglitz and His New York Galleries* (Washington, D.C.: National Gallery of Art, 2000); and Brennan, *Painting Gender, Constructing Theory*. For more general discussions of the ideological implications of curation, see Steven C. Dubin, *Displays of Power: Memory and Amnesia in the American Museum* (New York: New York University Press, 1999); Dorothee Richter et al., "Thirty-one Positions on Curating," *ONCURATING.org* 1 (2008): 1–9; and Mary Anne Staniszewski, *The Power of Display: A History of Museum Exhibitions at the Museum of Modern Art* (Cambridge, MA: MIT Press, 1998).

49 Hartley, "Rex Slinkard," 87.

50 *Patty Flanigan* (of a "street gamin") was part of the 1910 show, as was *The Hobble Sisters*, alongside others that seemed, by their descriptions, to fit more squarely into the Symbolist or imaginative mode Slinkard worked in. Also showing at this exhibition were George Bellows, Carl Sprinchorn, and Percy S. Stafford, though Slinkard's work received, by far, the most notice. Antony E. Anderson, "Art and Artists," *Los Angeles Times*, 28 August 1910.

51 A developmental template for the curation of Slinkard's work strikes me as fairly awkward, since Slinkard's drawings and paintings seem to reflect a still-developing, groping technique that changed rapidly, even in his "mature" period. Moreover, virtually all of his few extant paintings—"early" and "late"—are dated from the brief period between 1912 and 1917.

52 Eldredge, *American Imagination*, 16.

53 Quoted in Weinberg, *Speaking for Vice*, 217.

54 Hartley, "Rex Slinkard," 88.

55 Hartley, "Rex Slinkard: His Spirit and Purpose," from Marsden Hartley Papers, Yale Collection of American Literature, Beinecke Rare Book and Manuscript Library, courtesy of Gail R. Scott.

56 Hartley, "Rex Slinkard," 88.

57 Ibid.

58 Ibid., 93.

59 Ibid., 90.

60 R.W. Emerson to Walt Whitman, 21 July 1855; reprinted in *Walt Whitman's Leaves of Grass*, ed. Malcolm Cowley (New York: Penguin, 1959), ix.

61 Quoted in Weinberg, *Speaking for Vice*, 133.

62 Ibid.

63 Waldo Frank, Ezra Pound, Malcolm Cowley, and others emphasized the American essence of Whitman, but, as Price and others have shown, Whitman did not merely signal Americanness. Ruth L. Bohan, *Looking into Walt Whitman: American Art, 1850–1920* (University Park, PA: Penn State University Press, 2006); Marcia Brennan, *Painting Gender, Constructing Theory*; Celeste Connor, *Democratic Visions: Art and Theory of the Stieglitz Circle* (Berkeley: University of California Press, 2000); Luther S. Harris, *Around Washington Square: An Illustrated History of Greenwich Village* (Baltimore: The Johns Hopkins University Press, 2003); Kenneth M. Price, *To Walt Whitman, America* (Chapel Hill: University of North Carolina Press, 2004); David S. Reynolds, *A Historical Guide to Walt Whitman* (New York: Oxford University Press, 2000); and Alan Trachtenberg, "Walt Whitman: Precipitant of the Modern," in *The Cambridge Companion to Walt Whitman*, ed. Ezra Greenspan (Cambridge: Cambridge University Press, 1995): 194–207.

64 Antony Anderson, "Of Art and Artists," *Los Angeles Times*, 8 June 1919.

65 *Contact* ran for only three issues between 1920 and 1921 before folding. It was resuscitated in a very different form, and with only qualified endorsement from Williams (and none from McAlmon), in 1930—again, for a short run.

66 Gladys Williams and Hartley were friends with McAlmon from his days in Los Angeles (he, too, was a "boy on the grid"), and the friendship undoubtedly helped ease Slinkard's way into print. Also of some help was the $100 Williams gave to McAlmon to defray the costs of publication of the letters and the reproduction costs of the paintings. Gladys Williams to Carl Sprinchorn, [c. 1920–21]; Carl Sprinchorn Papers, Special Collections, Raymond H. Fogler Library, University of Maine/AAA, microfilm reels 3004–14.

67 William Carlos Williams, "Yours, O Youth," *Contact* 3 (Spring 1921): 15.

68 See Ilene Susan Fort, "The Adventuresome, the Eccentrics, and the Dreamers: Women Modernists of Southern California," in *Independent Spirits: Women Painters of the American West, 1890–1945*, ed. Patricia Trenton (Los Angeles: Autry Museum of Western Heritage, 1995), 90. See also Stanton Macdonald-Wright in Antony Anderson, "Of Art and Artists," *Los Angeles Times*, 11 February 1923.

69 Van Wyck Brooks, "On Creating a Usable Past," *The Dial* 64 (11 April 1918): 337–41.

70 See, for instance, Waldo Frank, *Our America* (New York: Boni and Liveright, 1919); D. H. Lawrence, *Studies in Classic American Literature*, eds. Ezra Greenspan, Lindeth Vasey, and John Worthen (Cambridge: Cambridge University Press, 2003); H. L. Mencken, "Our National Letters," *Baltimore Evening Sun*, 23 January 1922); and Harold E. Stearns, ed., *Civilization in the United States: An Inquiry by Thirty Americans* (New York: Harcourt, Brace and Company, 1922).

71 Heather Hole, *Marsden Hartley and the West: The Search for an American Modernism* (New Haven, CT: Yale University Press, 2007), 45–47.

72 Marsden Hartley to Nick Brigante, 27 August 1939, typescript, Yale Collection of American Literature, Beinecke Rare Book and Manuscript Library; copy at Carl Sprinchorn Papers, Special Collections, Raymond H. Fogler Library, University of Maine/AAA, microfilm reels 3004–14.

73 Memorialization of the wartime dead was an industry at this time, both at home and abroad. See Willa Cather's Pulitzer Prize–winning novel, *One of Ours* (New York: Knopf, 1925; New York: Vintage, 1991); also see popular novels such as that by Percival C. Wren, *Beau Geste* (New York: Grosset and Dunlap, 1926). For analysis of these and the phenomenon of World War I memorialization more broadly, see Paul Fussell, *The Great War and Modern Memory* (Cambridge: Oxford University Press, 2000), and also Steven Trout, *Memorial Fictions: Willa Cather and the First World War* (Lincoln: University of Nebraska Press, 2002).

74 Randolph Bourne, "The State," in *War and the Intellectuals: Collected Essays, 1915–1919*, ed. Carl Resek (Indianapolis: Hackett Publishing, 1999), 71.

75 Ezra Pound, "Hugh Selwyn Mauberly" (London: The Ovid Press, 23 April 1920); reprinted in *Personae: The Collected Poems of Ezra Pound* (New York: New Directions, 1971), 188.

76 Robinson Jeffers, "Prelude," in *The Selected Poetry of Robinson Jeffers*, ed. Tim Hunt (Stanford, CA: Stanford University Press, 2001), 148.

77 Pound, "Hugh Selwyn Mauberly," 188.

78 Laura Bride Powers, "Rex Slinkard Canvases at Fine Arts Palace," *Oakland Tribune*, n.d.; copy in Carl Sprinchorn Papers, Special Collections, Raymond H. Fogler Library, University of Maine, box 1896, file 68.

79 *New York American*, 25 January 1920; Carl Sprinchorn Papers, Special Collections, Raymond H. Fogler Library, University of Maine, box 1896, file 68. See as well Henry McBride, "Rex Slinkard as War Superman and Poet," *New York Herald*, 25 January 1920; Carl Sprinchorn Papers, Special Collections, Raymond H. Fogler Library, University of Maine, box 1896, file 68.

80 Quoted in Gail R. Scott, *Carl Sprinchorn* (Farmington, ME: Tom Veilleux Gallery, 1994), 3.

81 Anderson, "Of Art and Artists."

CATALOGUE

All works entered the Cantor Arts Center collection
as the bequest of Florence A. Williams unless
otherwise noted. Works in chalk, charcoal, ink,
pastel, and pencil are on paper unless indicated
otherwise. Height precedes width in dimensions.
Works marked with * are displayed in the exhibition.

PAINTINGS

*1 **Wild Horses (Green)**, 1915–16
Oil on canvas, 24⅛ × 30⅛ in.
1955.1013
Fig. 18

*2 **Ring Idols**, c. 1915–16
Oil on canvas, 26 × 30 in.
1955.1014
Fig. 42

3 **My Friends of the Soil**, c. 1914–16
Oil on canvas, 26⅛ × 30 in.
1955.1016
Fig. 12

*4 **Acolyte—Self-Portrait**, c. 1914–16
Oil on canvas, 28⅞ × 25⅛ in.
1955.1017
Fig. 22

*5 **The Flood**, c. 1914–16
Oil on canvas, 24 × 30 in.
1955.1018
Fig. 32

*6 **Infinite**, c. 1915–16
Oil on canvas, 26 × 30¼ in.
1955.1019
Fig. 48

*7 **Rex,** c. 1914–15
Oil on canvas, 30⅛ × 26¼ in.
1955.1020
Fig. 23

8 **Night Life**, c. 1915–16
Oil on canvas, 22⅛ × 24 in.
1955.1021
Fig. 33

9 **Easter**, c. 1914–15
Oil on canvas, 26 × 30 in.
1955.1022

10 **Ultimate Reunion**, c. 1915–16
Oil on canvas, 34¼ × 48¾ in.
1955.1023
Fig. 47

11 **Young Priest**, c. 1916–17
Oil on canvas, 35 × 40⅛ in.
1955.1025
Fig. 21

*12 **Colossus (The Pearl Fisher)**, c. 1915–16
Oil on canvas, 35 × 40¼ in.
1955.1026
Fig. 25

*13 **Young Rivers**, 1916
Oil on canvas, 34⅛ × 45¼ in.
1955.1027
Fig. 30

*14 **My Song**, c. 1915–16
Oil on canvas, 36 × 40⅛ in.
1955.1028
Fig. 36

15 **Portrait of Gladys Williams**, c. 1914–15
Oil on canvas, 30 × 24⅛ in.
1955.1030
Fig. 1

16 **Night Air**, c. 1915–16
Oil on canvas, 26⅛ × 33⅛ in.
1955.1031
Fig. 34

*17 **Oasis**, c. 1915–16
Oil on canvas, 36 × 40¼ in.
1955.1032
Fig. 35

*18 **Tehachapi**, c. 1914
Oil on canvas, 28¼ × 32¾ in.
1955.1034
Fig. 13

*19 **Wild Horses (Red)**, c. 1914–15
Oil on canvas, 24 × 27⅞ in.
1955.1035
Fig. 17

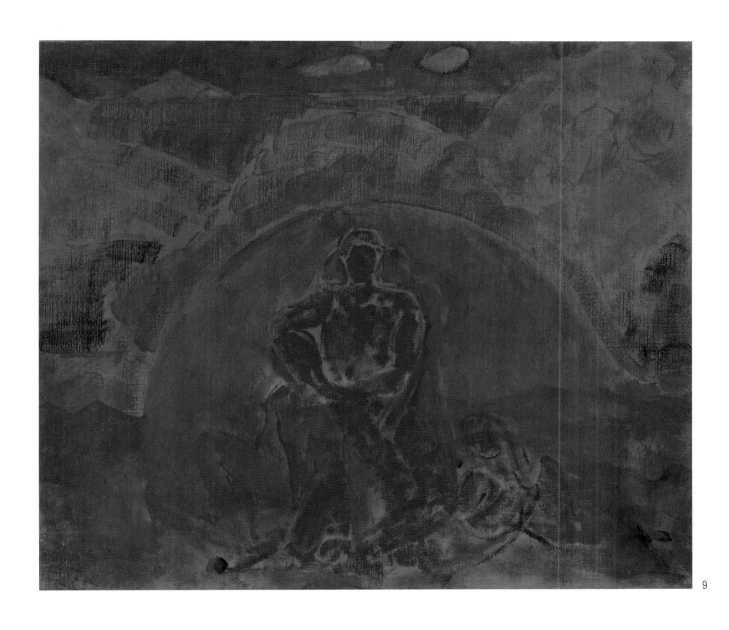

9

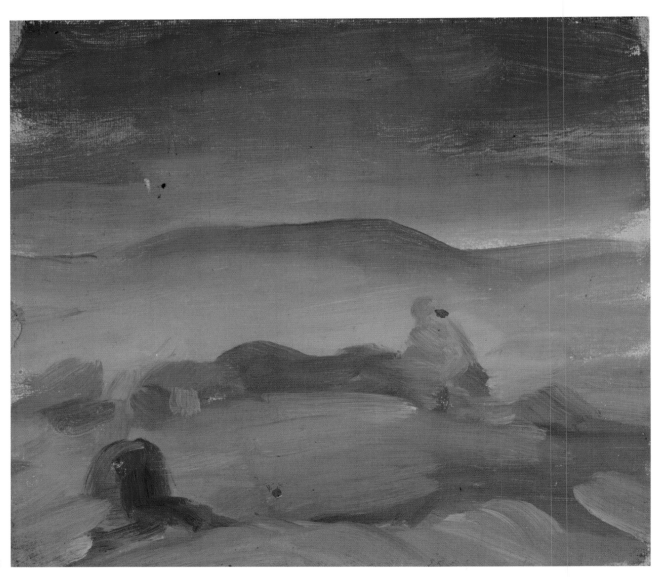

20

20 **Landscape**
Oil on board, 8 × 9 in.
1955.1304

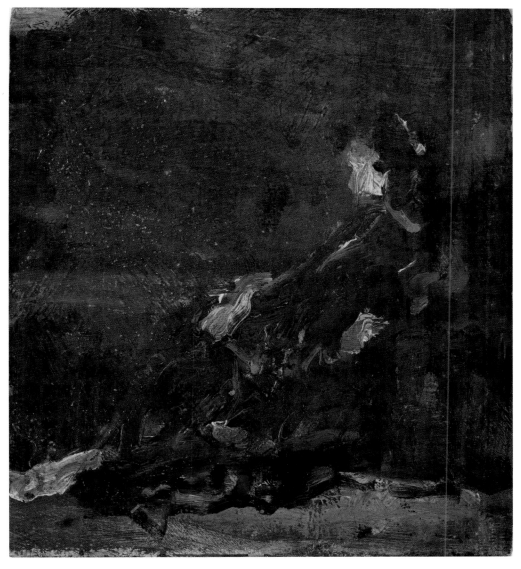

21

21 **Seated Female Figure**
Oil on board, 9¼ × 8³⁄₁₆ in.
1955.1305

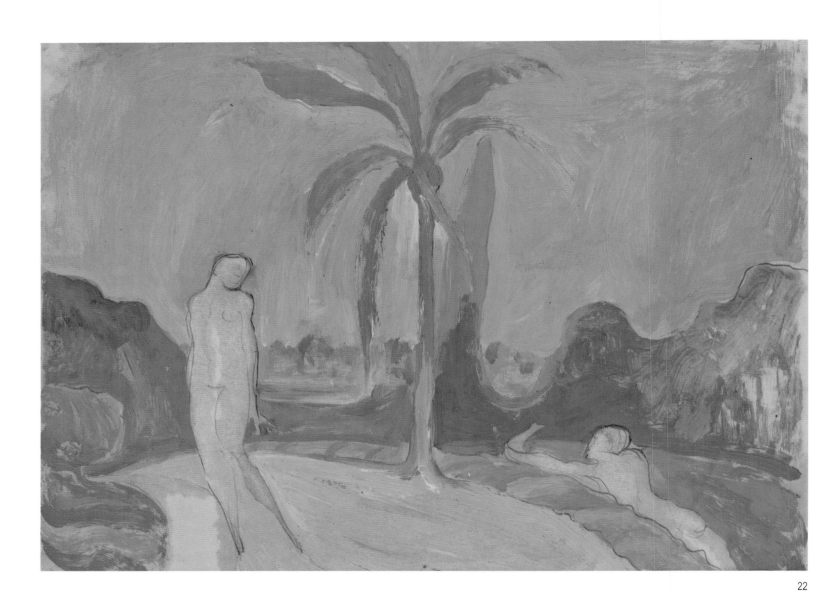

22

*22 **Two Figures with Palm Tree**
Oil on paper, 8 × 11 in.
1955.1309

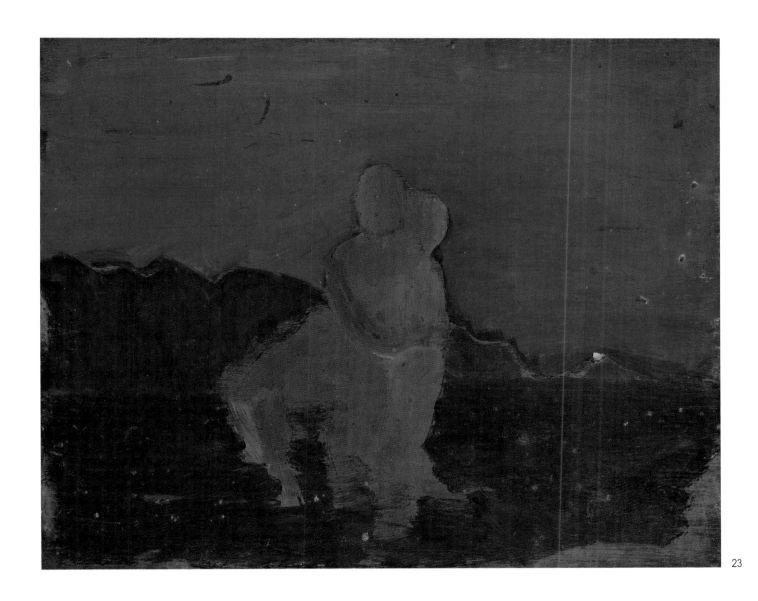

23

23 **Figures in a Landscape**
Oil on panel, 8¹¹⁄₁₆ × 10¾ in.
1955.1310

*24 **Self-Portrait**, c. 1910
Oil on canvas, 30 × 25 in.
Bequest of Carl Sprinchorn, 1972.191
Fig. 2

*25 **Portrait of Gladys Williams**, c. 1912
Oil on canvas, 29½ × 24 in.
Bequest of Carl Sprinchorn, 1972.192
Fig. 19

*26 **Self-Portrait**
Oil on canvas, 30 × 26 in.
Bequest of Carl Sprinchorn, 1972.193
Fig. 49

*27 **Portrait of Gladys Williams**, c. 1912
Oil on board, 5 × 4½ in.
Anonymous gift, 1976.301
Fig. 20

CHARCOAL DRAWINGS

All charcoal drawings are on laid paper; except where
indicated, they bear the watermark *Michallet, France.*
The designations "a" and "b" in accession numbers
signify the recto and verso of a sheet.

28 **Male Striding Forward**
Charcoal, 25 × 18¹¹⁄₁₆ in.
1955.1086.a
Fig. 43

29 **Seated Male Model**
Charcoal, 25 × 18¹¹⁄₁₆ in.
1955.1086.b
Fig. 3

30 **Seated Female Model**
Charcoal, 24⁷⁄₁₆ × 18⅞ in.
1955.1087.a

31 **Male Model with Stick**
Charcoal, 24⁷⁄₁₆ × 18⅞ in.
1955.1087.b

32 **Female Model**
Charcoal, 24⅝ × 18½ in.
1955.1088.a

33 **Male Model**
Charcoal, 24⅝ × 18½ in.
1955.1088.b

34 **Seated Female Model**
Charcoal, 24⁷⁄₁₆ × 18½ in.
1955.1089.a

35 **Seated Female Model**
Charcoal, 24⁷⁄₁₆ × 18½ in.
1955.1089.b

30

31

32

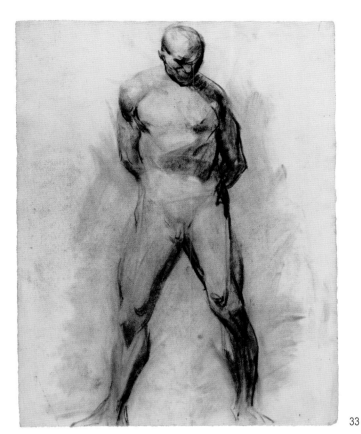

33

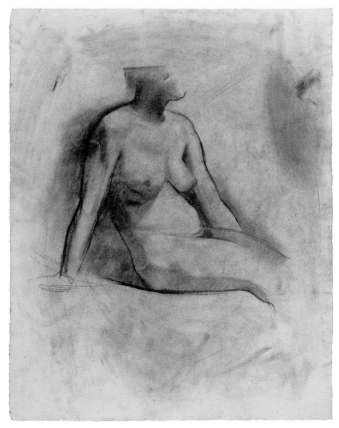

34

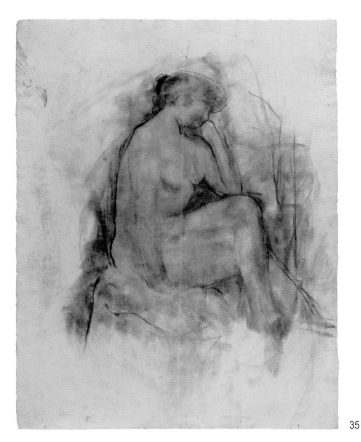

35

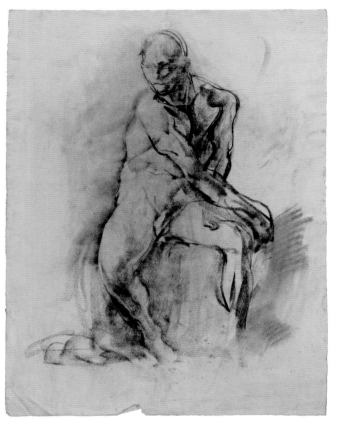

36

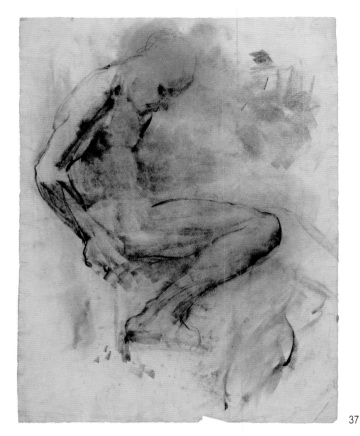

37

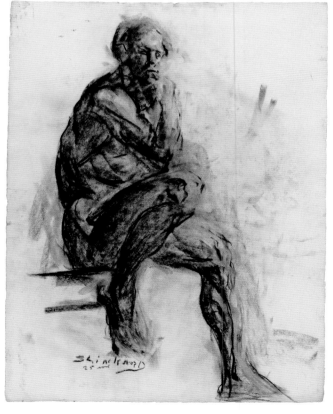

38

36 **Seated Male Model**
Charcoal, 24⁷⁄₁₆ × 18½ in.
1955.1090.a

37 **Seated Male Model**
Charcoal, 24⁷⁄₁₆ × 18½ in.
1955.1090.b

38 **Seated Male Model**
Charcoal, 24⁷⁄₁₆ × 18⅞ in.
Inscribed: *Slinkard / 25 min*
1955.1091

39 **Female Model**
Charcoal, 24⁷⁄₁₆ × 18⅞ in.
1955.1093

40 **Five Studies of a
Female Model**
Charcoal, 24⁷⁄₁₆ × 18⅞ in.
1955.1094

*41 **Seated Male Model**
Charcoal, 24⁷⁄₁₆ × 18¹¹⁄₁₆ in.
Inscribed: *Slinkard / 25 min*
1955.1095
Fig. 6

42 **Standing Male Model**
Charcoal, 24⁷⁄₁₆ × 18¹¹⁄₁₆ in.
1955.1096.a

43 **Seated Male Model**
Charcoal, 24⁷⁄₁₆ × 18¹¹⁄₁₆ in.
Inscribed: *Slinkard / 25 min*
1955.1096.b

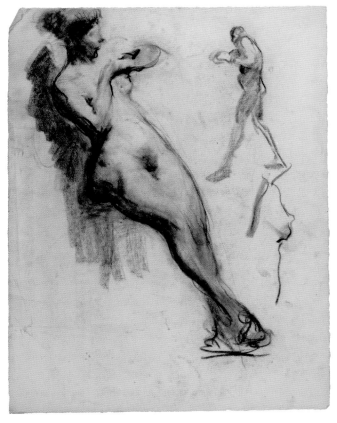

39

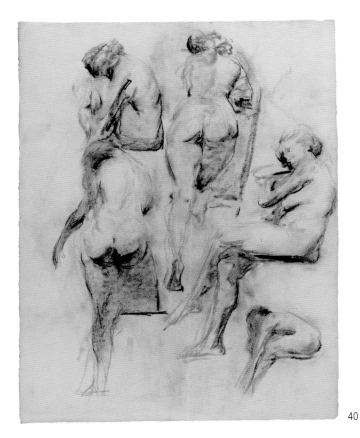

40

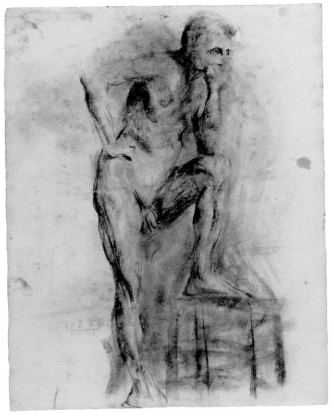

42

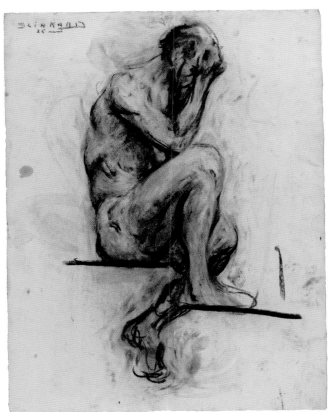

43

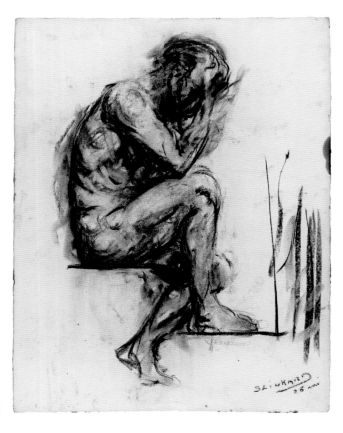

44

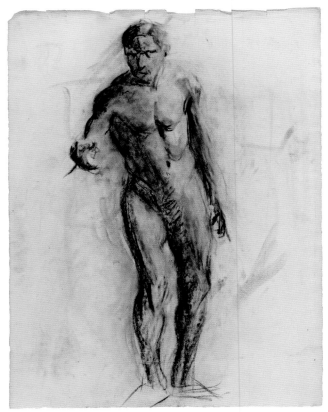

45

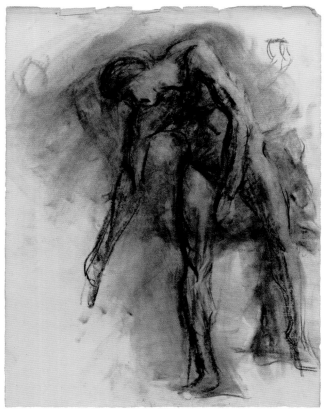

46

44 **Seated Male Model**
Charcoal, 24⁷⁄₁₆ × 18⁷⁄₈ in.
Inscribed: *Slinkard / 25 min*
1955.1097

45 **Standing Male Model**
Charcoal, 24⁷⁄₁₆ × 18½ in.
1955.1098.a

46 **Male Model Bending Over**
Charcoal, 24⁷⁄₁₆ × 18½ in.
1955.1098.b

47 **Reclining Female Model**
Charcoal, 24⁷⁄₁₆ × 18½ in.
1955.1099

48 **Standing Male Model**
Charcoal, 24⁷⁄₁₆ × 18¹¹⁄₁₆ in.
1955.1100

49 **Reclining Female Model**
Charcoal, 18¹¹⁄₁₆ × 24⁷⁄₁₆ in.
1955.1101
Fig. 4

50 **Reclining Female Model**
Charcoal, 18¹¹⁄₁₆ × 24⅝ in.
1955.1102

51 **Standing Male Model**
Charcoal, 24⁷⁄₁₆ × 18¹¹⁄₁₆ in.
1955.1103

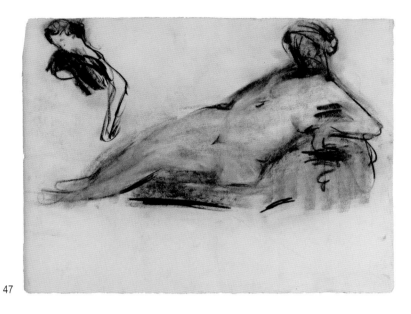

47

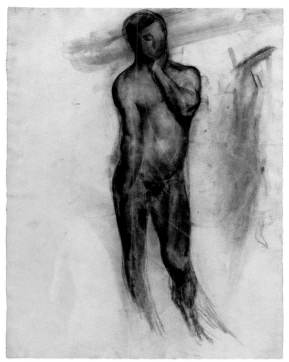

48

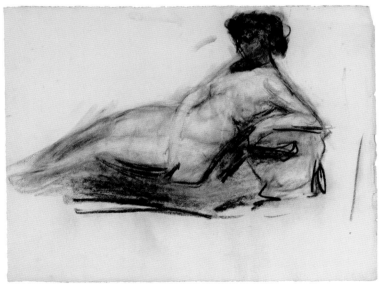

50

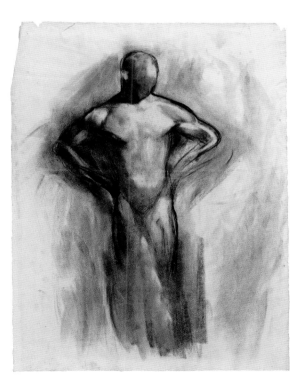

51

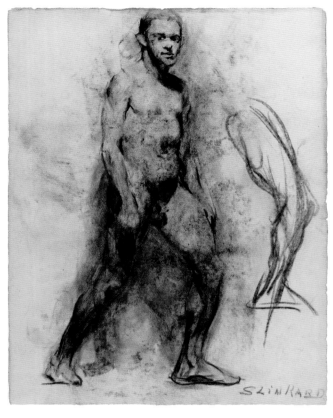

53

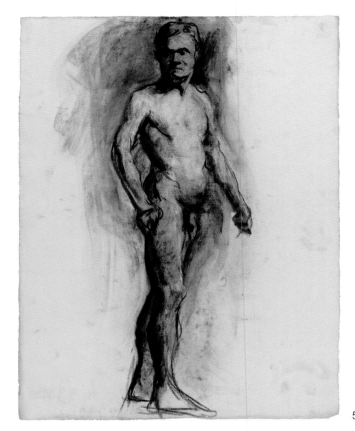

54

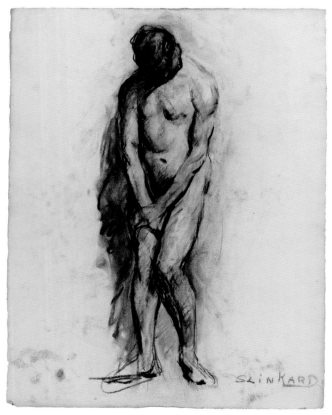

55

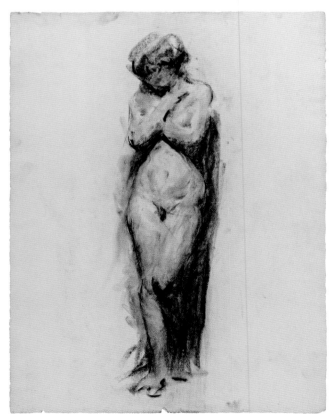

56

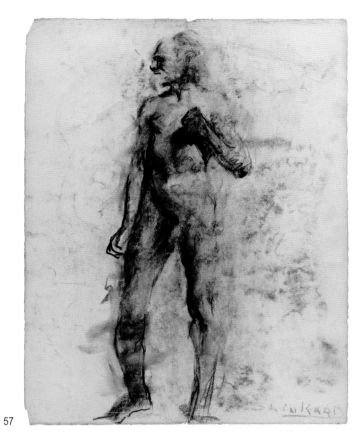

57

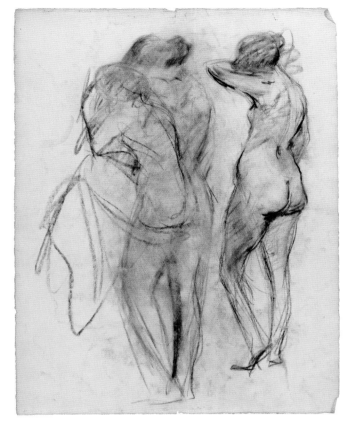

58

59

52 **Male Model Lying Down**
Charcoal, 18⅞ × 24⅝ in.
Inscribed: *Slinkard*
1955.1104
Fig. 9

53 **Standing Male Model**
Charcoal, 24⅞₁₆ × 18⅞ in.
Inscribed: *Slinkard*
1955.1105

54 **Standing Male Model**
Charcoal, 24⅝ × 18⅞ in.
1955.1106.a

55 **Male Model with Hands Crossed**
Charcoal, 24⅝ × 18⅞ in.
Inscribed: *Slinkard*
1955.1106.b

56 **Standing Female Model
with Crossed Arms**
Charcoal, 24⅝ × 18¹¹⁄₁₆ in.
1955.1107

57 **Standing Male Model**
Charcoal, 24⁷⁄₁₆ × 18⅞ in.
Inscribed: *Slinkard*
1955.1108.a

58 **Female Models**
Charcoal, 24⁷⁄₁₆ × 18⅞ in.
1955.1108.b

59 **Female Nude**
Charcoal, 18¹¹⁄₁₆ × 8¼ in.
1955.1109

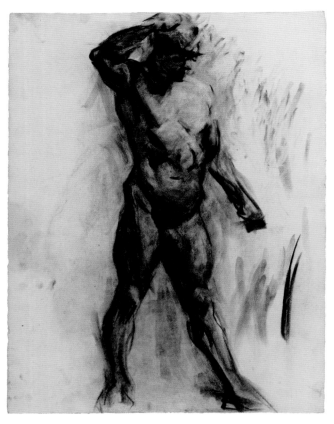

60

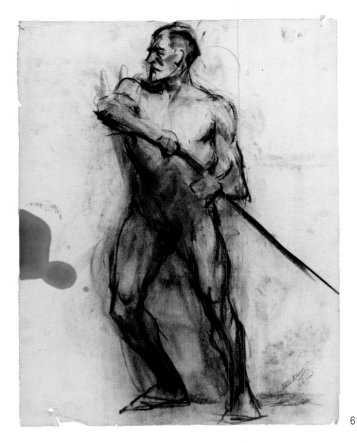

61

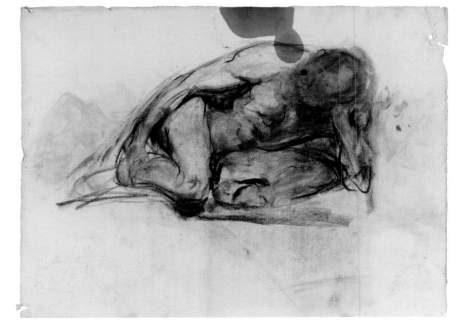

62

60 **Standing Male Model**
Charcoal, 24⅝ × 18¹¹⁄₁₆ in.
1955.1110

61 **Standing Male with a Pole**
Charcoal, 24⁷⁄₁₆ × 18½ in.
Inscribed: *Slinkard / 25 m*
1955.1111.a

*62 **Reclining Male Model**
Charcoal, 18½ × 24⁷⁄₁₆ in.
1955.1111.b

63 **Seated Female Model**
Charcoal, 24⅝ × 18½ in.
1955.1112

64 **Seated Female Model**
Charcoal, 18½ × 24⁷⁄₁₆ in.
1955.1113.a

65 **Seated Female Model**
Charcoal, 18½ × 24⁷⁄₁₆ in.
1955.1113.b

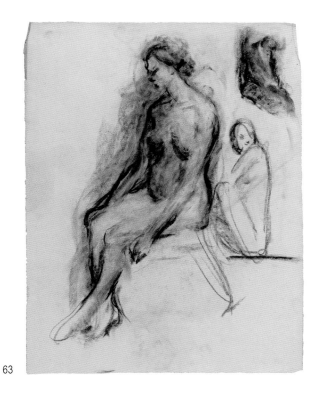

63

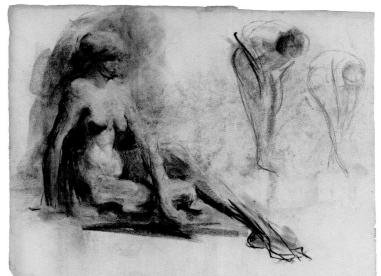

64

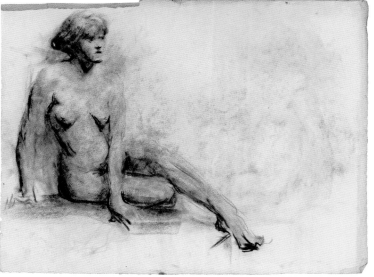

65

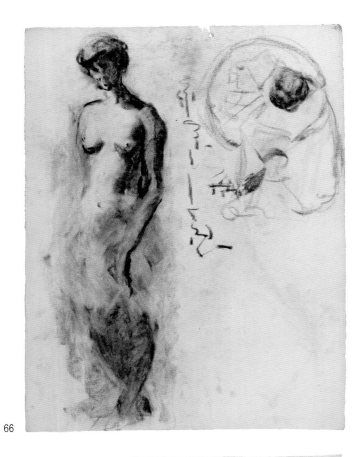

66

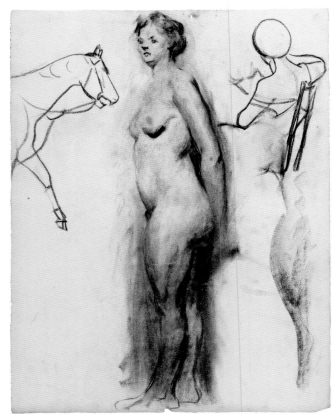

67

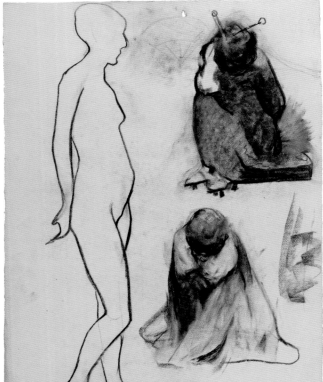

68

66 **Female Model**
Charcoal, 24⁷⁄₁₆ × 18½ in.
1955.1114

67 **Female Model and Horse**
Charcoal, 24⁷⁄₁₆ × 18½ in.
1955.1115

68 **Three Studies of Female Models**
Charcoal, 24⁷⁄₁₆ × 18½ in.
1955.1116

*69 **Male Model with Arms Crossed**
Charcoal, 10¼ × 8¼ in.
1955.1117

70 **Standing Male Model**
Charcoal, 24⁷⁄₁₆ × 18½ in.
Inscribed: *Slinkard*
1955.1118.a

71 **Standing Male Model**
Charcoal, 24⁷⁄₁₆ × 18½ in.
1955.1118.b

72 **Five Studies of a Male Head**
Charcoal, 24⁷⁄₁₆ × 18½ in.
1955.1119

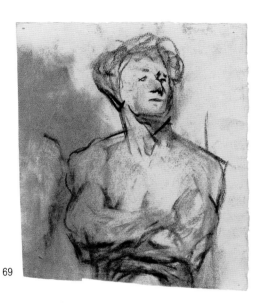

69

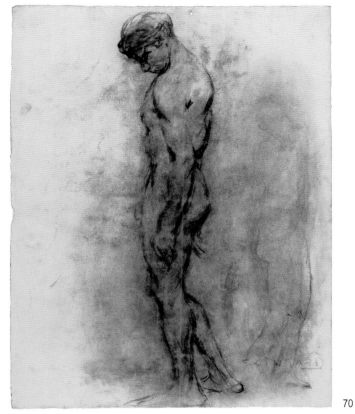

70

71

72

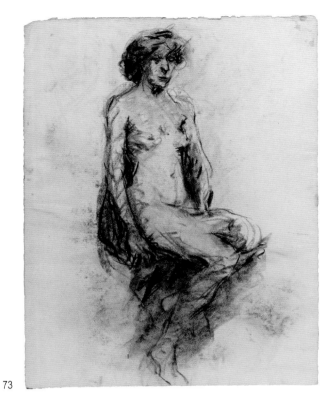

73

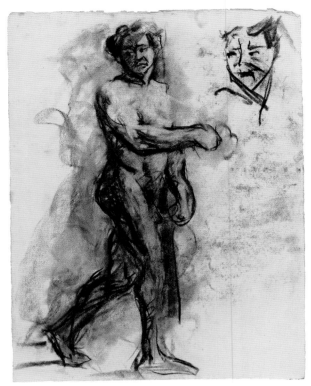

74

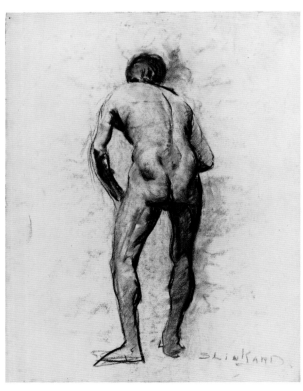

75

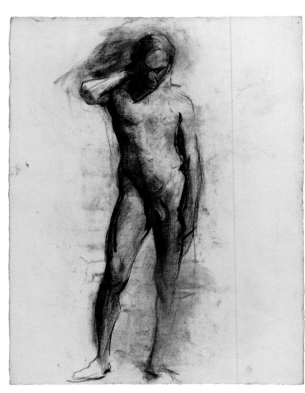

76

73 **Seated Female Model**
Charcoal, 24⁷⁄₁₆ × 18½ in.
1955.1120.a

74 **Standing Male Model**
Charcoal, 24⁷⁄₁₆ × 18½ in.
1955.1120.b

*75 **Male Model Leaning Forward**
Charcoal, 24⁷⁄₁₆ × 18½ in.
Inscribed: *Slinkard*
1955.1121.a

76 **Standing Male Model**
Charcoal, 24⁷⁄₁₆ × 18½ in.
1955.1121.b

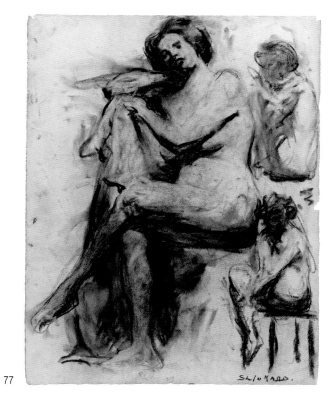

77

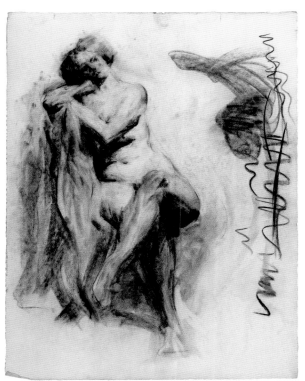

78

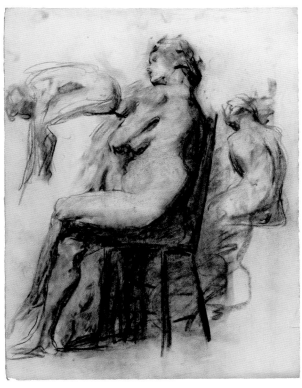

79

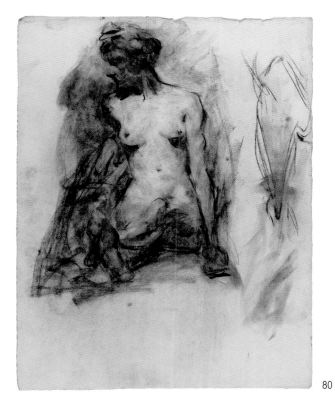

80

77 **Studies of a Seated Female Model**
 Charcoal, 24⁷⁄₁₆ × 18½ in.
 Inscribed: *Slinkard*
 1955.1122

78 **Seated Female Model**
 Charcoal, 24⁷⁄₁₆ × 18½ in.
 1955.1123

79 **Three Studies of a Female Model**
 Charcoal, 24⁷⁄₁₆ × 18½ in.
 1955.1124

80 **Seated Female Model**
 Charcoal, 24⁷⁄₁₆ × 18½ in.
 1955.1125

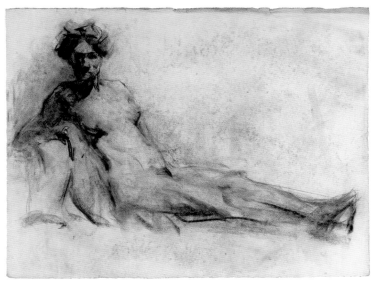

81

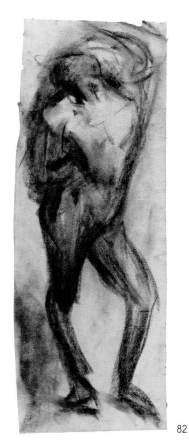

82

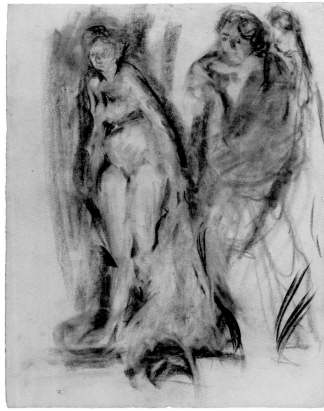

83

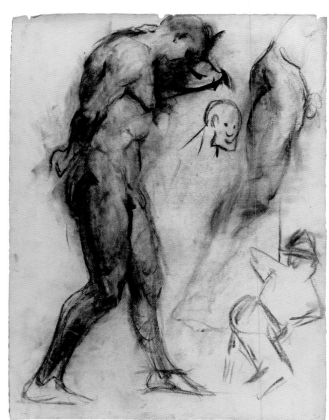

84

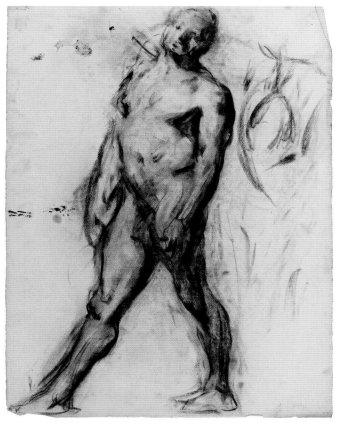

85

86

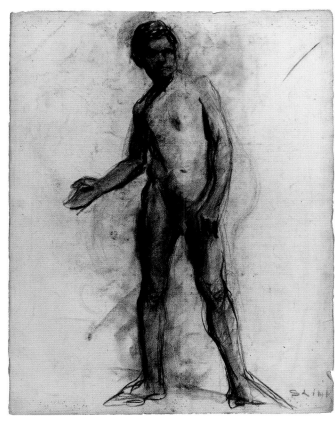

87

81 **Reclining Female Model**
Charcoal, 18½ × 24⁷⁄₁₆ in.
1955.1126

82 **Standing Male Model**
Charcoal, 20⅞ × 7⁵⁄₁₆ in.
1955.1127

83 **Female Model**
Charcoal, 24⁷⁄₁₆ × 18½ in.
1955.1128

84 **Standing Male Model**
Charcoal, 24⁷⁄₁₆ × 18½ in.
1955.1129

85 **Standing Male Model**
Charcoal, 24⁷⁄₁₆ × 18½ in.
1955.1130.a

86 **Female Model**
Charcoal, 24⁷⁄₁₆ × 18½ in.
1955.1130.b

87 **Standing Male Model**
Charcoal, 24⁷⁄₁₆ × 18½ in.
Inscribed: *Slink*
1955.1131.a

88

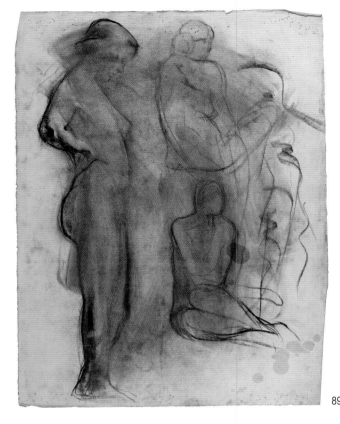

89

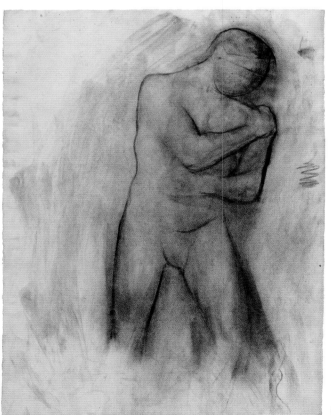

90

91

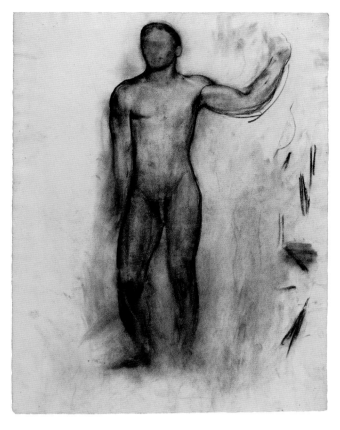

92

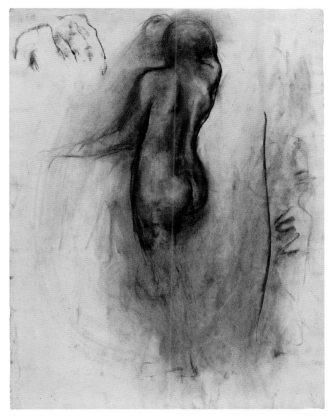

93

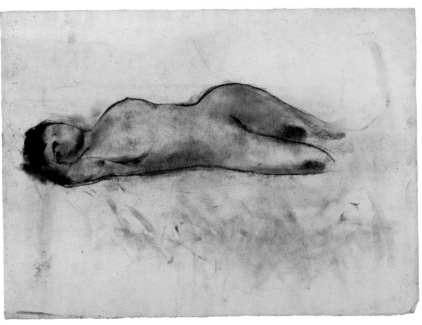

94

88 **Back View of a Model**
Charcoal, 24⁷⁄₁₆ × 18½ in.
1955.1131.b

89 **Three Views of a Female Model**
Charcoal, 24⁷⁄₁₆ × 18½ in.
1955.1132.a

90 **Male Model with Crossed Arms**
Charcoal, 24⁷⁄₁₆ × 18½ in.
1955.1132.b

91 **Male Model Clutching His Own Body**
Charcoal, 24⁷⁄₁₆ × 18¹¹⁄₁₆ in.
1955.1133

92 **Standing Male Model with Arm Raised**
Charcoal, 24⁷⁄₁₆ × 18½ in.
1955.1134.a

93 **Standing Female Model**
Charcoal, 24⁷⁄₁₆ × 18½ in.
1955.1134.b

94 **Reclining Female Model**
Charcoal, 18½ × 24⁷⁄₁₆ in.
1955.1135.a

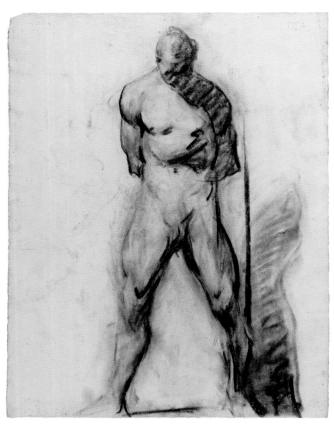

95

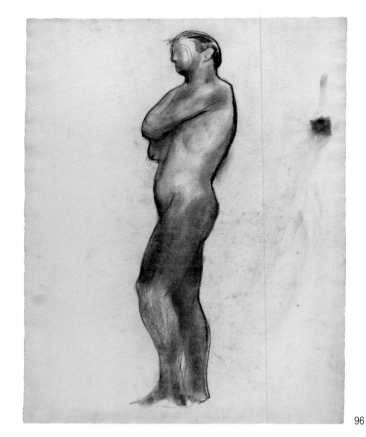

96

95　**Standing Male Model**
Charcoal, 24⁷⁄₁₆ × 18½ in.
1955.1135.b

96　**Standing Male Model**
Charcoal, 24⁷⁄₁₆ × 18½ in.
1955.1136

97　**Female Model**
Charcoal, 24⁷⁄₁₆ × 18½ in.
1955.1137

98　**Female Model**
Charcoal, 24⁷⁄₁₆ × 18½ in.
1955.1138

99　**Standing Female Model**
Charcoal, 24⁷⁄₁₆ × 18½ in.
1955.1139.a

100　**Standing Female Model**
Charcoal, 24⁷⁄₁₆ × 18½ in.
1955.1139.b

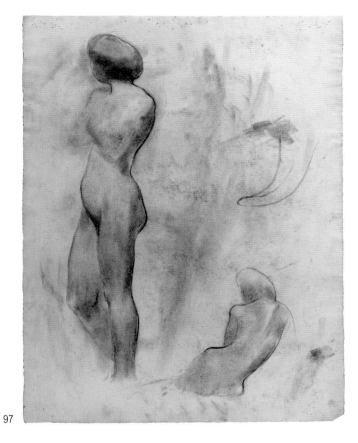

97

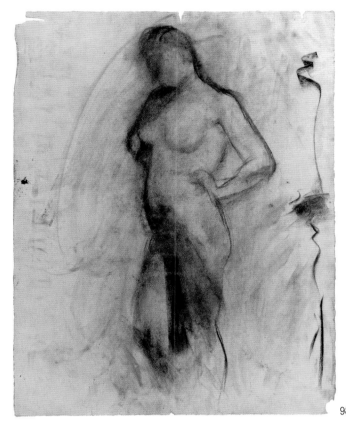

98

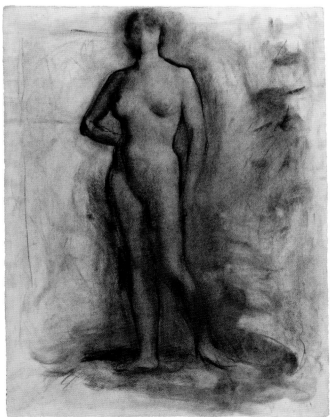

99

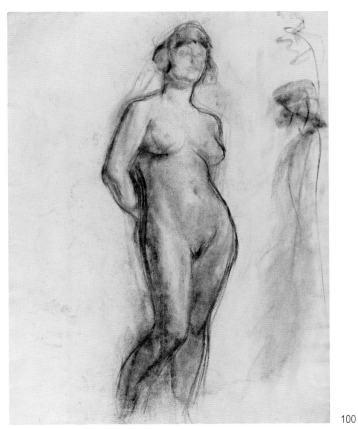

100

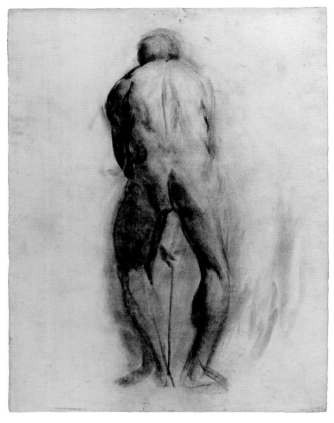

101

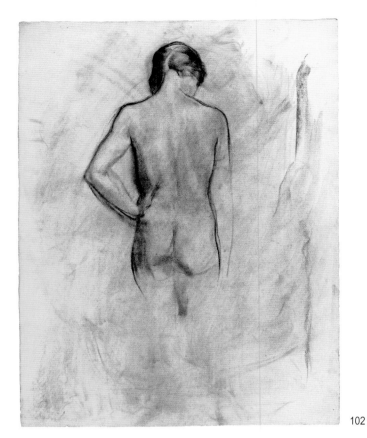

102

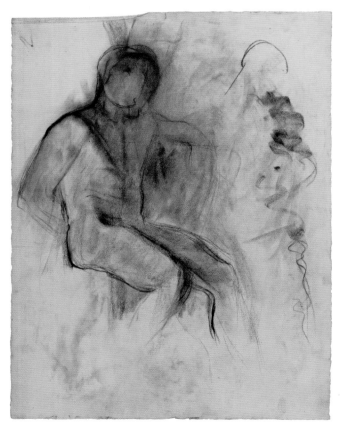

103

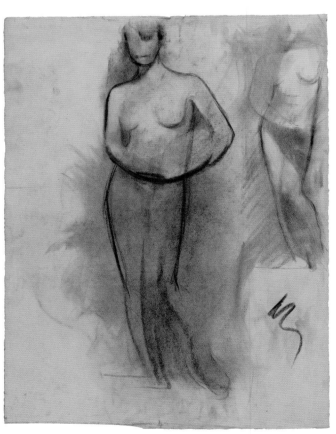

104

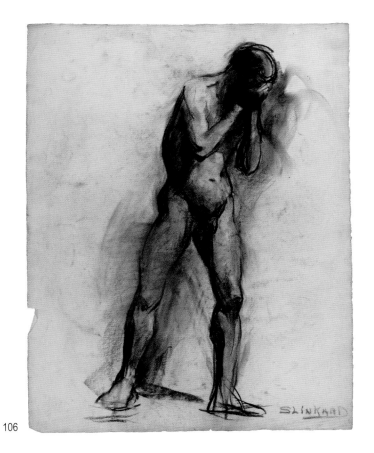

106

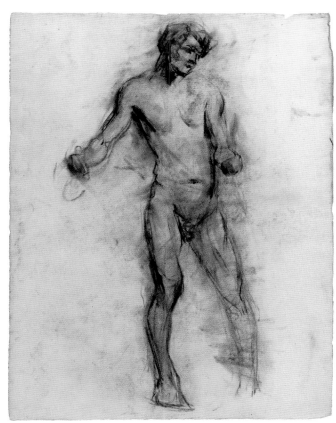

107

101 **Male Model, Back View**
Charcoal, 24⁷⁄₁₆ × 18½ in.
1955.1140.a

102 **Female Model, Back View**
Charcoal, 24⁷⁄₁₆ × 18½ in.
1955.1140.b

103 **Seated Male Model**
Charcoal, 24⁷⁄₁₆ × 18½ in.
1955.1141.a

104 **Standing Female Model**
Charcoal, 24⁷⁄₁₆ × 18½ in.
1955.1141.b

105 **Female Model**
Charcoal, 24⁷⁄₁₆ × 18½ in.
1955.1142.a
Fig. 5

106 **Male Model**
Charcoal, 24⁷⁄₁₆ × 18½ in.
Inscribed: *Slinkard*
1955.1142.b

107 **Standing Male Model**
Charcoal, 24⁷⁄₁₆ × 18½ in.
1955.1143.a

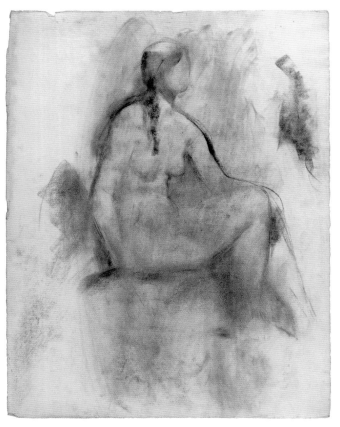

108

109

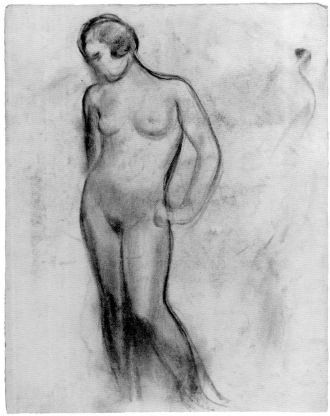

110

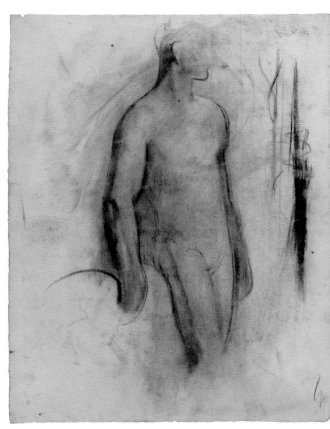

111

96

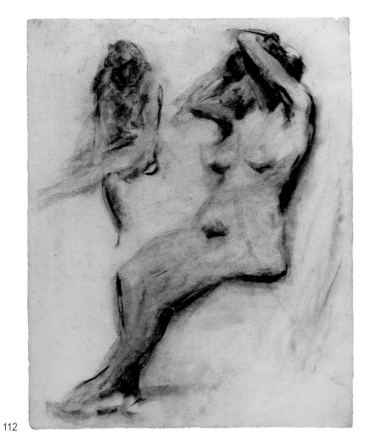

112

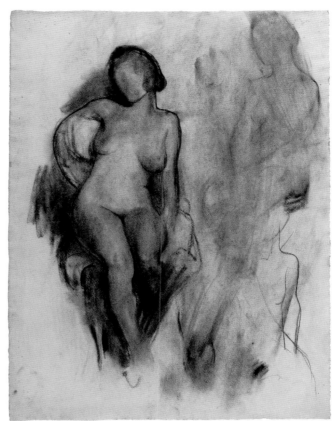

113

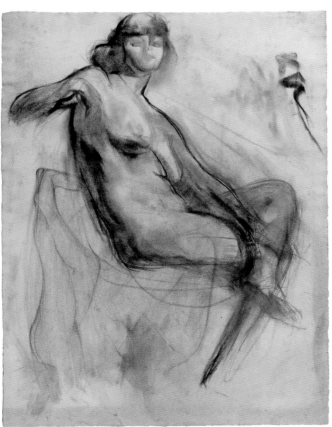

114

108 **Seated Female Model**
Charcoal, 24⁷⁄₁₆ × 18½ in.
1955.1143.b

109 **Female Model in Chair**
Charcoal, 24⁷⁄₁₆ × 18½ in.
1955.1144

110 **Female Model**
Charcoal, 24⁷⁄₁₆ × 18½ in.
1955.1146

111 **Standing Male Model**
Charcoal, 24⁷⁄₁₆ × 18½ in.
1955.1147.a

112 **Seated Female Model**
Charcoal, 24⁷⁄₁₆ × 18½ in.
1955.1147.b

113 **Seated Female Model**
Charcoal, 24⁷⁄₁₆ × 18½ in.
1955.1148

114 **Seated Female Model**
Charcoal, 24⁷⁄₁₆ × 18½ in.
1955.1149.a

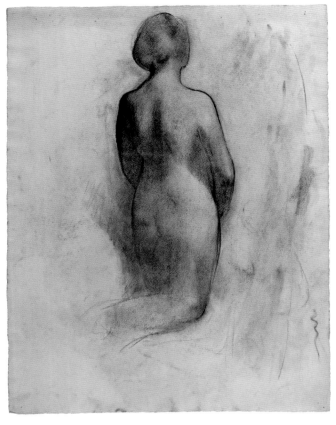

115

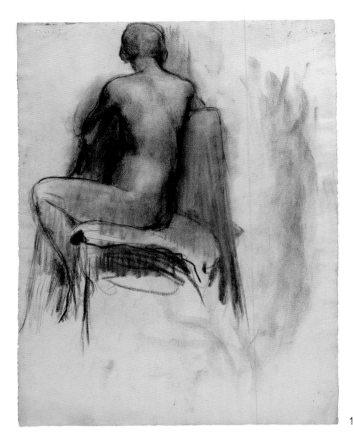

116

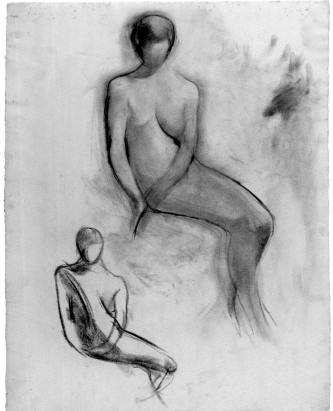

117

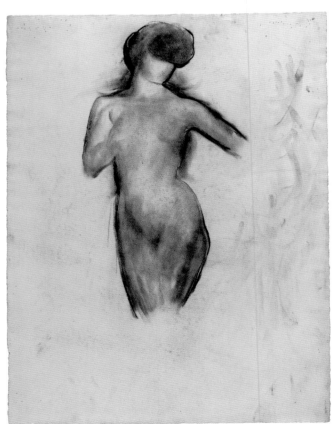

118

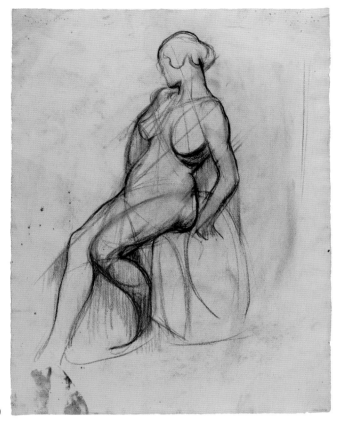

119

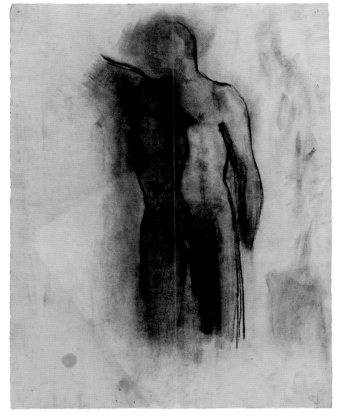

120

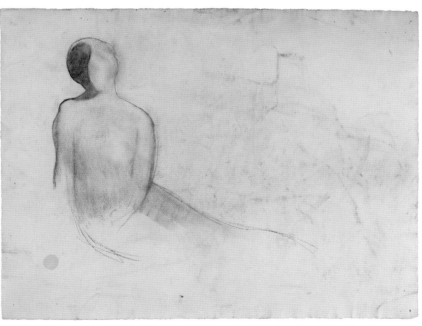

121

115 **Kneeling Female Model**
Charcoal, 24⁷⁄₁₆ × 18½ in.
1955.1149.b

116 **Seated Female Model**
Charcoal, 24⁷⁄₁₆ × 18½ in.
1955.1150.a

117 **Seated Female Model**
Charcoal, 24⁷⁄₁₆ × 18½ in.
1955.1150.b

118 **Standing Female Model**
Charcoal, 24⁷⁄₁₆ × 18½ in.
1955.1151.a

119 **Seated Female Model**
Charcoal, 24⁷⁄₁₆ × 18½ in.
1955.1151.b

120 **Standing Male Model**
Charcoal, 24⁷⁄₁₆ × 18½ in.
1955.1152.a

121 **Female Model**
Charcoal, 18½ × 24⁷⁄₁₆ in.
1955.1152.b

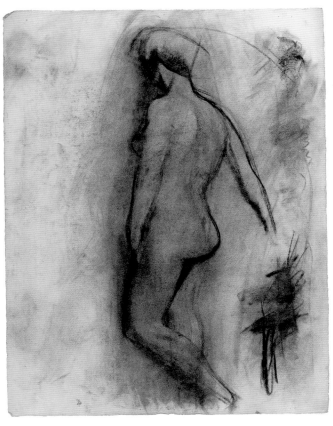

122

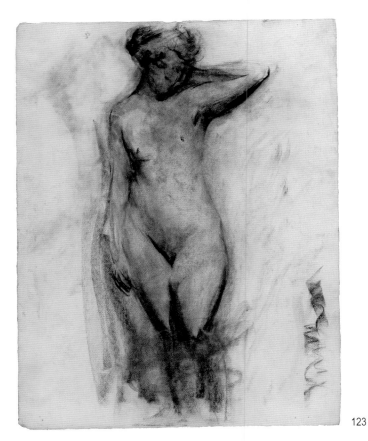

123

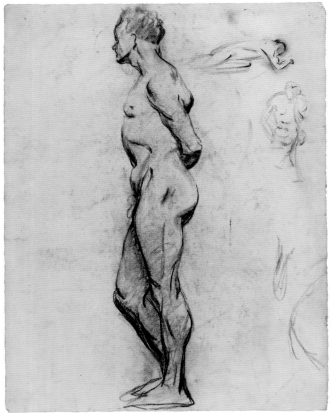

124

125

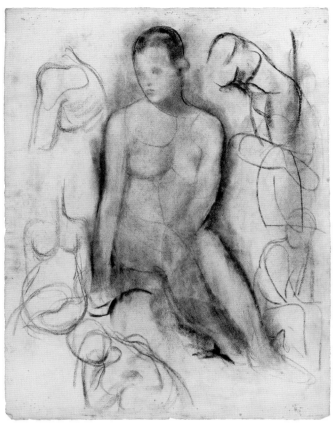

126

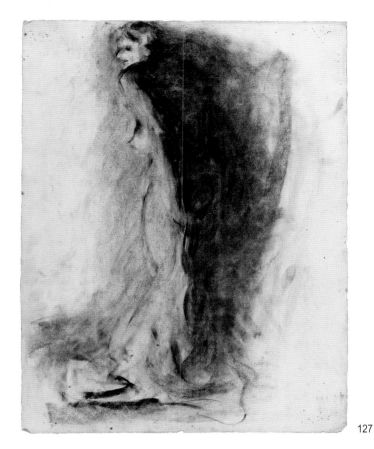

127

122 **Standing Female Model**
Charcoal, 24⁷⁄₁₆ × 18½ in.
1955.1153.a

123 **Standing Female Model**
Charcoal, 24⁷⁄₁₆ × 18½ in.
1955.1153.b

124 **Standing Male Model**
Charcoal, 24⁷⁄₁₆ × 18½ in.
1955.1154.a

125 **Female Model**
Charcoal, 24⁷⁄₁₆ × 18½ in.
1955.1154.b

126 **Seated Female Model**
Charcoal, 24⁷⁄₁₆ × 18½ in.
1955.1155.a

127 **Standing Female Model**
Charcoal, 24⁷⁄₁₆ × 18½ in.
1955.1155.b

128 **Standing Male Model**
Charcoal, 24⁷⁄₁₆ × 18½ in.
1955.1156

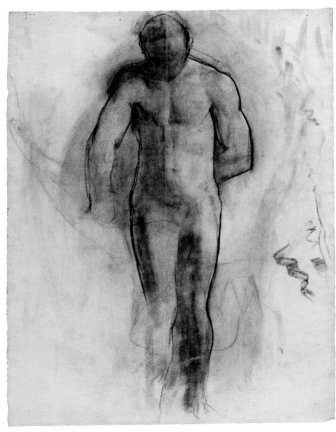

128

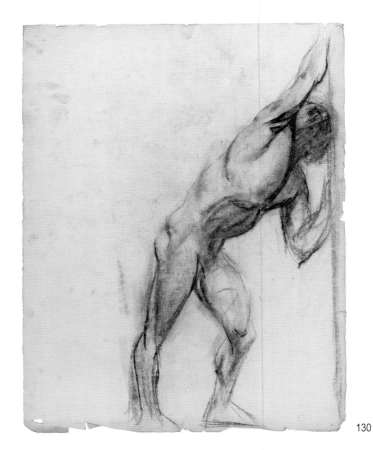

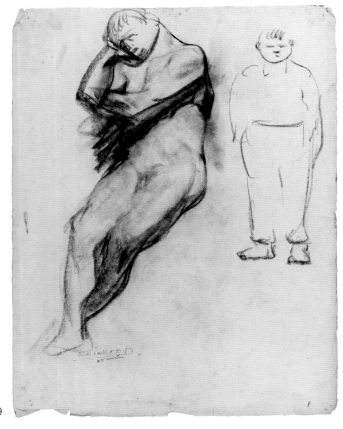

129

130

131

132

133

134

129 **Male Model**
Charcoal, 24⅞₁₆ × 18½ in.
Inscribed: *Slinkard / 25 min*
1955.1157

130 **Male Model Leaning Against a Wall**
Charcoal, 24⅞₁₆ × 18½ in.
1955.1158

131 **Study of a Leg**
Charcoal, 24⅞₁₆ × 18½ in.
Inscribed: *R R*
1955.1159

132 **Standing Female Model**, 1913
Charcoal, 24⅞₁₆ × 18½ in.
Inscribed: *7-28-13*
1955.1160

133 **Standing Female Model**
Charcoal, 24⅞₁₆ × 18½ in.
1955.1161

134 **Male Model**
Charcoal, 24⅞₁₆ × 18½ in.
1955.1162

135 **Seated Female Model**
Charcoal, 24⅞₁₆ × 18½ in.
1955.1163

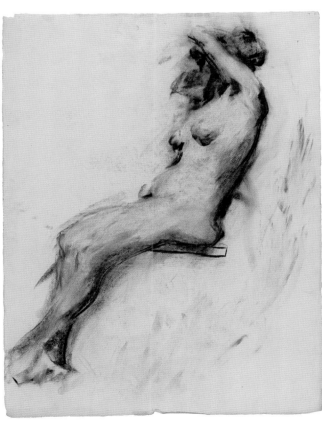

135

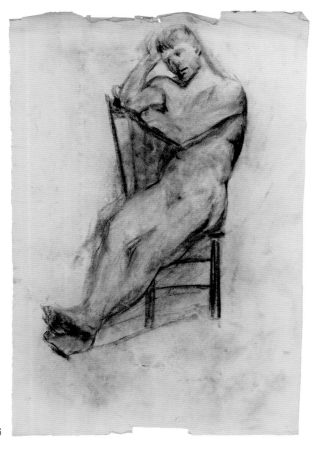

136

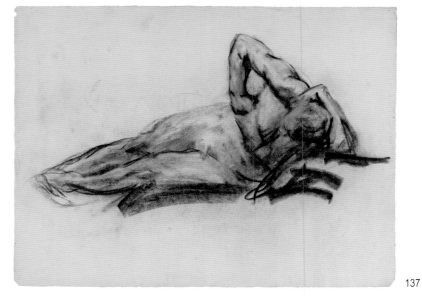

137

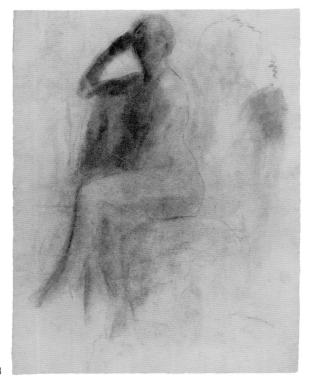

138

136 **Male Model in Chair**
Charcoal, 24⁷⁄₁₆ × 16⅛ in.
1955.1164

137 **Reclining Male Model**
Charcoal, 18½ × 24⁷⁄₁₆ in.
1955.1165

138 **Seated Female Model**
Charcoal, 24⁷⁄₁₆ × 18½ in.
1955.1166.a

139 **Standing Female Model**
Charcoal, 24⁷⁄₁₆ × 18½ in.
1955.1166.b

140 **Seated Female Model**
Charcoal, 24⁷⁄₁₆ × 18½ in.
1955.1167

141 **Seated Female Model**
Charcoal, 24⁷⁄₁₆ × 18½ in.
1955.1169.a

142 **Female Model**
Charcoal, 24⁷⁄₁₆ × 18½ in.
1955.1169.b

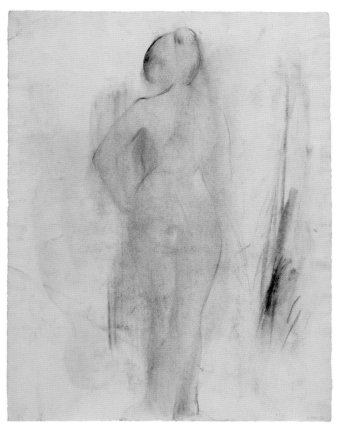

139

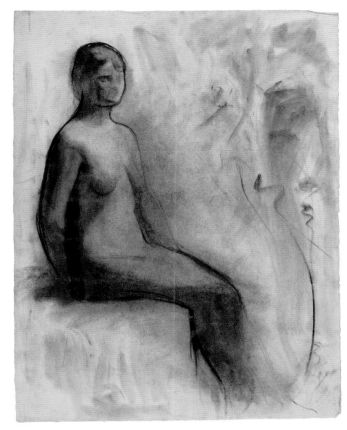

140

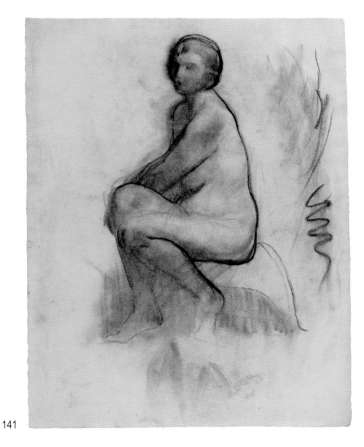

141

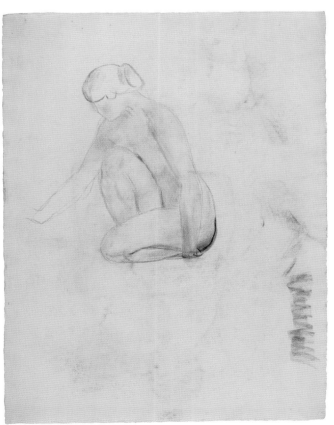

142

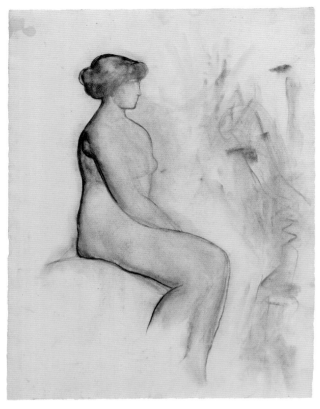

143

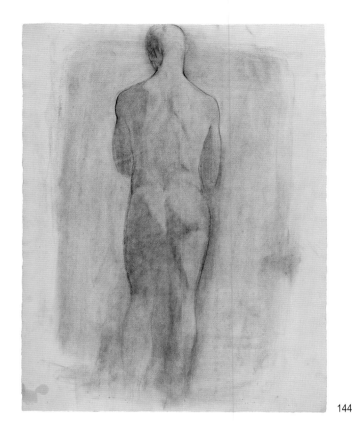

144

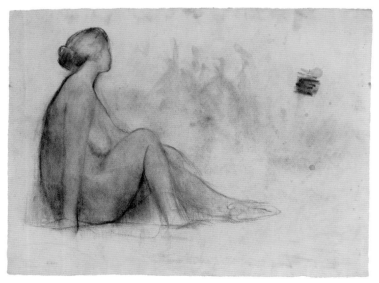

145

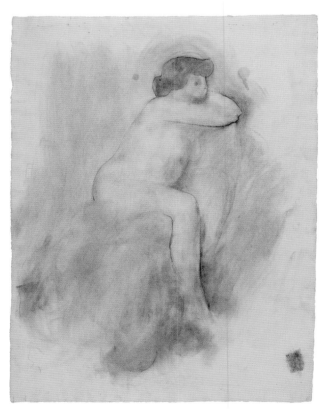

146

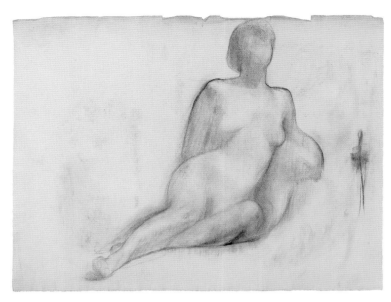

147

143 **Seated Female Model**
Charcoal, 24⁷⁄₁₆ × 18½ in.
1955.1170.a

144 **Standing Male Model**
Charcoal, 24⁷⁄₁₆ × 18½ in.
1955.1170.b

145 **Seated Female Model**
Charcoal, 18½ × 24⁷⁄₁₆ in.
1955.1171.a

146 **Female Model in a Chair**
Charcoal, 24⁷⁄₁₆ × 18½ in.
1955.1171.b

147 **Reclining Female Model**
Charcoal, 18½ × 24⁷⁄₁₆ in.
1955.1172

148 **Seated Female Model**
Charcoal, 16⁹⁄₁₆ × 26⅜ in.
1955.1173

149 **Female Model**
Charcoal, 18½ × 24⁷⁄₁₆ in.
1955.1174

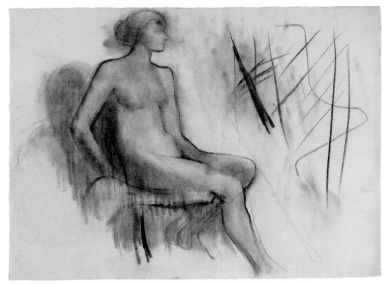

148

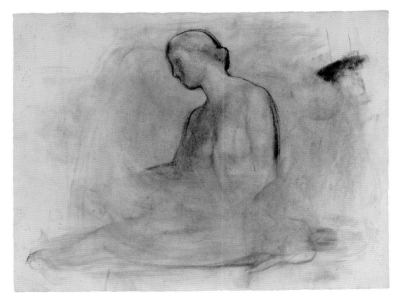

149

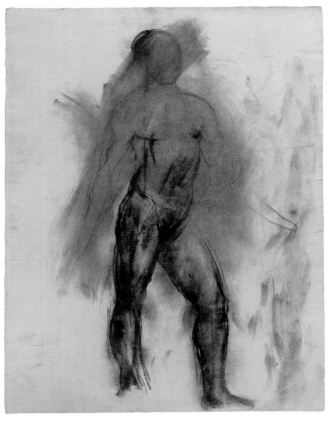

150

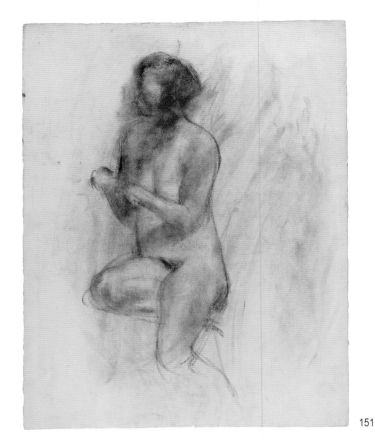

151

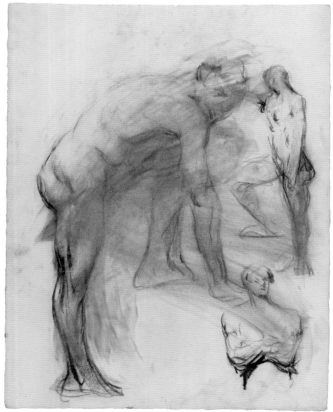

152

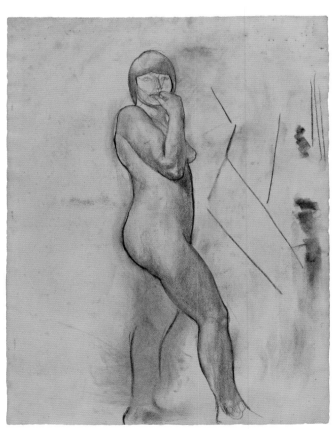

153

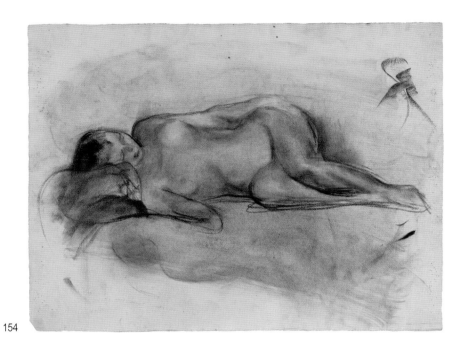

150 **Standing Male Model**
Charcoal, 24⁷⁄₁₆ × 18½ in.
1955.1175

151 **Seated Female Model**
Charcoal, 24⁷⁄₁₆ × 18½ in.
1955.1176.a

152 **Male Models**
Charcoal, 24⁷⁄₁₆ × 18½ in.
1955.1176.b

153 **Standing Female Model**
Charcoal, 24⁷⁄₁₆ × 18¹¹⁄₁₆ in.
1955.1177

154 **Reclining Female Model**
Charcoal, 18½ × 24⁷⁄₁₆ in.
1955.1178

155 **Reclining Female Model**
Charcoal, 24⁷⁄₁₆ × 18½ in.
1955.1179

156 **Seated Female Model**
Charcoal, 24⁷⁄₁₆ × 18½ in.
1955.1181

154

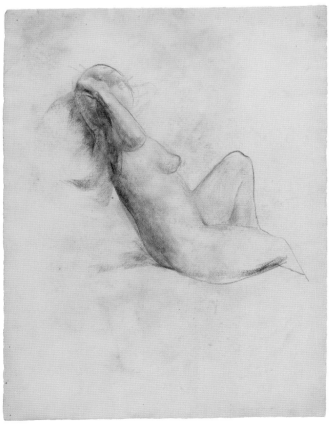

155

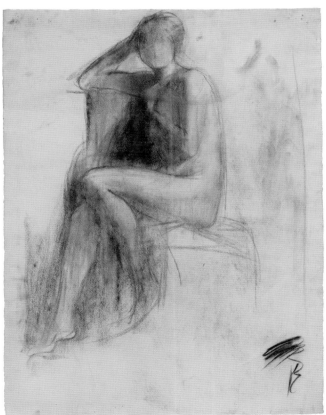

156

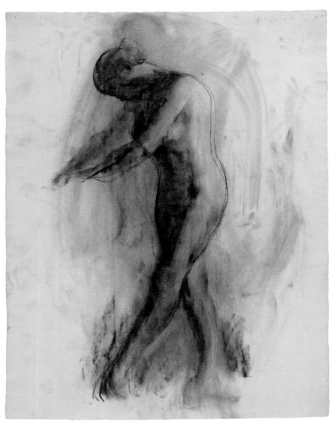

157

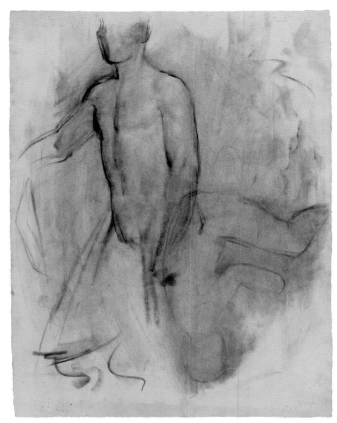

158

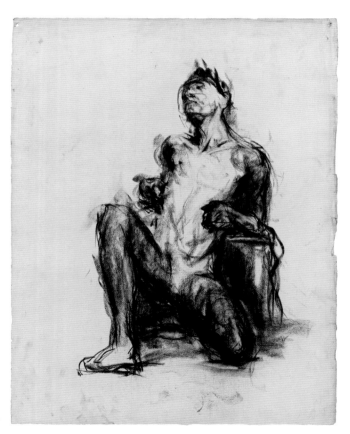

159

157 **Standing Female Model**
Charcoal, 24⁷⁄₁₆ × 18½ in.
1955.1182

158 **Male Models**
Charcoal, 24⁷⁄₁₆ × 18½ in.
1955.1183

*159 **Male Model**
Charcoal, 24⅝ × 19⅛ in.
1955.1184

160 **Female Model**
Charcoal, 18½ × 24⁷⁄₁₆ in.
1955.1185

161 **Male Model, Back View**
Charcoal, 24⁷⁄₁₆ × 18½ in.
1955.1186.a

*162 **Male Model**
Charcoal, 24⁷⁄₁₆ × 18½ in.
1955.1186.b

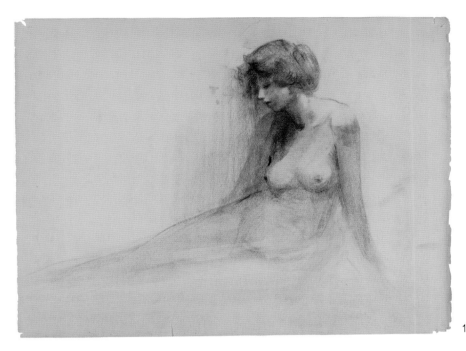

160

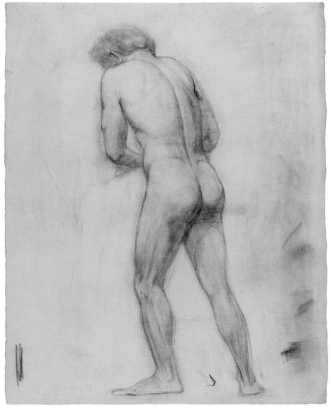

161

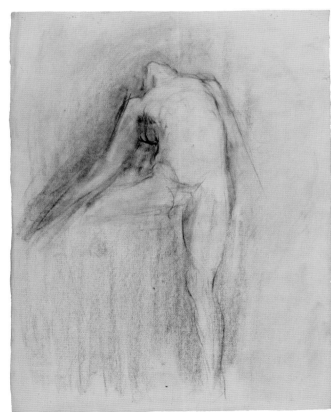

162

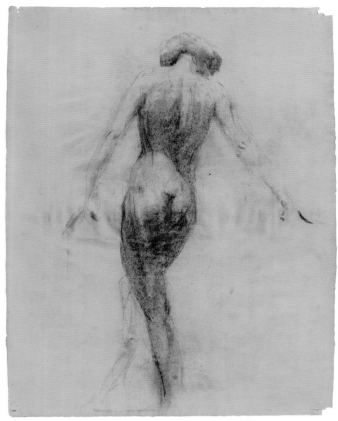

163

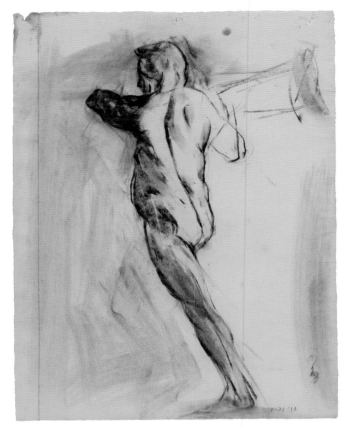

164

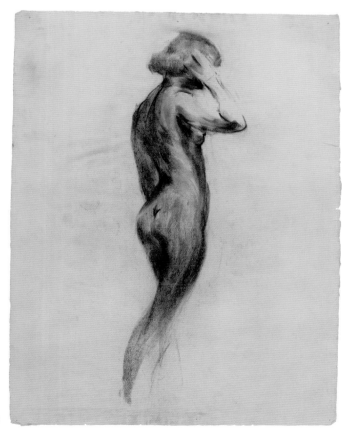

165

163 **Female Model, Back View**
Charcoal, 24⁷⁄₁₆ × 18½ in.
1955.1187

164 **Male Model Wielding Chair**, 1913
Charcoal, 24⁷⁄₁₆ × 18½ in.
Inscribed: *1-31 '13*
1955.1188

165 **Standing Female Model**, 1911
Charcoal, 24⁷⁄₁₆ × 18½ in.
Inscribed in another hand: *June 30 '11*
1955.1189

166 **Seated Female Model**
Charcoal, 24 × 16⁵⁄₁₆ in.
1955.1190

167 **Seated Male Model**
Charcoal, 24⁷⁄₁₆ × 18½ in.
1955.1191.a

168 **Female Model**
Charcoal, 24⁷⁄₁₆ × 18½ in.
1955.1191.b

169 **Draped Female Model**
Charcoal, 24⁷⁄₁₆ × 18½ in.
1955.1192.a

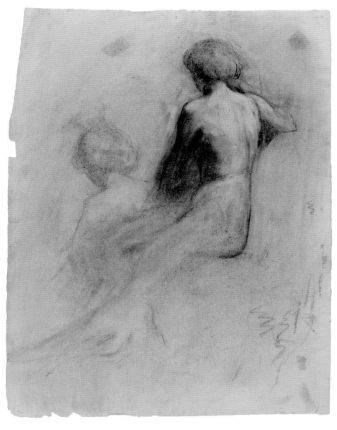

166

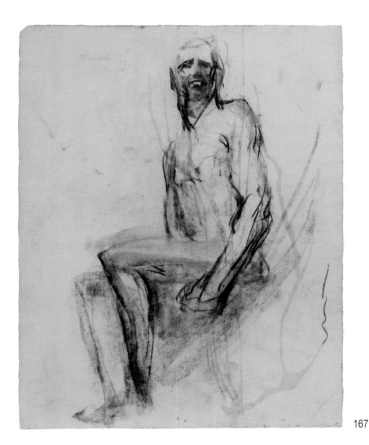

167

168

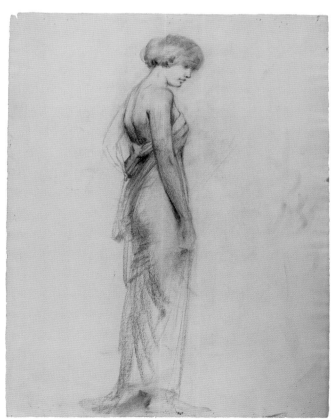

169

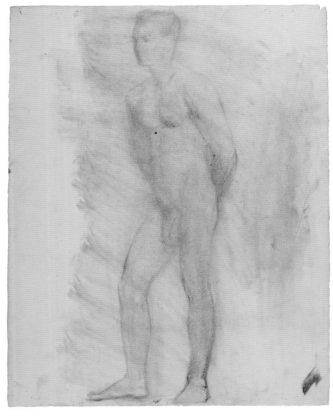

170

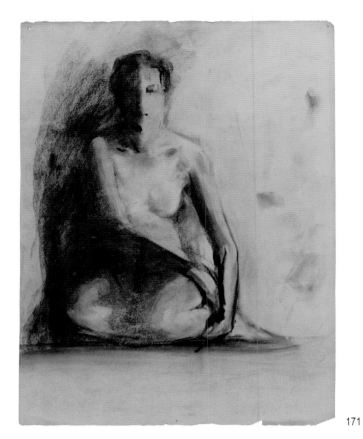

171

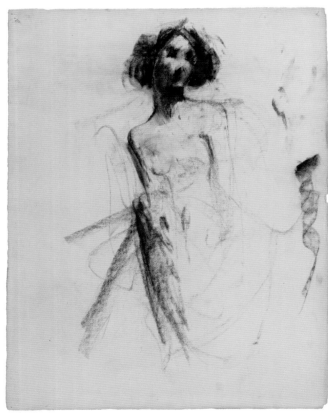

172

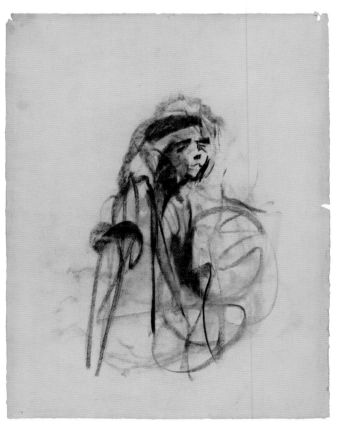

173

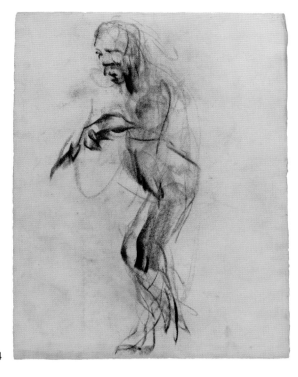

174

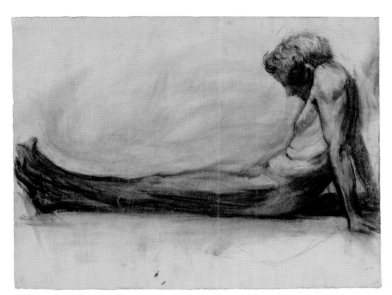

175

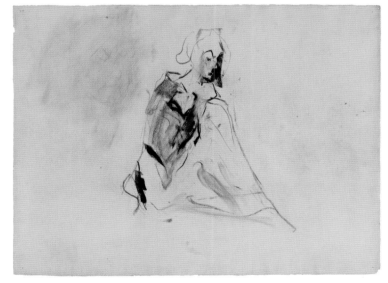

176

170 **Standing Male Model**
Charcoal, 24⁷⁄₁₆ × 18½ in.
1955.1192.b

171 **Seated Female Model**
Charcoal, 24⁷⁄₁₆ × 18½ in.
1955.1193

172 **Female Model**
Charcoal, 24⁷⁄₁₆ × 18½ in.
1955.1194

173 **Study of a Head**
Charcoal, 24⁷⁄₁₆ × 18½ in.
1955.1195

174 **Male Model**
Charcoal, 24⁷⁄₁₆ × 18½ in.
1955.1196

175 **Male Model**
Charcoal, 18¹¹⁄₁₆ × 24⅝ in.
1955.1197

176 **Female Model**
Charcoal, 18½ × 24⁷⁄₁₆ in.
1955.1198

177 **Female Model**
Charcoal, 18½ × 24⁷⁄₁₆ in.
1955.1199

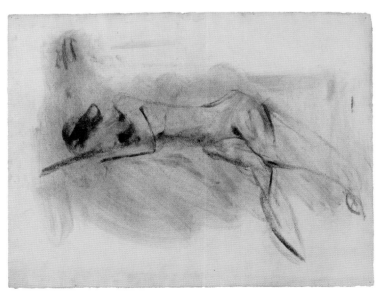

177

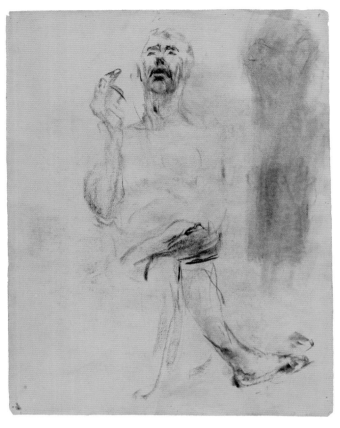

178

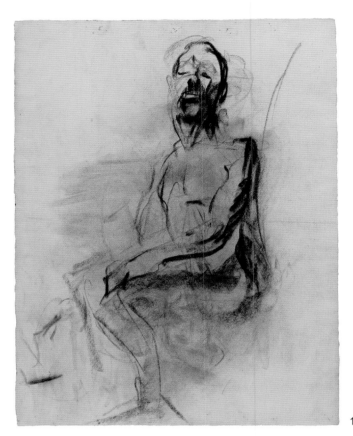

179

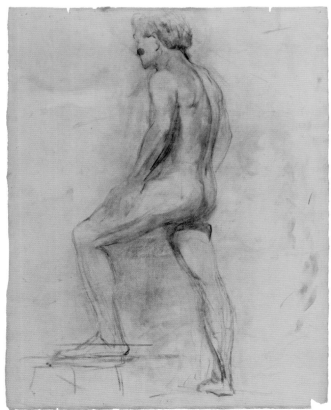

180

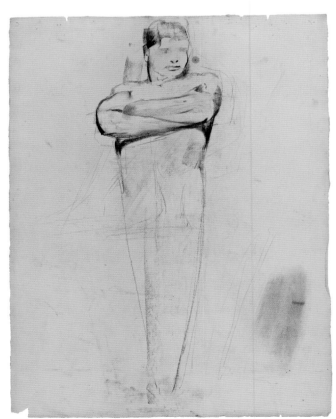

181

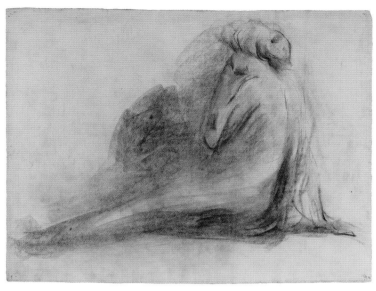

182

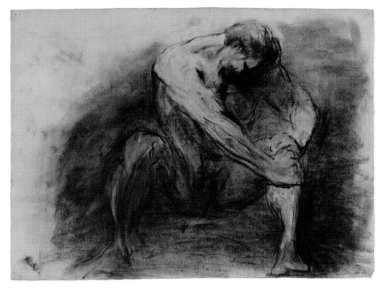

183

178 **Seated Male Model**
Charcoal, 24⅝ × 18⅞ in.
Watermark: *PMF, Italia*
1955.1200

179 **Seated Male Model**
Charcoal, 24⁷⁄₁₆ × 18½ in.
1955.1201

180 **Standing Male Model**
Charcoal, 24⁷⁄₁₆ × 18½ in.
1955.1202.a

181 **Standing Male Model
with Crossed Arms**
Charcoal, 24⁷⁄₁₆ × 18½ in.
1955.1202.b

182 **Seated Female Model**
Charcoal, 18½ × 24⁷⁄₁₆ in.
1955.1203.a

183 **Seated Male Model**
Charcoal, 18½ × 24⁷⁄₁₆ in.
1955.1203.b

*184 **Clothed Figure at an Easel**
Charcoal, 24 × 18½ in.
1955.1204.a

184

185

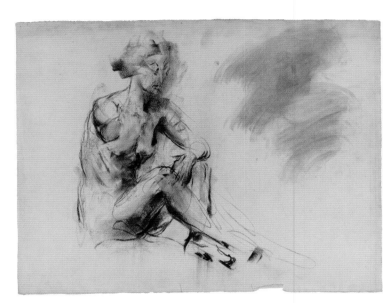

186

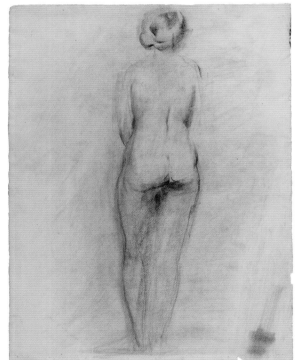

187

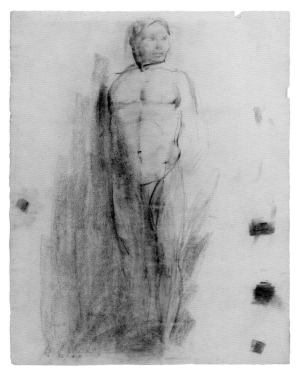

188

189

190

185 **Female Model**
Charcoal, 24 × 18½ in.
1955.1204.b

186 **Seated Female Model**
Charcoal, 18½ × 24⁷⁄₁₆ in.
1955.1205

187 **Standing Female Model**
Charcoal, 24⁷⁄₁₆ × 18½ in.
1955.1206.a

188 **Standing Male Model**
Charcoal, 24⁷⁄₁₆ × 18½ in.
1955.1206.b

189 **Two Models**
Charcoal, 18½ × 24⁷⁄₁₆ in.
1955.1207.a

190 **Standing Female Model**
Charcoal, 24⁷⁄₁₆ × 18½ in.
1955.1207.b

191

192

193

195

196

191 **Standing Female Model**
Charcoal, 24⁷⁄₁₆ × 18½ in.
1955.1208.a

192 **Standing Female Model**
Charcoal, 24⁷⁄₁₆ × 18½ in.
1955.1208.b

193 **Study of a Leg**
Charcoal, 24³⁄₁₆ × 7½ in.
1955.1209

*194 **Standing Clothed Female Model**
Charcoal, 24⁷⁄₁₆ × 18½ in.
Watermark: *L. Berville, France*
1955.1210
Fig. 38

195 **Standing Female Model**
Charcoal, 24⁷⁄₁₆ × 18½ in.
1955.1211

196 **Seated Female Model**
Charcoal, 24⁷⁄₁₆ × 18½ in.
1955.1212

197 **Seated Male Model Reading**
Charcoal, 24⁷⁄₁₆ × 18½ in.
1955.1213

198 **Man with Bow Tie**
Charcoal, 24⁷⁄₁₆ × 18½ in.
1955.1214

197

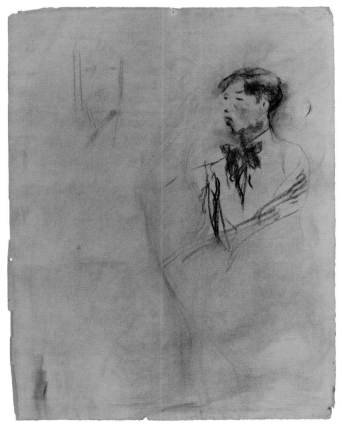

198

DRAWINGS IN PASTEL, INK, AND OTHER MEDIA

199

199 **Reflections**
Gouache or pastel, 11½ × 28¾ in.
1955.1036

*200 **Head of a Medieval Youth**
Pastel, 9¹³⁄₁₆ × 7⅞ in.
1955.1037
Fig. 24

*201 **Reclining Female Figure
on a Couch in a Landscape**
Pen and wash in blue ink, 7¹⁄₁₆ × 8⁷⁄₁₆ in.
Inscribed: *R.S.*
1955.1038

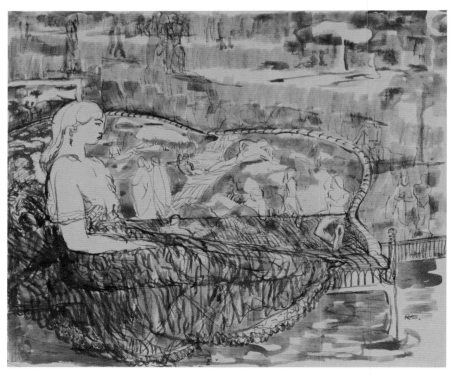

201

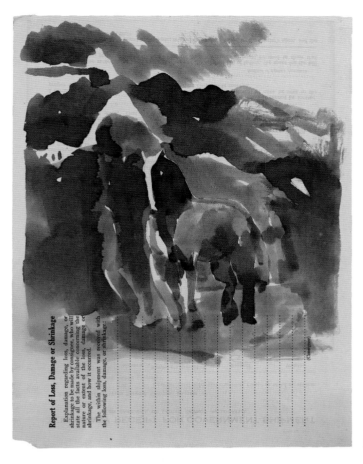

202

202 **Horse in Landscape**
Brown wash and pencil, 11^{5}⁄$_{16}$ × 8^{15}⁄$_{16}$ in.
Mounted on card, government form for
receipt of shipment
1955.1039

203 **Male Figure, Back View**
Pencil, 10^{15}⁄$_{16}$ × 8^{7}⁄$_{16}$ in.
Inscribed, verso: *No. 27 cream*
1955.1040

203

204

205

204 **Just a Note in Crying**
Pencil and blue ink, 4¹⁵⁄₁₆ × 7⅞ in.
Inscribed in blue ink: *Just a note in crying*
1955.1041

*205 **Four Figures with Trees**
Pen and wash in blue ink, 5⅛ × 7⅞ in.
Inscribed in pencil, verso: *XXIV*
1955.1042

206

207

206 **Figure for *Peach Bill* Picture**
Pen and blue ink, 7¹³⁄₁₆ × 5¹⁄₁₆ in.
Inscribed, recto: *Rex S*; verso: *Figure for
Peach Bill picture*
1955.1043

207 **Figures in Landscape**
Pen and wash in blue ink, 7⅞ × 5 in.
Inscribed, verso: *X*
1955.1044

208

209

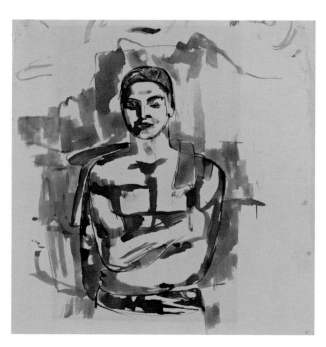

211

*208 **Nude Male Figures**
Pen, ink, and blue wash, 5⅛ × 8¼ in.
Imprint: *364 / Co. D.* Inscribed, verso: *No. 13*
1955.1045

209 **Figure in Landscape**, 1917–18
Pen and ink, 4¹⁵⁄₁₆ × 7⅞ in.
Inscribed in pencil, verso: *XXV*
1955.1046

*210 **Woman in Exotic Dress**, 1917–18
Pen and blue ink over pencil, 4¹⁵⁄₁₆ × 7⅞ in.
Inscribed: *R.S.*
1955.1047
Fig. 37

211 **Out of the East**
Pen and wash in brown ink, 8¹⁄₁₆ × 8¹¹⁄₁₆ in.
1955.1048

212 **Flying Figure**, 1917–18
Pen and ink, 5⅞ × 9¹⁄₁₆ in.
Imprint, verso: YMCA stationery.
Inscribed, recto: *Jack Red*; verso: *XXIII*
1955.1049

*213 **What Many Don't Know**
Pen and blue ink, 3⁹⁄₁₆ × 7⁵⁄₁₆ in.
Inscribed on a separate sheet:
What Many Don't Know
1955.1050
Fig. 51

214 **Two Figures**
Pencil and crayon, 6¹¹⁄₁₆ × 5⅛ in.
Inscribed in pencil, verso: *XXVIII*
1955.1051

*215 **Figures with Horses**
Pen and brown wash, 8¹⁄₁₆ × 10½ in.
1955.1052
Fig. 15

216 **Standing Male**, 1918
Brown ink and wash, 9⁷⁄₁₆ × 4⁵⁄₁₆ in.
Inscribed: *Nigar on board ship / the grup in
swimming / in N. river / NY N. River / R.S.*
1955.1053

212

214

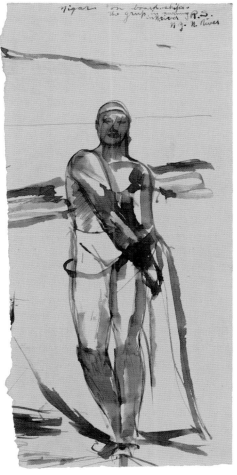

216

217

218

219

*217 **Figures in the Snow**, c. 1917–18
Pen and blue ink, 5⅛ × 8¼ in.
Imprint: *364 / Co. D.*
Inscribed: *hanging / full of snow*
1955.1054

*218 **Study with Eight Figures in a Landscape**
Pencil and blue ink, 5⅛ × 7⅞ in.
Inscribed: *red orange ground here Rex. S. /
N.C. C. Greene a Pink Peach tree young G. /
silver pines Back ground*
1955.1055

219 **Figures in a Landscape**
Pen and wash in blue ink, 7⅞ × 10³⁄₁₆ in.
Inscribed in pencil, verso: *IV*
1955.1056

220

220 **Figure Studies with Tree**, 1917–18
Pen and wash in blue ink, 5⅞ × 9 in.
Inscribed, recto: *RS*; verso: *No. 29*
1955.1057

221 **Standing Figure**
Pen and wash in brown ink, 10⁷⁄₁₆ × 4⁵⁄₁₆ in.
Inscribed, verso: *No. 28*
1955.1058

221

222

223

*222 **Reclining Male Nude**
Pen and wash in blue ink, 6¹¹⁄₁₆ × 9½ in.
Imprint: *American Looseleaf Mfg. Co.,*
Chicago, Sole Makers
1955.1059

*223 **Standing Male Figure from the Back**
Pen and wash in blue ink, 7¹³⁄₁₆ × 5¹⁄₁₆ in.
Inscribed, recto: *R.S. / May;* verso: *No. 11*
1955.1060

*224 **Figures Reclining on Clouds**
Pen and wash in blue ink, 5⅞ × 8¹⁵⁄₁₆ in.
Imprint: YMCA stationery
1955.1061

225 **Two Allegorical Figures in a Landscape**
Pen and ink in blue wash, 8⅛ × 5⅛ in.
Imprint: *364 / Co. D.*
Inscribed in pencil, verso: *10 cream*
1955.1062

*226 **Landscape with Figures**
Pen and wash in blue ink, 7⅞ × 10¼ in.
Inscribed, recto: lengthy description
of composition; in pencil, verso: *XVIII*
1955.1063
Fig. 16

227 **Male Figure in Landscape**
Pencil, pen, and wash in blue ink, 10¼ × 7⅞ in.
Inscribed, verso: *XXVI*
1955.1064

*228 **French Sailor, New York Docks**
Pen and ink with brown wash, 10⅝ × 7½ in.
Inscribed, recto: *RS.;* verso: *French Sailor,*
New York Docks
1955.1065

224

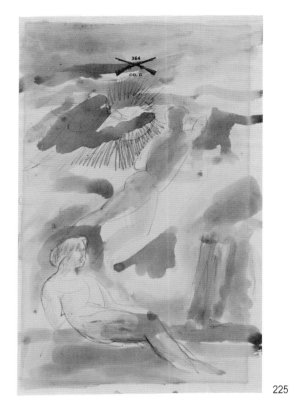

225

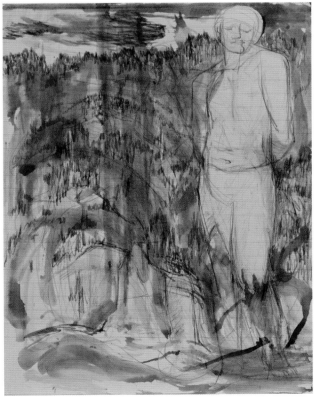

227

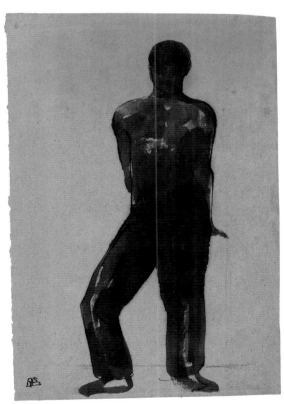

228

229

230

229 **Seated and Reclining Figures**
Pen and wash in blue ink, 5 × 8¼ in.
Inscribed, verso: *No. 22*
1955.1066

230 **Figures in Mountainous Landscape**,
1917–18
Pen and ink in blue wash, 5⅛ × 8¼ in.
Imprint: *364 / Co. D.*
Inscribed in pencil, verso: *no. 28*
1955.1067

232

233

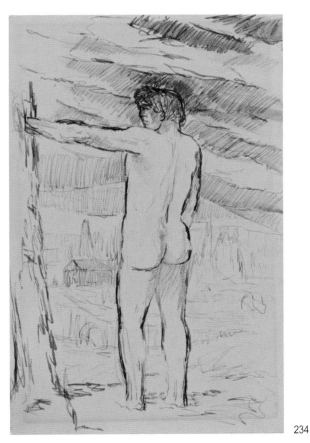

234

231 **Study for *Self-Portrait in the Pines***
Pen and wash in blue ink, 5⅛ × 8¼ in.
Imprint: *364 / Co. D.* Inscribed, recto:
extensive color notations for painting; verso: *VIII*
1955.1068
Fig. 52

232 **Two Figures Regarding a Shadowy Scene**
Pen and wash in blue ink, 7¾ × 4¹⁵⁄₁₆ in.
Inscribed, verso: *no. 15*
1955.1069

*233 **Man in a Uniform**
Pen and wash in blue ink, 5⅜ × 7¹⁵⁄₁₆ in.
1955.1070

234 **Standing Male Model, Back View**
Pen and wash in blue ink, 7⅞ × 5¹⁄₁₆ in.
1955.1071

235

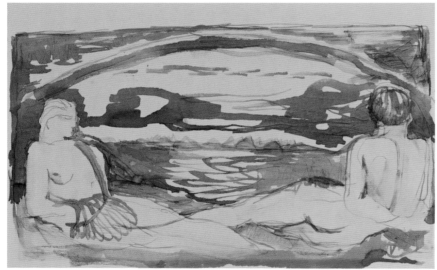

236

237

235 **Figures by Water**, 1917–18
 Pen and wash in blue ink, 5⅞ × 9⅟₁₆ in.
 Imprint, verso: YMCA stationery
 1955.1072

236 **Male and Female Reclining Figures**
 Ink and blue wash, 5⅛ × 7⅞ in.
 Inscribed, verso: *XY*
 1955.1073

237 **Horses and Figures**
 Pen and wash in blue ink, 5 × 7⅞ in.
 Inscribed, verso: *no. 8*
 1955.1074

238

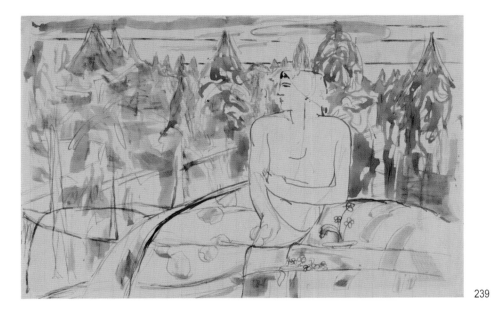

239

238 **Mountainous Landscape**
with Trees, 1917–18
Pen and ink with blue wash, 6⅛ × 9¹⁄₁₆ in.
Imprint: YMCA stationery
Inscribed: *Blue silver sky / Blue Trees /*
Silver like the silver lead
1955.1075

*239 **Seated Woman in Landscape**
Pen and wash in blue ink, 5⅞ × 9¹⁄₁₆ in.
Imprint, verso: YMCA stationery
Inscribed, verso: *No. 16*
1955.1076

*240 **Ferry Horses**
Pencil and black wash, 6⅛ × 8¼ in.
Inscribed: *ferry Horses*
1955.1077
Fig. 14

*241 **Male Figures and Horses**
Pen and ink with blue wash, 6 × 9⅛ in.
Inscribed: *RS.*
1955.1078

241

243

245

247

242 **The Great Air Spirits**
Pen and wash in blue ink, 5⅛ × 7⅞ in.
1955.1079
Fig. 29

243 **Seated Figures**
Pen and ink and wash, 5⅛ × 8 in.
Inscribed: *Rex R.S.*
1955.1080

*244 **Hospital**, 1918
Pen and blue ink, 5⅛ × 7⅞ in.
Inscribed, recto: *R.R.S. / 1918*
and *Hospital*; verso: *No. 17*
1955.1081
Fig. 41

*245 **Two Figures in a Landscape**, 1917–18
Pen and wash in blue ink, 4¹⁵⁄₁₆ × 8 in.
Inscribed, recto: *R.S.*; verso: *No. 23*
1955.1082

*246 **Rain on the Roof Tops**
Pen and wash in blue ink, 8⁷⁄₁₆ × 11 in.
Inscribed: *Rain on the Roof Tops*
1955.1083
Fig. 50

247 **Standing Male Model
with Arms Crossed**
Pencil and colored chalk (?), 10⅜ × 7 in.
1955.1084

248

249

*248 **Black Horses in Front of Hill with the Great Pines**, c. 1917–18
Ink and blue wash, 5⅞ × 9 in.
Imprint: YMCA stationery
Inscribed: *Black Horses / in the front of Hill with / the great Pines*
1955.1085

249 **Seated Woman**, 1918
Pen and blue ink, 4¹⁵⁄₁₆ × 7⅞ in.
Imprint, verso: *Camp Greene, Charlotte, N.C.* Inscribed: *No. 5*
1955.1092

*250 **Monks and Workers in a Field**, 1918
Pen and ink in blue wash, 6½ × 10¼ in.
Inscribed: extensive inscriptions, including color notations, *hospital,* and *remember N.C.*
1955.1145

250

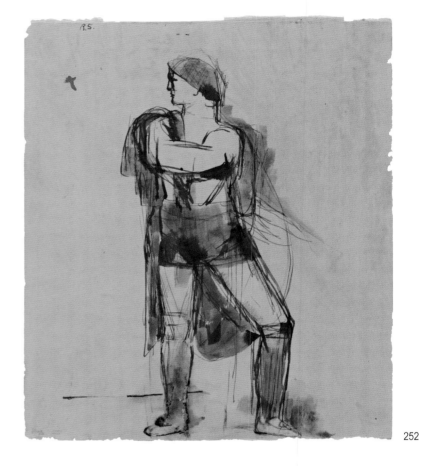

251 252

251 **Half-Robed Standing Male**
 Pen and ink in blue wash, 7⅞ × 4¹⁵⁄₁₆ in.
 Inscribed, recto: *Not to show any bodys. /*
 But a great Deal to use / R.S.;
 verso: *no. 7*
 1955.1168

*252 **Young Workman**
 Pen and wash in blue ink, 8⅜ × 7¹⁄₁₆ in.
 Inscribed: *R.S.*
 1955.1180

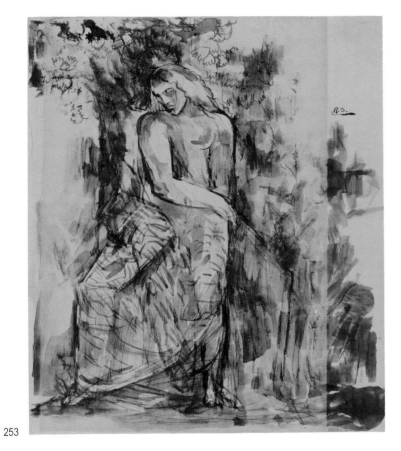

253

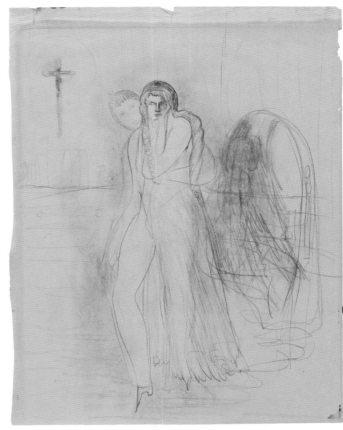

255

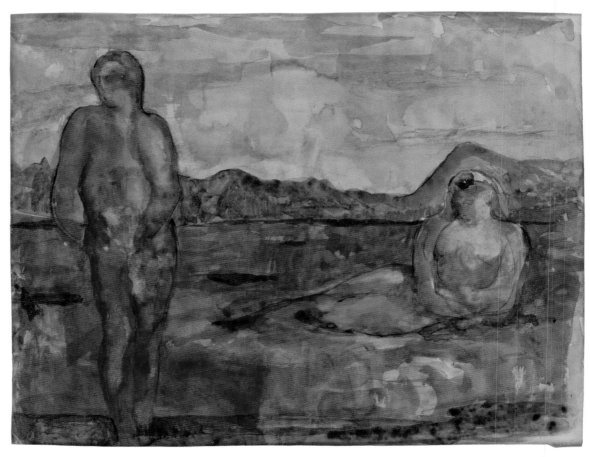

256

*256 **Two Figures in a Landscape**
Pencil with watercolor, 8¹⁄₁₆ × 10⁷⁄₁₆ in.
1955.1299

257

257 **Mountain**
Pastel, 8¹⁵⁄₁₆ × 12 in.
1955.1300

259

258 **Figure in Landscape**
Pastel, 12 × 8¹⁵⁄₁₆ in.
1955.1301
Facing page 7

259 **Pines**
Watercolor over pencil, 11⅞ × 8⁷⁄₁₆ in.
1955.1302

260

*260 **Trees**
Pastel, 12⅝ × 9¼ in.
1955.1303

261

*261 **Young Man Wearing a Hat**
Pencil and pastel, 9¹³⁄₁₆ × 8 in.
Inscribed: *Rex. S.*
1955.1306

*262 **Tahiti**
Pastel and pencil, 11 × 8⁷⁄₁₆ in.
1955.1307

262

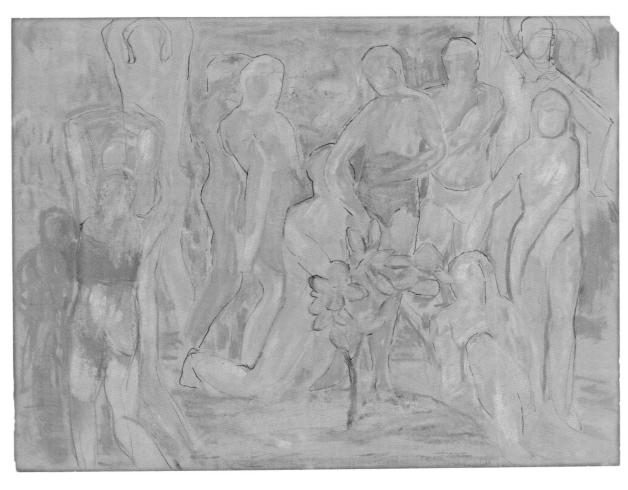

263

***263 Figures with Flowers**
Pastel and pencil, 8$\frac{7}{16}$ × 11 in.
1955.1308

CHRONOLOGY

ASL Art Students League of Los Angeles
CS Carl Sprinchorn
GW Gladys Williams
RS Rex Slinkard

1887

5 June Rex Rudy Slinkard is born in Bicknell, Indiana, the second son of Stephen Wall Slinkard (1858–1921) and Laura Simonson Slinkard (1856–1945). Around the turn of the century, the family relocates to Southern California.

1903

12 May The *Los Angeles Times* reports that S. W. Slinkard of Indianapolis is seeking a business venture, probably a hotel, in San Pedro, the port of Los Angeles. (RS's older brother, Donald, later recalled that the teenaged RS was co-owner and operator of a waterfront saloon in San Pedro, an investment made with an inheritance from a female relative.) In July 1904, S. W. Slinkard is denied a saloon license in the San Pedro district, and his operation is shut down.[1]

1905

RS takes his first art classes at the College of Fine Arts, Los Angeles, with William Lees Judson.

1906

RS begins studies at ASL, which is led by Warren Hedges, a disciple of Robert Henri; Stanton Macdonald-Wright is among his classmates.

1908

April–July S. W. Slinkard advertises to trade his Los Angeles home (1435 Wright Avenue) for property in San Antonio, Texas. In July the Slinkards move to San Antonio, where S.W. acquires twenty acres to establish an ostrich farm to provide plumage to the fashion industry; with them are six adult birds and fourteen babies from his flock in Los Angeles, where the business proved unprofitable. S.W. also plans to develop a pleasure park at the ostrich farm.[2]

RS wins a scholarship to study at William Merritt Chase's New York School of Art; there he meets Carl Sprinchorn, the monitor for Robert Henri's class, who becomes his lifelong friend. RS lives and works in the Lincoln Arcade Building (1947 Broadway, at Sixty-sixth Street) with painter George Bellows, Frank Best, Ed Keefe, and occasionally playwright Eugene O'Neill. RS joins Bellows at prize fights and in painting metropolitan subjects (such as street scenes and Jersey Palisades) and studio models (such as Paddy Flannigan).

December Henri quits New York School to establish his own school.

1909

January RS follows his teacher to the new Henri School of Art, part of an initial class that includes Andrew Dasburg, Morgan Russell, Stuart Davis, and Patrick Henry Bruce.

March Henri meets Hardesty Maratta and becomes a convert to his color theory; he then emphasizes Maratta's principles in his classes.

May Bellows completes a portrait of RS.

Summer RS spends the summer in San Antonio.

Autumn RS returns to the Henri School.

1910

June At his father's insistence, RS returns to California, where his family had relocated following the failure of the ostrich enterprise; en route, he stops for the world championship boxing match between Jack Johnson and Jim Jeffries in Reno on 4 July.[3]

Summer	RS exhibits recent work with CS, Bellows, and Percy S. Stafford at the Blanchard Art and Music Building, home to ASL (233 South Broadway, L.A.). RS earns favorable notice—his *Nocturne* is "equal to that of Whistler"—in the *Los Angeles Times*, which reproduces his painting *The Hobble Sisters*.[4]
Autumn	RS resumes work at ASL; he shares a studio with Howard Potter on the edge of the Westlake district, with a view of the Hollywood Hills, where he produces full-length portraits of women, notable for their size and Goyaesque palette.
End of year	Following the death of ASL director Warren Hedges (8 June) and a brief interim leadership, RS is chosen as successor; he holds the director's position through 1912.

1911

RS meets Jessie Augsbury, an artist's model and aspiring movie actress, who poses for a life-sized portrait, *The Nymph* (unlocated).

According to a report in the *Los Angeles Times* (28 February 1913), RS had "returned from his studies in Paris two years ago," i.e., in winter 1910–11. That information came from the artist's estranged wife, but such a visit has not been documented elsewhere.

1912

15 February	RS marries Jessie Augsbury.
19 March	Their son, Maurice Rudy Slinkard (later renamed Robert), is born.
December	RS quits ASL.

1913

January	CS replaces RS at ASL and serves through December; RS relocates initially to Nevada, then to the family ranch at Honby, near Saugus, California, where CS is an occasional visitor. At the ranch, "where nothing bothers me," RS discovers "things that help me paint."[5]
February	The Armory Show opens in New York City (and later moves to Chicago and Boston); RS studies reproductions of modern art from the exhibition.
February	Jessie Slinkard sues her parents-in-law for alienation of affection; in July, she is reported (in the *Los Angeles Times*) to sue RS for divorce, claiming abandonment.
November	During a visit to Los Angeles, RS attends a boxing match with CS, who claims it was the inspiration for RS's painting *Ring Idols*.

1914

RS is romantically involved with art student Gladys Whitney Williams, whose portrait he had painted as early as 1912; during one of RS's occasional visits to ASL, he meets Nicholas Brigante, who becomes a lifelong champion of RS's work and memory.

28 June	The assassination of Austrian Archduke Ferdinand in Sarajevo leads to the start of World War I.

1915

RS visits the Panama-Pacific International Exposition in San Francisco, accompanied by GW, who is now his fiancée; they locate a ranch site near San Simeon and plan to return and work there after the war.[6]

RS develops a close friendship with Jack Gage Stark, an early Postimpressionist in Southern California, and when in Los Angeles shares a West Sixth Street studio with him.[7]

1916

RS encounters financial difficulties: "I was never so broke in my life."[8] His stays in Los Angeles grow more frequent and lengthier, sometimes due to ill health, but also to be closer to GW; he develops a seasonal cycle, alternating harvest labors at the ranch with art making in L.A., where he paints in a basement studio at his parents' home. His painting *Peace* is exhibited in an unspecified L.A. exhibition. He makes more frequent but informal visits to ASL, where he befriends young students and introduces Nicholas Brigante to Chinese painting. He poses for Jack Gage Stark, whose portrait (unlocated) RS also paints.

Fall	In Los Angeles, RS reports intense work on *Young Rivers*—"I have never been so interested in painting a thing before"—part of a productive season that also produces *My Song* and *Young Priest* among works whose progress he records in January 1917.

1917

January	Despite financial difficulties, RS plans for the future: "G.W. and I are going to have a home by next year. I don't know where—but some place or other."[9]
6 April	U.S. Congress declares war on Germany.
5 June	RS registers as a "rancher" for the military draft.
September	RS is drafted into the Army's 364th Infantry Regiment, 91st Division, the "Wild West Division," recruited largely from western states. He is briefly hospitalized in Los Angeles for an unknown condition before going for training at the newly established Camp Lewis, American Lake, Washington State—"a place so wonderful . . . far away where people spring from an unknown where, and glisten in the shining light . . . where the trees are placed by the hand of a god—by a god so young, by a youth so fair, that mortal cannot see the placing hand."[10] Throughout his military service, RS produces numerous drawings, some on military stationery, developing concepts for future paintings.

1918

22 February	RS is among more than four hundred soldiers from the 364th transferred as a Casual Company to Camp Greene, near Charlotte, North Carolina, one of several such relocations of replacement troops by the War Department.
May	RS is hospitalized for scarlet fever at Camp Greene;[11] following his medical examination, he is marked for limited service. Although he hopes for placement in the camouflage unit painting ships,[12] he is instead transferred to the newly organized Company A, 10th Battalion, U.S. Guards at Fort Niagara, New York, where "I got homesick, first time in my life."[13]
1 July	RS is promoted to sergeant at Port Newark, New Jersey. He then serves with the battalion in New York City, guarding Pier 58, North River, while preparing for embarkation to the Western Front; in his rare free time, he visits the Metropolitan Museum, where he is enchanted by a display of antique carved gems.
9 September	RS is engaged in loading troops onto transport vessels, "westerners, every one of them . . . So young, so strong, so American. Another bunch of wonders."[14]
15 September	New York City records the first death from influenza.
12 October	RS is admitted to St. Vincent's Hospital, New York, ill with "pneumonia"; CS arrives at the hospital three days later.
18 October	RS dies; CS accompanies the body to California.
11 November	Germany signs the armistice, ending fighting on the Western Front.

1919

18 February	RS is included in the "Exhibition of Independent Artists" at the MacDowell Club, New York, through 2 March, the last in the series of shows organized by Robert Henri.
February	Marsden Hartley interrupts his New Mexico sojourn to visit his friend CS in La Cañada, California, where he remains several months; impressed by RS's work, Hartley composes a tribute, "Rex Slinkard—Ranchman and Poet-Painter," which becomes the foreword for the memorial exhibition catalogue.
June	RS's memorial exhibition, including twenty-five paintings and ten watercolors, plus fifty drawings selected from those he made while in the Army, opens at Los Angeles County Museum; it is subsequently shown at San Francisco's Palace of Fine Arts (3–27 October) and Knoedler Galleries, New York City (19–31 January 1920, apparently without the watercolors).

1920

December	Selected letters of RS are published by Robert McAlmon and William Carlos Williams in *Contact* 1; subsequent selections appear in nos. 2 and 3 (1921), the last accompanied by reproductions of four paintings and a photograph of RS.

1921

	Hartley's memorial tribute to RS is included in his collection of essays, *Adventures in the Arts*.
June	Several of RS's drawings are reproduced in *The Dial*.

1923

February	The first exhibition of the "Group of Independent Artists" in Los Angeles includes seven paintings and three drawings by RS, loaned by GW.

1924

GW dies; RS's artworks are bequeathed to her sister, Florence A. Williams, who acts as custodian for the balance of her life.

1929

March Los Angeles County Museum opens a reprise of RS's memorial exhibition.

1943

Summer A selection of RS's works shown at Los Angeles County Museum wins him acclaim as "California's most imaginative painter."[15]

1945

CS visits California and helps catalogue the works from RS's estate.

December Fifty-four drawings by RS are exhibited at Los Angeles County Museum.

1952

CS completes his eighty-two-page manuscript, "Rex Slinkard: A Biographical-Critical Study of His Life, Paintings and Drawings."

1955

Stanford University receives a bequest of RS artworks—25 paintings and 176 drawings—plus an endowment for their care from alumna Florence A. Williams.

1956

February The inaugural exhibition of the Slinkard collection opens at Stanford University Art Gallery. Occasional presentations of RS's artworks appear at Stanford and elsewhere in subsequent years.

NOTES

1 *Los Angeles Times*, 12 May 1903 and 7 August 1904; Donald Slinkard, quoted in Carl Sprinchorn, "Rex Slinkard: A Biographical-Critical Study of His Life, Paintings and Drawings," 2; original in Carl Sprinchorn Papers, Raymond H. Fogler Library, University of Maine, Orono; microfilm copy at Archives of American Art, Smithsonian Institution, reel 3014.

2 *San Antonio Gazette*, 18 April and 11 July 1908; *San Antonio Light*, 26 July 1908.

3 The Reno stopover is reported by CS in "Rex Slinkard" manuscript, 9, but is not documented elsewhere.

4 *Los Angeles Times*, 28 August 1910.

5 RS to CS, [1913]; "Rex Slinkard's Letters," *Contact* 3 (Spring 1921): 6.

6 CS recalled the site as near San Simeon. Nicholas Brigante said it was in Yosemite (Anita Mozley, Notes of a conversation with Nicholas Brigante, 2 September 1976; CCVA curatorial files). In either case, it was certainly rural.

7 Nancy Dustin Wall Moure, *California Art: 450 Years of Painting and Other Media* (Los Angeles: Dustin Publications, 1998), 107.

8 RS to CS [1916]; CS, "Rex Slinkard" manuscript, 45.

9 RS to CS, 29 January 1917.

10 RS to GW, as recorded by CS; "Letters of Rex Slinkard," *Contact* 1 (December 1920): 1.

11 RS to Nicholas Brigante, 11 May 1918; CCVA curatorial files.

12 RS to CS, 3 May 1918; "Rex Slinkard's Letters," *Contact* 3 (Spring 1921): 7.

13 RS to GW; "Rex Slinkard's Letters," *Contact* 3 (Spring 1921): 4.

14 RS to GW, 9 September 1918; "Rex Slinkard's Letters," *Contact* 3 (Spring 1921): 7.

15 *Los Angeles Times*, 8 August 1943.

SELECTED BIBLIOGRAPHY

Anderson, Susan M. *California Progressives: 1910–1930*. Newport Beach, CA: Orange County Museum of Art, 1996.

Armstrong-Totten, Julia. "The Legacy of the Art Students League: Defining This Unique Art Center in Pre-War Los Angeles." In *A Seed of Modernism: The Art Students League of Los Angeles, 1906–1953*. Edited by Will South, Marian Yoshiki-Kovinick, and Julia Armstrong-Totten. Exh. cat., Pasadena Museum of California Art. Berkeley: Heyday Books, 2008.

Barry, John M. *The Great Influenza*. New York: Penguin Books, 2005.

Bohan, Ruth L. *Looking into Walt Whitman: American Art, 1850–1920*. University Park, PA: Penn State University Press, 2006.

Bourne, Randolph. *War and the Intellectuals: Collected Essays, 1915–1919*. Edited by Carl Resek. Indianapolis, IN: Hackett Publishing, 1999.

Brennan, Marcia. *Painting Gender, Constructing Theory: The Alfred Stieglitz Circle and American Formalist Aesthetics*. Cambridge, MA: MIT Press, 2001.

Brinton, Christian. *Impressions of the Art at the Panama-Pacific Exposition*. New York: John Lane, 1916.

Brooks, Van Wyck. "On Creating a Usable Past." *The Dial* 64 (11 April 1918): 337–41.

Chauncey, George. *Gay New York: Gender, Urban Culture, and the Making of the Gay Male World, 1890–1940*. New York: Basic Books, 1995.

Connor, Celeste. *Democratic Visions: Art and Theory of the Stieglitz Circle*. Berkeley: University of California Press, 2000.

Cooper, Emmanuel. *The Sexual Perspective: Homosexuality and Art in the Last 100 Years in the West*. New York: Routledge, 1994.

Corn, Wanda. *The Great American Thing: Modern Art and National Identity, 1915–1935*. Berkeley: University of California Press, 1999.

Cortissoz, Royal. *American Artists*. 1923. Reprint, Freeport, NY: Books for Libraries Press, 1970.

Dawson, Michael. "Photography: South of Point Lobos." In *LA's Early Moderns: Art, Architecture, Photography*, edited by William Deverell, Victoria Dailey, Michael Dawson, and Natalie W. Shivers, 217–315. Glendale, CA: Balcony Press, 2003.

Devlin, Kieron. "Symbolists." In *The Queer Encyclopedia of the Visual Arts*, edited by Charles J. Summers, 325–27. San Francisco: Cleis Press, 2004.

Dijkstra, Bram. "Early Modernism in Southern California: Provincialism or Eccentricity?" In *On the Edge of America: California Modernist Art, 1900–1950*, edited by Paul J. Karlstrom, 156–78. Berkeley: University of California Press, 1996.

Dubin, Steven C. *Displays of Power: Memory and Amnesia in the American Museum*. New York: New York University Press, 1999.

Eldredge, Charles C. *American Imagination and Symbolist Painting*. New York: Grey Art Gallery and Study Center, 1979.

Figurative Art in California during the Modern Period. Exh. brochure. Los Angeles: Spencer Jon Helfen Fine Arts, 2008.

Fort, Ilene Susan. "The Adventuresome, the Eccentrics, and the Dreamers: Women Modernists of Southern California." In *Independent Spirits: Women Painters of the American West, 1890–1945*, edited by Patricia Trenton. Los Angeles: Autry Museum of Western Heritage, 1995.

Frank, Waldo. *Our America*. New York: Boni and Liveright, 1919.

Furtwängeler, Adolf. *Masterpieces of Greek Sculpture*. New York: Charles Scribner's Sons, 1895.

Fussell, Paul. *The Great War and Modern Memory*. Cambridge: Oxford University Press, 2000.

Gagnier, Cindy. Telephone interview by Geneva Gano. 22 July 2009.

Goldman, Jason. "Subjects of the Visual Arts: Sailors and Soldiers." In *The Queer Encyclopedia of the Visual Arts*, edited by Charles J. Summers, 319–20. San Francisco: Cleis Press, 2004.

Greenough, Sarah. *Modern Art in America: Alfred Stieglitz and His New York Galleries*. Washington, D.C.: National Gallery of Art, 2000.

Harris, Luther S. *Around Washington Square: An Illustrated History of Greenwich Village*. Baltimore: The Johns Hopkins University Press, 2003.

Hartley, Marsden. "Rex Slinkard: Ranchman and Poet-Painter." In *Memorial Exhibition: Rex Slinkard, 1887–1918*. Los Angeles: Los Angeles Museum of History, Science, and Art, 1919. Reprinted as "Rex Slinkard." In Marsden Hartley, *Adventures in the Arts: Informal Chapters on Painters, Vaudeville, and Poets*, 87–85. New York: Boni and Liveright, 1921.

Hartley, Marsden, Papers. Yale Collection of American Literature. Beinecke Rare Book and Manuscript Library, Yale University. Microfilm copy at Archives of American Art, Smithsonian Institution, reel 3014.

Henri, Robert. *The Art Spirit: notes, articles, fragments of letters and talks to students, bearing on the concept and technique of picture making, the study of art generally, and on appreciation*. Compiled by Margery Ryerson. Philadelphia: J. B. Lippincott, 1923.

Hole, Heather. *Marsden Hartley and the West: The Search for an American Modernism*. New Haven, CT: Yale University Press, 2007.

Homer, William Innes. *Robert Henri and His Circle*. Ithaca, NY: Cornell University Press, 1969.

Kennedy, David M. *Over Here: World War I and American Society*. New York: Oxford University Press, 1980.

Lawrence, D. H. *Studies in Classic American Literature*. Edited by Ezra Greenspan, Lindeth Vasey, and John Worthen. Cambridge: Cambridge University Press, 2003.

MacDowell Club. "Exhibition of Paintings and Sculpture." Exh. cat. New York: MacDowell Club, 1920.

Martin, Robert K. *The Homosexual Tradition in American Poetry*. Iowa City: University of Iowa Press, 1998.

McCarroll, Stacey. *California Dreamin': Camera Clubs and the Pictorial Photography Tradition*. Boston: Boston University Art Gallery, 2004.

Miller, Tyrus. "Ridiculously Modern Marsden: Tragicomic Form and Queer Modernity." *Modernist Cultures* 2 (October 2006): 87–101.

Moure, Nancy Dustin Wall. *California Art: 450 Years of Painting and Other Media*. Los Angeles: Dustin Publications, 1998.

Mowry, George. *The California Progressives*. Berkeley: University of California Press, 1951.

Orozsvary, Chandra. "Official Responses to Homosexuality During World War I." *Illumination: The Undergraduate Journal of Humanities* (Spring 2006): 42–49.

Putnam's Monthly & the Reader, "The Lounger," 5 (December 1908): 378.

Richter, Dorothee, et al. "Thirty-one Positions on Curating." *ONCURATING.org* 1 (2008): 1–9.

Scott, Gail R. *Carl Sprinchorn*. Farmington, ME: Tom Veilleux Gallery, 1994.

Slinkard, Rex, Papers. Iris & B. Gerald Cantor Center for the Visual Arts, Stanford University, Stanford, CA.

———. "Extracts from Letters." *Contact* 2 (January 1921): 3.

———. "Letters of Rex Slinkard." *Contact* 1 (December 1920): 2–4.

———. "Rex Slinkard's Letters." *Contact* 3 (Spring 1921): 1–8.

Smith, Richard Candida. "The Elusive Quest for the Moderns." In *On the Edge of America: California Modernist Art, 1900–1950*, edited by Paul Karlstrom, 26. Berkeley: University of California Press, 1996.

Sprinchorn, Carl, Papers. Special Collections, Raymond H. Fogler Library, University of Maine. Microfilm copy at Archives of American Art, Smithsonian Institution, reels 3004–14.

———. Letter to Rex Slinkard, 25 February 1914. Personal files of Stephen Slinkard.

———. Telegram to Rex Slinkard's parents, 17 October 1918. Personal files of Stephen Slinkard.

Staniszewski, Mary Anne. *The Power of Display: A History of Museum Exhibitions at the Museum of Modern Art*. Cambridge, MA: MIT Press, 1998.

Stearns, Harold E., ed. *Civilization in the United States: An Inquiry by Thirty Americans*. New York: Harcourt, Brace and Company, 1922.

Summers, Charles J., ed. *The Queer Encyclopedia of the Visual Arts*. San Francisco: Cleis Press, 2004.

Vernon, Arthur G. "Modern Art in California." *The Graphic*, 20 April 1918: 18

Walker, John Alan. "Rex Slinkard (1887–1918): Pioneer Los Angeles Modernist Painter." *The Los Angeles Institute of Contemporary Art Journal*, no. 3 (December 1984): 20–23.

Weinberg, Jonathan. *Male Desire: The Homoerotic in American Art*. New York: Abrams, 2004.

———. *Speaking for Vice: Homosexuality in the Art of Charles Demuth, Marsden Hartley, and the First American Avant-Garde*. New Haven and London: Yale University Press, 1993.

Wilson, Michael G., and Dennis Reed. *Pictorialism in California*. Malibu, CA: J. Paul Getty Museum; San Marino, CA: Henry E. Huntington Library and Art Gallery, 1994.

THE LEGEND OF REX SLINKARD
was produced under the auspices of the
Iris & B. Gerald Cantor Center for Visual Arts
Publication management Bernard Barryte

Produced by Wilsted & Taylor Publishing Services
Project manager Christine Taylor
Copy editor Melody Lacina
Designer and compositor Jody Hanson
Proofreader Nancy Evans
Production assistant LeRoy Wilsted
Printer's devil Lillian Marie Wilsted

The book was composed in Granjon with
Arial Narrow display. The text paper is
157 gsm China Gold East Matte Artpaper.
It was printed and bound by Regal Printing,
Ltd., in Hong Kong through Michael Quinn
of QuinnEssentials Books and Printing, Inc.

Oasis (detail) [Cat. no. 17]